TURNER

THE LATE SEASCAPES

YALE UNIVERSITY PRESS *New Haven & London*

STERLING AND FRANCINE CLARK ART INSTITUTE *Williamstown, Massachusetts*

TURNER

THE LATE SEASCAPES

James Hamilton

This book is published on the occasion of
the exhibition *Turner: The Late Seascapes*

Sterling and Francine Clark Art Institute
Williamstown, Massachusetts
14 June–7 September 2003

Manchester Art Gallery
Manchester, England
31 October 2003–25 January 2004

Burrell Collection
Glasgow, Scotland
19 February–23 May 2004

Turner: The Late Seascapes has been organized
by the Sterling and Francine Clark Art
Institute and Manchester City Galleries.

Cover illustration: Detail of *Van Tromp, Going
about to Please His Masters, Ships a Sea, Getting
a Good Wetting* (fig. 54)

Title page: Detail of *Yacht Approaching
the Coast* (fig. 81)

Details used at chapter openings: Chapter 1,
*"Now for the Painter," (Rope.) Passengers Going
on Board* (fig. 8); Chapter 2, *Slave Ship* (fig.
28); Chapter 3, *Brunnen, from the Lake of
Lucerne* (fig. 48); Chapter 4, *Whalers (The
Whale Ship)* (fig. 56)

Designed by Carol S. Cates
Set in Bembo and Castellar type by Amy Storm
Printed in Italy at Conti Tipocolor

Library of Congress
Cataloging-in-Publication Data
Hamilton, James.
Turner: the late seascapes / James Hamilton.
 p. cm.
"Published on the occasion of the exhibition
Turner: the late seascapes, Sterling and
Francine Clark Art Institute, Williamstown,
Massachusetts, 14 June–7 September 2003,
Manchester Art Gallery, Manchester,
England, 31 October 2003–25 January 2004,
Burrell Collection, Glasgow, Scotland,
19 February–23 May 2004."
ISBN 0-300-09900-2 (cloth: alk. paper) —
ISBN 0-931102-52-9 (pbk.: alk. paper)
1. Turner, J.M.W. (Joseph Mallord William),
1775–1851—Exhibitions. 2. Sea in art—
Exhibitions. I. Sterling and Francine Clark Art
Institute. II. Manchester Art Gallery.
III. Burrell Collection. IV. Title.
ND497.T8A4 2003
759.2—dc21 2003000545

A catalogue record for this book is available
from the British Library.

The paper in this book meets the guidelines
for permanence and durability of the Com-
mittee on Production Guidelines for Book
Longevity of the Council on Library
Resources.

10 9 8 7 6 5 4 3 2

Contents

Lenders to the Exhibition

Aberdeen Art Gallery and Museums

Ashmolean Museum, Oxford

Birmingham Museums and Art Gallery

Cincinnati Art Museum

Courtauld Institute Gallery, Somerset House, London

Fogg Art Museum, Harvard University, Cambridge, Massachusetts

Indianapolis Museum of Art

The J. Paul Getty Museum, Los Angeles

Kimbell Art Museum, Fort Worth, Texas

Manchester Art Gallery

The Metropolitan Museum of Art, New York

Museum of Fine Arts, Boston

National Gallery of Art, Washington, D.C.

Board of Trustees of the National Museums and Galleries on
 Merseyside (Walker Art Gallery), Liverpool

Sterling and Francine Clark Art Institute, Williamstown, Massachusetts

Tate Britain, London

Trustees, Cecil Higgins Art Gallery, Bedford, England

Ulster Museum, Belfast

University College, London

Wadsworth Atheneum, Hartford, Connecticut

Yale Center for British Art, New Haven, Connecticut

Victoria and Albert Museum, London

Private collections

Foreword

Several years ago the distinguished Turner specialist James Hamilton approached the Clark Art Institute and the Manchester Art Gallery, urging an unorthodox and thrilling new look at Turner's late seascapes and their debt to discoveries in science and navigation that had occurred in the 1830s and 1840s. Given Turner's tremendous stature as both painter and cultural icon, it was surprising to us that this exhibition would be the first devoted to his late seascapes and the first Turner show in America drawing from multiple collections in more than a generation. A deeper and long overdue investigation of Turner's use of the sea to explore British and, ultimately, all of human history and endeavor was impossible to resist. *Turner: The Late Seascapes* was born.

Turner had described the sea in a poem as a "power supreme," and he explored that power through representation and metaphor from the 1820s through the end of his life. The forms of the sea in his mid-career work had a tremendous effect on Turner's paintings of mountains and land storms, and, later, he gradually extinguished all sense of place to leave the viewer with empty, uncontrollable seas and a clear pallet for reflection on the meaning of life. On one level, Turner's late seascapes express his growing obsession with light and color abstractions. On another, his seascapes enact Turner's own views on the vastness and infinity of the spirit. They are deeply emotional paintings and among the most radical art of the century.

There was a great need for a show examining Turner's late seascapes. These wonderful, expressive paintings have not been treated as a distinct group in almost forty years. Our work is special in respects related not only to subject matter but also to timing. There have been a number of

Turner shows in the recent past, the scholarship of each leading in some key respect to *Turner: The Late Seascapes*. General retrospectives in Essen and Zurich in 2001, Vienna in 1997, and Canberra and Melbourne in 1996 have significantly set the stage for exhibitions such as ours that treat central, specific aspects of Turner's career. The Birmingham Museums and Art Galleries' smaller show on Turner's early sea pictures, scheduled for fall 2003, complements our own and ends roughly where ours begins. Other exhibitions slated for 2003 and 2004 will consider Turner's Venice paintings and Turner's expression of British national identity.

Turner: The Late Seascapes is also the first major multicollection Turner exhibition in over twenty years in the United States and the first major Turner show in Scotland and in Manchester for many decades. Taken together, these shows create an enviably apt environment for our own look at some of Turner's greatest accomplishments. Our exhibition in particular takes a fresh look at the Clark's *Rockets and Blue Lights* (1840), a great and difficult Turner canvas long considered one of the Institute's major paintings, but also one of its most cryptic. Manchester's own great Turner, *"Now for the Painter," (Rope.) Passengers Going on Board* (1827), a large, early seascape that foretold the artist's later achievement, made the newly expanded and refurbished Art Gallery a logical partner for a major show on one of the least understood aspects of Turner's genius. Manchester, with important collections of works by Turner, has always been a locus of Turner studies, and in Turner's lifetime the city was home to some of his key patrons. We were fortunate to attract the Burrell Collection in Glasgow as a final venue for the exhibition and are grateful for the assistance the Glasgow City Galleries provided in conceptualizing the show. Our collaboration has been a good and enjoyable one, and we commend our respective staffs for their hard work and enthusiasm.

We are particularly grateful to Dr. Hamilton for his exacting scholarship and diligence in preparing both the list of objects and the catalogue text. We believe his contribution to Turner studies through *Turner: The Late Seascapes* will be a substantial and significant one.

Visitors to all three venues of *Turner: The Late Seascapes* will see works very rarely on view in our respective regions and countries. We are deeply grateful, of course, to our lenders for their support of our efforts. Their generosity, taken together with Dr. Hamilton's new findings and the work of our museum staffs, will present new facets on Turner studies and exciting new ways to look at one of the most enigmatic artists of his age.

Michael Conforti, *Director*
Sterling and Francine Clark
Art Institute

Virginia Tandy, *Director*
Manchester City Galleries

Preface and Acknowledgments

The exhibition *Turner: The Late Seascapes* grew out of an idea for a much smaller show that would bring together, for the first time since they were originally exhibited in 1840, two seminal paintings by Turner. With their long, informative but winding titles, *Slave Ship (Slavers Throwing Overboard the Dead and Dying—Typhon Coming On)* and *Rockets and Blue Lights (Close at Hand) to Warn Steamboats of Shoal Water*, the paintings were conceived, so this exhibition argues, as a pair. Nonetheless, they were sold from the artist's studio to separate buyers, and commerce, reality, and chance have kept them apart ever since. Despite many changes of ownership, variously in English, French, and American collections, they now hang only about 130 miles apart: *Slave Ship* has come to rest in the Museum of Fine Arts, Boston, and *Rockets and Blue Lights* at the Clark Art Institute in Williamstown, Massachusetts. We had hoped to celebrate their brief reunion in the same room by presenting them side by side; alas, the surface of *Slave Ship* is so fragile that it is considered unwise to allow it to leave Boston.

———

I am deeply grateful to Michael Conforti and his staff at the Clark Art Institute for supporting and fostering this exhibition in their galleries, and for giving me encouragement and time to develop the ideas that thread through the exhibition and this book. In particular, I wish to thank Brian Allen, Harry Blake, Michael Cassin, Sharon Clark, Paul Dion, David Edge, Lindsay Garratt, Alexis Goodin, Adam Greenhalgh, Sherrill Ingalls, Mattie Kelley, John Ladd, Sarah Lees, Mary Leitch, Saul Morse, Mark Reach, Katie Pasco, Kate Philbin, Kathryn Price,

Richard Rand, Curtis Scott, Noel Wicke, and Breta Yvars, and the very many other friendly people at the Clark who made my association with the Institute a happy and rewarding one. Special mention should also be made of David Bull, who undertook with scrupulous attention and care the painstaking conservation of the Clark's *Rockets and Blue Lights.*

In Manchester, I wish to thank Virginia Tandy and her staff at the Manchester City Galleries for their enthusiasm in bringing the exhibition to the United Kingdom, particularly Tim Wilcox, Andrew Loukes, and Janet Boston, who were involved at every stage, and Howard Smith and Jane Hall, who provided additional support. In Glasgow, I wish to thank Vivien Hamilton and Muriel King of the Burrell Collection, Glasgow City Art Gallery.

All involved in the exhibition owe an immense debt of gratitude to the lenders to a show that was especially complex because of the vulnerability of the works, many of which could not travel to all three venues for reasons of conservation. I wish to thank Ian Warrell, David Blayney Brown, and Stephen Hackney at the Tate, London; Julia Alexander, Gillian Forrester, and Scott Wilcox at the Yale Center for British Art; Franklin Kelly and Alan Shestack at the National Gallery, Washington, D.C.; George Shackelford and James Wright at the Museum of Fine Arts, Boston; Malcolm Warner at the Kimbell Art Museum in Fort Worth, Texas; Eric Zafran of the Wadsworth Atheneum in Hartford, Connecticut; and Scott Schaefer of the J. Paul Getty Museum in Los Angeles; as well as Julian Agnew and Christopher Kingzett of Agnew's London, Diana Kunkel, and Anthony Spink, who facilitated important loans from private collections.

My warm thanks also go to friends and colleagues who have helped me in my research and have read and, always, improved my text at various stages of its evolution. In particular they are Brian Allen, Andrew Loukes, Pieter van de Merwe, Cecilia Powell, Richard Rand, Paul Spencer-Longhurst, Sarah Weatherwax, and Andrew Wilton. The perceptive and skillful team at Yale University Press, including Heidi Downey, Patricia Fidler, Michelle Komie, John Long,

and Mary Mayer, working closely with Curtis Scott at the Clark, brought this catalogue to fruition. The book's handsome design and layout were provided by Carol Cates, Amy Storm typeset the manuscript, and Kathleen Friello expertly prepared the index.

Finally, I want to thank my friends and colleagues at the University of Birmingham, particularly David Allen and Clare Mullett, who have given me the encouragement and the space to help bring the project to fruition, and my wife, Kate Eustace, and our daughter, Marie, who have endured another couple of long, hot Turner years.

When I proposed this exhibition as long ago as 1998, I proposed also the idea for a quite different Turner exhibition, *Turner's Britain*, to the Museum and Art Gallery of Birmingham. A happy consequence of *Turner: The Late Seascapes* being shown in Manchester and Glasgow is that briefly both exhibitions will be on display at the same time in two British cities. A further consequence is that the catalogues of the two exhibitions were written in parallel and might properly be considered one work, to be read, perhaps, together. Threads of ideas in one have become caught in the weaving of the other, enriching the color of the whole without, I hope, distorting my account of the artist's purpose.

Two books require two dedicatees, and no two Turner scholars are woven more closely together through their work than are Martin Butlin and the late Evelyn Joll. Their comprehensive catalogue, *The Paintings of J.M.W. Turner*, revolutionized Turner studies when it was published by Yale University Press in 1977. I should like to dedicate this book to Martin Butlin, and the catalogue of *Turner's Britain* to the memory of Evelyn Joll.

TURNER

THE LATE SEASCAPES

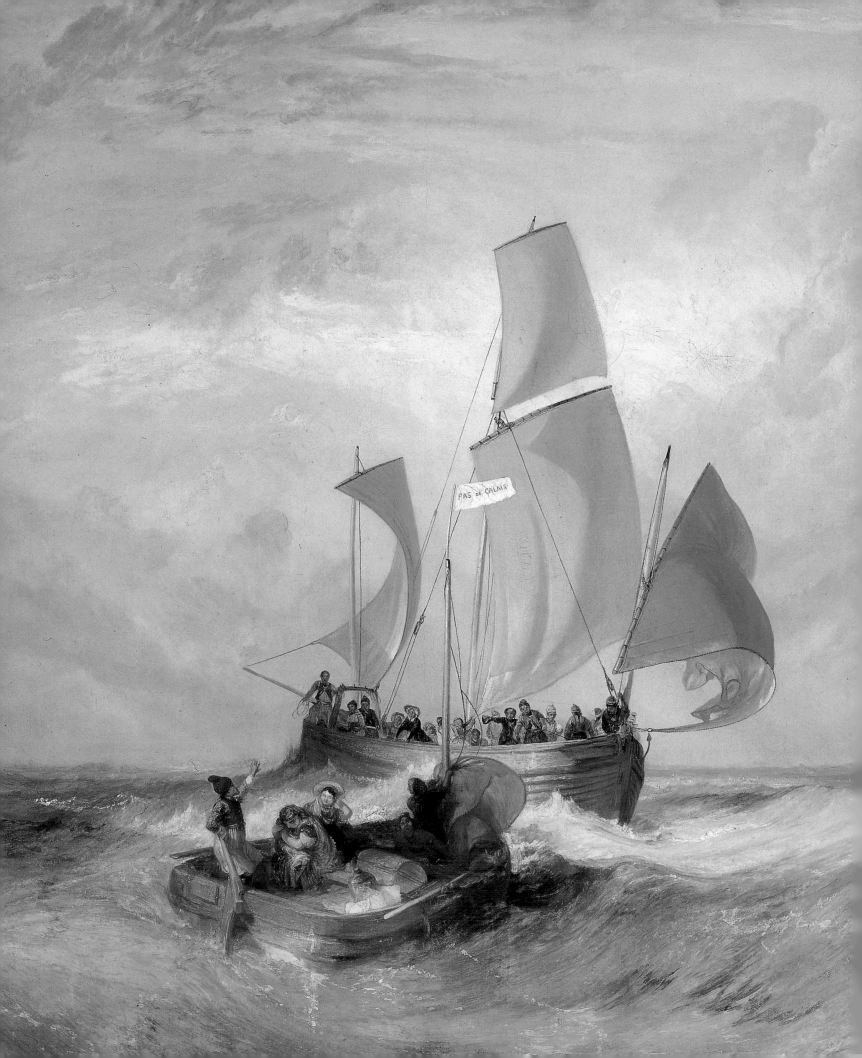

One

A POWER SUPREME

The sea, in the work of J. M. W. Turner, is a stage on which the artist enacts and reenacts past, present, and future, and unites them into an integrated and enthralling narrative. As it flowed around his beloved islands of Britain, the sea bore tales of history, myth, drama, natural power, and the progress and improvement of man which, across a painting career of sixty years, Turner articulated and launched again on seas of his own making. His first exhibited oil painting was a sea-piece, *Fishermen at Sea* (exh. 1796; Tate Britain, London; BJI),[1] and the works he was engaged in during the months before his death, depicting the story of Aeneas, embraced the myth of the sea in dream. As the sea flowed around Turner's nation, so too did it flow around him.

Turner's childhood and youth were spent within sight and sound both of the shipping on the Thames near Covent Garden, London, where he was born in 1775, and of the sea itself, on childhood journeys to the Kent coast. The sea became central to Turner's art: nearly one-third of his extant oils are seapieces, and within the period covered by this exhibition, the mid-1820s to his death in 1851, he painted more sea subjects than any other. Although during his mature years he lived and worked in London, he spent long periods at and on the sea, principally in the Kent and Sussex towns of Margate, Deal, Folkestone, and Hastings.

In his paintings of the British landscape Turner created an image of Britain in oil, watercolor, and engraving that form a composite picture of the nation's peoples and history. In the landscape works he was constrained by the realities of each view, with the nature of the horizon defined by the location. But with sea subjects he had more freedom to act, because seascape shares a quality with the stage: both begin empty, with an inescapable horizontal. This can be tilted, bent, raised, or lowered at will, with a cast of characters—ships, boats, people, weather—taking their moment upon it. In contrast to landscape, which centuries of human activity changes irrevocably, the sea remains the same whatever may happen upon it. The sea has no memory. A sense of place at sea can be indicated or extinguished at the artist's will, and at his will also the sea can equally render both a moment of time and an eternity. The particular fascination of the sea for humanity across the centuries is rooted in its elemental, uncontrollable, and immeasurable force, which human beings can watch, harvest, and travel upon but can never direct.

During his early years as an artist Turner became professionally aware of the metaphor and mechanics of the stage, working briefly in 1791 as a scene painter at the Pantheon in London, newly converted into an opera house.[2] In his youth and beyond he was a regular and attentive member of theater and opera audiences, and he reflected theatrical manner and subject matter in his art: the stagey *Aeneas and the Sibyl, Lake Avernus* (c. 1798; Tate Britain, London; BJ34; a later version painted in 1815 is in the Yale Center for British Art, New Haven; BJ226); *"What You Will!"* (exh. 1822; Private collection, U.K.; BJ229); *Vision of Medea* (exh. 1828; Tate Britain, London; BJ293); *Jessica* (exh. 1830; Petworth House; BJ333); and *Juliet and Her Nurse* (exh. 1836; Private collection, Argentina; BJ365)—these can stand as examples from all points in Turner's career.[3] Later in life Turner began acquiring neat and precisely made ship models, with backgrounds and plaster waves that he himself seems to have painted with an appropriate bravura. Although we do not know for certain which pictures

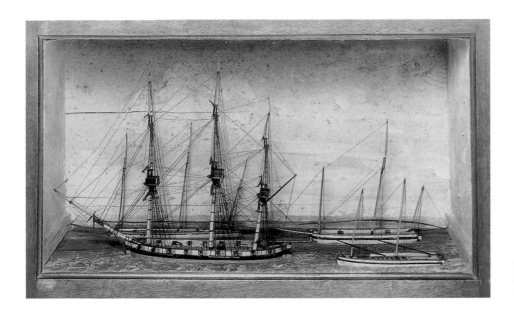

FIGURE 1 A model ship in its display box, owned by Turner. Tate Britain, London

he used these for, or even if he did so at all, they were no doubt of help to him in correctly depicting details of rigging and ship design (fig. 1). He was enthralled, too, by the sea's official theatricals, and he traveled to Portsmouth in 1807 to see the arrival of two captured Danish men o' war. He went there again in 1814 for the Spithead Review of the fleet, and yet again in 1844 to watch the arrival of King Louis-Philippe of France on a state visit.[4]

Turner's own practical experience as an inshore amateur sailor fueled the intimate knowledge of the movements of the sea and ships that he proclaims in his paintings. He has a penchant for danger: throughout his maritime oeuvre he draws and paints dangerous situations, such as a boat rapidly dropping sail to avoid collision, the few terrifying moments immediately before a disaster, the frighteningly close near miss.[5] These would have been easily understood by the majority of Turner's audiences, to whom the rules of good seamanship were as well known then as the rules of good driving should be today. He owned and borrowed small boats over his lifetime, and there is a strong clue in the "River and Margate" sketchbook of 1806–8 that he ordered a sailing boat to be built for him. On a flyleaf of the sketchbook he lists the materials required, and their prices,

A Power Supreme

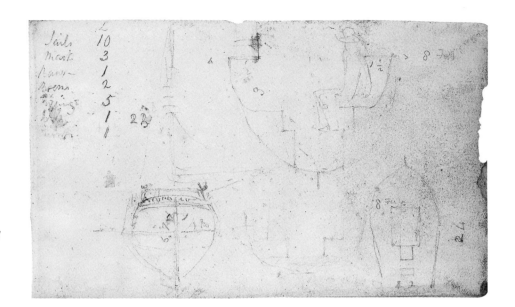

FIGURE 2　J. M. W. Turner, *Diagrams and Measurements of a Boat*, from "River and Margate" sketchbook, 1806–8. Pencil on paper, 4 1/2 x 7 1/2 in. (11.5 x 19 cm). Tate Britain, London [TB XCIX 86, 85v]

and the doodles and quick cutaway sections of a boat suggest that he was speaking as he drew them, perhaps to the boat builder himself (fig. 2).[6]

In this exhibition, the term "Late Seascapes" should be taken fairly broadly; indeed, the show opens earlier rather than late, with a work from the mid-1820s, painted when Turner was only fifty years old. Nevertheless, by that time the artist's mature styles were set, and, feeling mortality creeping up on him, Turner was evidently beginning to see himself as an older artist who, whether he liked it or not, was entering his latter period. His close friend and collaborator Walter Fawkes, a Yorkshire landowner, had died in 1825; his partner, father, and friend, William Turner the elder, was old and ailing, and was to die in 1829; and Turner himself, "thin as hurdle," as he put it, had by the late 1820s breathing troubles and a weak heart, and he was beginning to feel the cold dreadfully.[7] At this time Turner also began the long and complicated process of making his will.

The modest oil painting *View from the Terrace of a Villa at Niton, Isle of Wight, from Sketches by a Lady* (fig. 3) is one in which the viewer approaches the distant sea from the land. Unless one was born on board ship, that is what everybody does the first time he or she sees

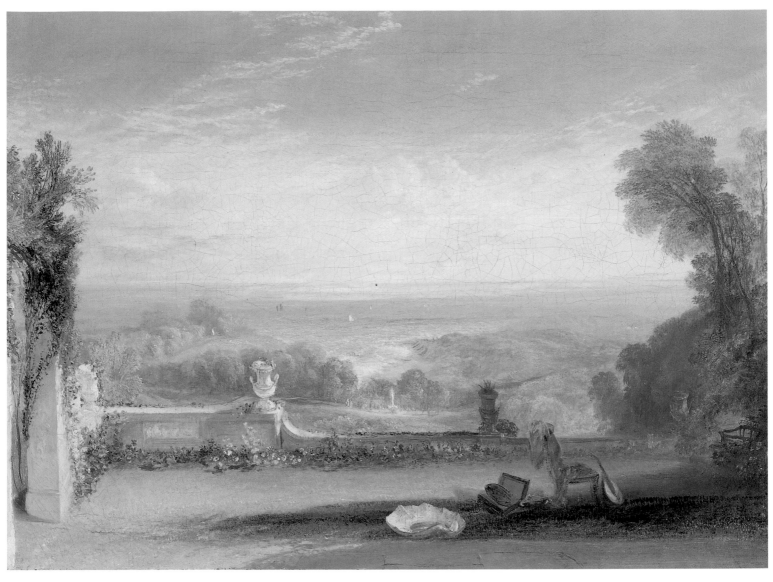

FIGURE 3 J. M. W. Turner, *View from the Terrace of a Villa at Niton, Isle of Wight, from Sketches by a Lady*, exh. 1826. Oil on canvas, 18 x 24 in. (45.7 x 61 cm). Museum of Fine Arts, Boston. Bequest of William A. Coolidge [BJ234]

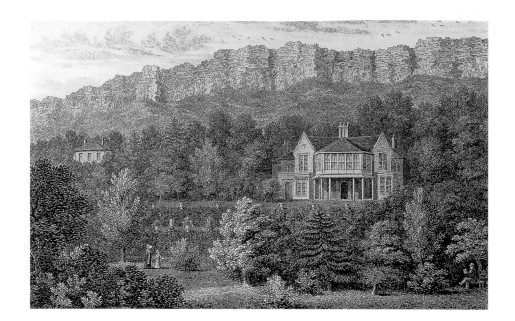

FIGURE 4 George Brannon, *The Undercliff. Viewed from the Grounds of The Orchard, the Elegant Villa of Sir Willoughby Gordon, Niton, Isle of Wight*, 1821. Engraving, 5 3/8 x 8 1/2 in. (13.6 x 21.7 cm). Isle of Wight County Record Office

the sea. There is an enigmatic quality associated with beginnings, with birth, and with myth in this picture, for although the southern view of the English Channel from Niton was a landscape that Turner must have seen on his many visits to the Isle of Wight, this particular view, as the long and characteristically informative title tells us, was taken from a group of sketches by "a Lady." The particular lady in question, Julia Bennet (1775–1867), had been a friend of Turner's for years. They were the same age, and she had been one of his earliest pupils.[8] She married a soldier, James Willoughby Gordon, in 1805, and when in 1818 her husband became a baronet, she became Lady Gordon.

The enigma in the picture is of a kind that had come to haunt Turner's work, and here it is typified by the pearly oyster shell, itself reflecting the shine on the sea. The shell, evidently painted to be "real" but far too big to be true to life, carries two messages: the first is that it transforms a stone shell fountain that decorated the terrace of the Gordons' house, The Orchard, Niton.[9] The shell fountain is just visible in figure 4.[10] In this Turner neatly enchants reality with artifice and brings the sea, symbolically, into contact with the land.

The second message is the reflection the shell throws on the ancient myth of Venus, the goddess of love, who was born from the sea on a scallop. Venus was also the goddess of garden fertility, and there, blossoming along the foreground terrace, are summer flowers whose lightness of touch and color echo the fresh sparkling light of the sea.

Turner could hardly pick up a paintbrush without painting a poem of some kind, and in this bright little view, where we are introduced to the sea in both reality and myth, we see mature Turner at his most engaging and poetic. It is an apposite introduction to the exhibition, not only because it walks us gently to the sea from the land but also because of its tapestry of allusions, which are of a kind that we shall meet many times in Turner's later marine art. In addition to the flowers, the warm light, and the endearing staginess of the terrace, balcony, and seashell, Turner also brings us a deep middle ground with figures and setting that allude to the paintings of the French master Jean-Antoine Watteau (1684–1721), an artist whom Turner admired deeply, and who was also a favorite of Julia Gordon and her husband.[11] Further, there is an elegant still life of painter's paraphernalia in the foreground that undoubtedly refers to Lady Gordon's painting hobby, and a small but illegible classical relief in the terrace wall that underlines the picture's root in myth. In complimenting Lady Gordon by painting and exhibiting this modest masterpiece from one of her sketches, Turner is celebrating in one work his long friendship with her and her family,[12] his affection and long-standing association with the Isle of Wight and the seas surrounding it, his appreciation of the Gordons' fondness for Watteau, and his pride at his early pupil's perseverance in sketching to a creditable standard. He is also playing with one of the many sea myths that weave their way through his later art.[13]

Seeing himself by the mid-1820s as the professional equal of the European Old Masters, Turner felt perfectly confident in his sea paintings in making stylistic quotations, in playing the same tunes as his continental forebears. Such quotations enrich his oeuvre. He made

play with the manner of the French sea painter Claude-Joseph Vernet (1714–1789) in *Fishermen at Sea*, but his richest marine influence comes from Holland. The seventeenth-century Dutch painters Jan van Goyen (1596–1656) and Willem van de Velde the Elder (1611–1693) and Younger (1633–1707), are the inspirations behind both *Van Tromp's Shallop, at the Entrance of the Scheldt* (exh. 1832; see fig. 19) and *Rotterdam Ferry Boat* (exh. 1833; see fig. 20); Aelbert Cuyp (1620–1691) is the guiding spirit whom Turner honors in *"Now for the Painter," (Rope.) Passengers Going on Board* (exh. 1827; see fig. 8); while Turner pays homage to Jacob van Ruisdael (1628/29–1682) in the composition, subject matter, style, and title of *Port Ruysdael* (fig. 5). To discover the reason Turner felt such affection for seventeenth-century Dutch art we must look to his past, to the nature of his tuition as an artist, and to the pattern of his travels. There are few, if any, whims in Turner; his manner of painting, his subject matter, his relationships with fellow artists living or dead, and his methods of experimentation are deeply rooted in the events and experiences of his youth and young manhood, and if we find a puzzling apparent departure in middle or late Turner, its roots can invariably be found in his early career.

The influential and charismatic teacher of Turner's youth was the president of the Royal Academy, Sir Joshua Reynolds (1723–1792). In his Discourses to Royal Academy students, some of which Turner must have attended before the president's retirement in 1790, Reynolds recommended an "implicit obedience to the *Rules of Art*, as established by the practice of the great Masters, [which] should be exacted from the *young* students."[14] He goes on to urge older artists to bend or disregard rules. With a flash of his ready wit in an entry in the journal of his 1781 tour of Holland, Reynolds observed: "Painters should go to the Dutch school to learn the art of painting, as they would go to a grammar-school to learn languages. They must go to Italy to learn the higher branches of knowledge."[15] Turner was prompt in his response to this and many other instances of Reynolds's teacherly advice. He saw Dutch paintings in the sale rooms and in some of the

FIGURE 5 J. M. W. Turner, *Port Ruysdael*,
exh. 1827. Oil on canvas, 36 1/4 x 48 1/4 in.
(92 x 122.5 cm). Yale Center for British Art,
New Haven, Connecticut. Paul Mellon
Collection [BJ237]

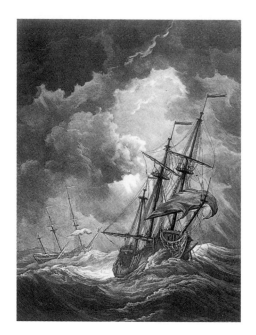

FIGURE 6 Elisha Kirkall, after Willem van de Velde the Younger, *A Ship Scudding in the Gale*, 1724. Mezzotint. National Maritime Museum, London

private collections he had access to as early as the 1790s, and he came across the spirited mezzotint, after Willem van de Velde the Younger, of a man o' war caught in a squall (fig. 6), later recalling, "Ah! That made me a painter!"[16] When he visited the Louvre for the first time in 1802, he sought out Ruisdael in particular.

Standing in the Louvre in front of two Ruisdael masterpieces, *The Burst of Sunlight* and *Storm on the Dykes of Holland* (fig. 7), enthusiasm and a certain delight in getting the better of his masters led the twenty-seven-year-old Turner to write long and involved criticisms that reveal the firmness and intensity with which he viewed the work of other artists. Describing a picture that he called "Landscape by G. Rysdael [*sic*]" (known now as *The Burst of Sunlight*), Turner wrote:

> *A fine coloured grey picture, full of truth and fin[e]ly treated as to light which falls on the middle ground, all beyond is of a true deep ton'd greyish green. The sky rather heavy, but well managed, but possesses too much of the Picture and the light. The Objects near to the light are poor and ill-jud[g]ed particularly about the Windmill inclin'd to be chalky. The foreground dark, violently so near the bright light that gives a crudeness inconsistent with the purity of the distance.*[17]

In his critique of the second painting, which he called "Sea Port. Rysdale,"[18] Turner reveals his profound knowledge of the motions of the sea, but, as A. G. H. Bachrach has pointed out, Turner wrongly criticized Ruisdael for painting a dangerous lee shore incorrectly.[19] Turner, accustomed to the rapidly shelving seabed of the English coast, had by 1802 experienced only the high, rounded waves of a rising tide blowing onto an English lee shore. In fact, he had just that spring exhibited his skill in painting such seas, in the oil *Fishermen Upon a Lee-Shore, in Squally Weather* (Southampton City Art Gallery, U.K.; BJ16), which he showed at the Royal Academy a few months before he left for Europe. Off the Dutch coast, which Turner had yet to visit, sandy shallows run a long way out to sea, and, as a result, when the prevailing westerly or northwesterly winds blow on shore, the waves

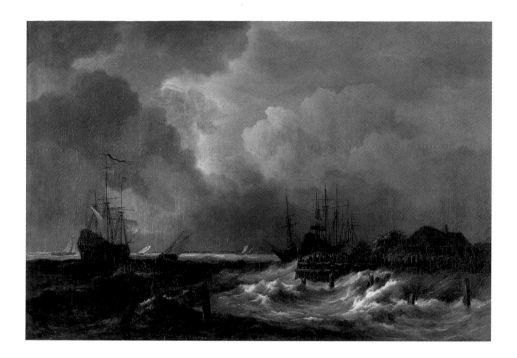

FIGURE 7 Jacob van Ruisdael, *Storm on the Dykes of Holland*, c. 1660. Oil on canvas, 43⁵/₁₆ x 63 in. (110 x 160 cm). Musée du Louvre, Paris

are a very different shape when at last they arrive at land, because they have traveled for miles across shallow water. Thinking only of English seas, and failing to acknowledge that Ruisdael was a very perceptive sailor, too, Turner writes: "The chief light is upon the surge in the foreground—but too much is made to suffer—so that it is artificial—and shows the brown in a more glaring point of v[i]ew and *this* inattention of the forms which waves make upon a lee shore Embanked (the ships all in shadow)."[20]

By the time, twenty-five years later, that Turner came to paint *Port Ruysdael*, the arrogant and knowing younger artist had matured into an experienced and reflective master who paid homage to his mentor in a painting that echoed but did not mimic Ruisdael's style. There is no "Port Ruysdael" in Holland or anywhere else; the title is in itself a compliment to the Dutch artist and may have been prompted, as has been suggested, by Turner's rereading of the inscription above the note in the "Studies in the Louvre" sketchbook, where he wrote in well-spaced words "Sea Port. Rysdale."[21] On the other hand, it may just be one of Turner's good-humored picture titles, such as *Bridge of Sighs, Ducal Palace and Custom-House, Venice: Canaletti Painting* (exh.

1833; Tate Britain, London; BJ349) and *Van Goyen, Looking out for a Subject* (exh. 1833; Frick Collection, New York; BJ350), in which the artist evoked an Old Master's style and acknowledged it with his name.

There is a slight formal kinship in *Port Ruysdael* with Ruisdael's *Storm on the Dykes of Holland*—the proportions of sea to sky are about the same in both, illuminating the fact that by the 1820s Turner's horizons had sunk lower, being more sky than sea. The common factor, however, and the root of Turner's homage, is the overall brown and gray tonality and the Ruisdaelian marriage of sea and sky. The diagonals in Turner's clouds (top right to horizon left) oppose the diagonals in the sea (bottom right to horizon left), and the scooped troughs of the waves echo the segments of the heaped-up clouds as they bear heavily onto the harbor. John Ruskin wrote about *Port Ruysdael* with graphic directness: "I know of no work at all comparable for the expression of the white, wild, cold, comfortless waves of northern sea, even though the sea is almost subordinate to the awful rolling clouds."[22]

But things are not quite so bad in the picture as Ruskin suggests—the storm is clearing rapidly, the clouds are scudding away, and in the sky there will soon be enough blue to make a sailor's jerkin, as the saying goes. *Port Ruysdael* is one of the first in the long series of turbulent seas that Turner painted in the 1830s and 1840s, and one that purposefully introduces the element of time passing—the weather on the point of change from storm to calm. The time element also is present in, for example, Turner's *Slave Ship (Slavers Throwing Overboard the Dead and Dying—Typhon Coming On)* (exh. 1840; see fig. 28), in which the smallest touch of blue sky appears at the top right. Further details in *Port Ruysdael* that enliven it and bring a touch of humanity to the "comfortless waves" are the small boat in full sail running bravely for home before the wind, and the vertical markers that guide the sailors into harbor. In the foreground a basket and scattered fish, dropped no doubt in panic as the storm rose, give a narrative to the picture—a "before" that balances the "after" of the coming calm.

Time in Turner is real. It flows in and around his sea paintings, pinning to a moment the eternity of the subject.

In the 1827 Royal Academy exhibition Turner showed two marine paintings with overtly Dutch connections. *Port Ruysdael* was one, and the other, *"Now for the Painter,"(Rope.) Passengers Going on Board* (fig. 8).[23] Since 1820, when Turner returned home from his first extended visit to Italy, his palette had lightened—his blues had become richer and his reds more prominent, and his extensive use of yellow was becoming something of a joke among the chattering classes of early nineteenth-century London. After his friend the portrait painter Thomas Phillips (1770–1845) had come back from Italy in 1826 with a sunburn, his face the color of a carnation, Turner observed to a mutual friend that a spell on the Hanging Committee of the Royal Academy had brought Phillips back to his "original tone of colour—but I must not say yellow, for I have taken it *all* to my keeping this year, so they say, and so I meant it should be."[24]

The color, mood, and composition of *"Now for the Painter"* depend heavily on the example of Aelbert Cuyp; the blond tonality, the green-blue sea, the simple lines of the boats and their sails. Although it shows greater movement, it follows, in its Cuypean mood and large scale, in the manner of Turner's *Dort or Dordrecht: The Dort Packet-Boat from Rotterdam Becalmed* (exh. 1818; Yale Center for British Art, New Haven; BJ137) and the pendant pair *Harbor of Dieppe (Changement de Domicile)* (exh. 1825) and *Cologne, the Arrival of a Packet Boat, Evening* (exh. 1826; both Frick Collection, New York; BJ231, BJ232).

A further common factor shared by these four pictures is the sense of departure and arrival, evident in *"Now for the Painter"* as the tide reaches its height and the sails billow. Here, once again, Turner renders time both in the images themselves and in the thought he has given to the structure of their titles. All four, whose titles or inscriptions also evoke Dordrecht and Rotterdam, Dieppe, Cologne, and Calais, celebrate a newfound calm in Europe as the Napoleonic Wars slip into history and other political concerns take their place. There

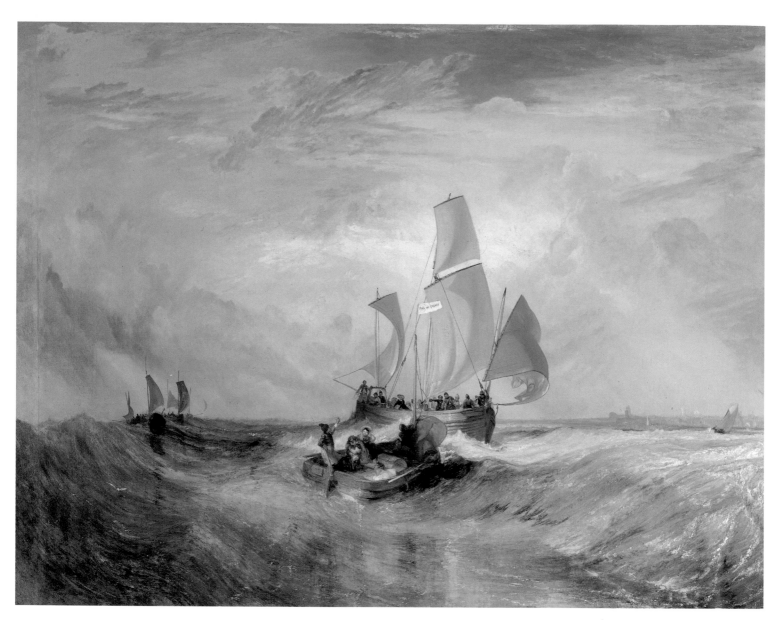

FIGURE 8 J. M. W. Turner, *"Now for the Painter," (Rope.) Passengers Going on Board*, exh. 1827. Oil on canvas, 67 x 88 in. (170.2 x 223.5 cm). Manchester Art Gallery [BJ236]

is a new freedom to travel and to trade, indicated in *"Now for the Painter"* by the fluttering pennant on the smaller boat reading "Pas de Calais," the name the French give to the Straits of Dover. This suggests that we are on the French side of the Channel, off Calais, and that the larger boat is about to sail for England, taking the party from the smaller vessel as passengers. The exotic dress of the joining passengers may be Turner's way of suggesting that Britain is a haven for outcasts and the persecuted.[25] And is the figure of the man waving his hat a self-portrait? Turner himself had made this same journey when he returned from his 1826 Loire tour, so an autobiographical element here is not unexpected. The title of the painting is one of Turner's little jokes—the "painter," as we can see if the title is read thoughtfully, being the rope that smaller boats have in their bows to tie up to shore; it is also, of course, Turner's own part in the drama of painting. When casting off from shore the painter is the final link to be undone, while the further allusion to the painter's role in advancing human understanding is implicit and hard to escape.

Turner had jocular relationships with his "brother artists," as he called them; close friendships and rivalries abounded in the club-like atmosphere of the Royal Academy. The joke in the title of this painting may come from a running gag of the year before, when Clarkson Stanfield (1793–1867) vainly tried to finish a picture he proposed to show at the 1826 exhibition, *Throwing the Painter*; on hearing this, Augustus Wall Callcott (1779–1844) created *Dutch Fishing Boats Running Foul in the Endeavor to Board, and Missing the Painter Rope* (exh. R.A. 1826). To round off the joke, Turner painted *"Now for the Painter"* for the 1827 exhibition, though after more than 175 years the joke has worn thin. Wordplay was a rich source of fun for Turner, who peppered his letters with puns, as it was for a generation whose popular reading matter was only thinly illustrated with line engravings— readers had to rely on text for amusement. For that reason, anagrams, poems, and jocose stories abounded in magazines and journals of the day.

Turner was a good friend of John Nash (1752–1835), the architect who made a definitive mark on Regency England with his designs

for Regent Street, Regent's Park, Carlton House Terrace, and the Brighton Pavilion. In the 1790s Nash built himself a modest house with two towers and crenellations whose name, East Cowes Castle, makes it sound much grander than it was.[26] There, on the north coast of the Isle of Wight, Nash entertained generously and in high style. He became a patron of Turner's in the 1820s, and in 1827 he invited the artist to his castle, where Turner, realizing that he did not have the right clothes for the party, badgered his father to send more light trousers and white waistcoats so that he could be nattily dressed.[27] As also was the case during his extended visits to Farnley Hall in Yorkshire, and Petworth in Sussex, Turner assumed the part of the resident and good-humored artist of the weekend. He made dozens of preparatory and finished drawings and paintings at East Cowes—of the amusements, the fellow guests, and the boats.[28]

The great event of the summer of 1827 was the Cowes Regatta, which provided endless material for Turner's pencil and brush. The "Windsor and Cowes, Isle of Wight" sketchbook has pages of spirited studies of yachts racing and little boats moving about, and at the back of the book is Turner's list of racing yachts, their owners, and the colors they carried.[29] The yacht races were as exciting to Turner as they would have been to any participant or spectator, and it is apparent from the many oil studies in the Turner Bequest from Turner's "Cowes Week" excursion that he must have both painted and drawn in the open air, invigorated by the light, the water, and the movement.

Nash commissioned a pendant pair of oils from Turner, and these carry the long descriptive titles that we have come to see as standard. Turner's titles should be thought about carefully, as they invariably carry information that helps the viewer to understand the picture and its genesis more fully. In Turner's work, picture and title are indissoluble, and in the few cases where a work has lost its title, we have lost much more than a convenient peg. John Nash's commissioned pictures are *East Cowes Castle, the Seat of J. Nash Esq.; the Regatta Starting for Their Moorings* (fig. 9) and *East Cowes Castle, the Seat of J. Nash Esq.; the Regatta Beating to Windward* (fig. 10). As a pair they

FIGURE 9 J. M. W. Turner, *East Cowes Castle, the Seat of J. Nash Esq.; the Regatta Starting for Their Moorings*, exh. 1828. Oil on canvas, 36 x 48 ½ in. (91.4 x 123.2 cm). Victoria and Albert Museum, London [BJ243]

FIGURE 10 J. M. W. Turner, *East Cowes Castle, the Seat of J. Nash Esq.; the Regatta Beating to Windward*, exh. 1828. Oil on canvas, 35 ½ x 47 ½ in. (90.2 x 120.7 cm). Indianapolis Museum of Art. Gift of Mr. and Mrs. Nicholas Noyes [BJ242]

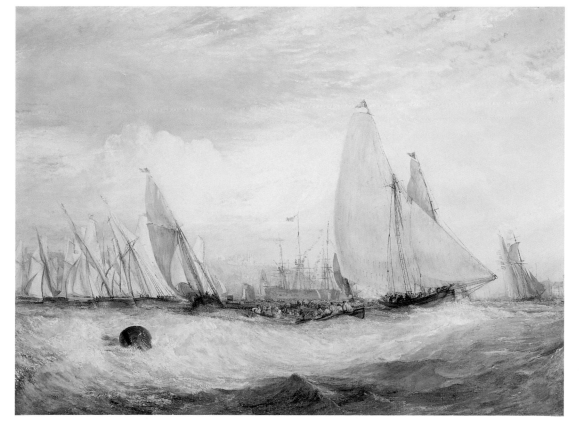

follow the pattern of Turner's recent Dutch-inspired canvases by celebrating maritime competence and peaceableness, but they extend this idea by asserting that in the post-Napoleonic era sailing had become the property not of war, trade, or travel, but of sport and human enjoyment. Although *Regatta Starting for Their Moorings* was inspired by Claude Lorrain (1604–1682) and is an amalgam of Turner's many earlier interpretations of Claude, *Regatta Beating to Windward* moved out of Claudean and seventeenth-century Dutch influence into a manner that was at once Turner's own. He created an explosion of sailing boats, a breakout that rushes down onto the viewer in a stiff wind and a pitching sea. The composition that Turner invented here offsets the jagged diagonals of the yachts with the glimpse of rowing boats and the distant ships and castle. This is a painting of action (which contrasts with the calm of its pendant) that translates into paint the immediacy and freshness of the rapid pencil and ink sketches of small boats that Turner made at Cowes and elsewhere throughout his career.

The exuberance of wind and water that Turner expressed in painting was met with gloomy pedantry by some critics. A critic writing in the *Morning Herald* considered Turner's sea to be "more like marble-dust than any living waters," and he went on to suggest that the yachts were "over-masted, and represented as carrying sail such as no vessel of their dimensions could carry in wind for a single moment."[30] He may be right.

Across the Solent, and forty miles east of Cowes, was Petworth, the large country house in Sussex owned by the third earl of Egremont. Turner was a regular guest there until the earl died, in 1837. With Petworth as his base, Turner made his habitual seaside excursions, and it is likely that on these he made the studies in pen, ink, and watercolor of sailing boats running with the wind, *Ship and Cutter* (fig. 11)[31] and *Shipping* (fig. 12). A slightly later watercolor sketch, *Ship Aground: Brighton* (fig. 13), presents the severe black silhouette of a two-masted ship against an atmospheric rendering of a coming summer storm, with the Brighton Chain Pier in the background. It

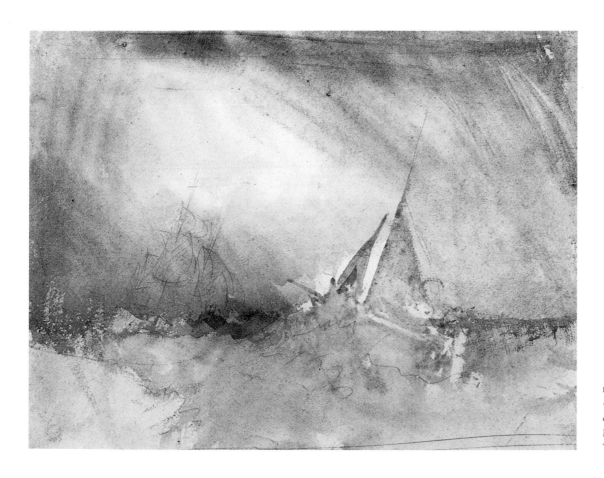

FIGURE 11 J. M. W. Turner, *Ship and Cutter*, c. 1825. Watercolor and graphite on paper, 9 3/8 x 10 3/8 in. (23.8 x 28.9 cm). Museum of Fine Arts, Boston. Gift of William Norton Bullard [W777]

FIGURE 12 J. M. W. Turner, *Shipping*, c. 1828–30. Pen and brush and brown ink and white highlighting, with bodycolor over graphite on blue wove paper, 5 3/8 x 7 3/8 in. (13.6 x 18.6 cm). Yale Center for British Art, New Haven, Connecticut. Paul Mellon Collection [W915]

FIGURE 13 J. M. W. Turner, *Ship Aground: Brighton*, c. 1828–30. Black ink, watercolor, and bodycolor on blue paper, 5⅝ x 7⅝ in. (14.3 x 19.4 cm). Yale Center for British Art, New Haven, Connecticut. Paul Mellon Collection [w917]

FIGURE 14 J. M. W. Turner, *Fishing Boats Becalmed off Le Havre*, 1830s? Watercolor and bodycolor on blue paper, 5½ x 7¹¹⁄₁₆ in. (14 x 19.5 cm). Yale Center for British Art, New Haven, Connecticut. Paul Mellon Collection [w1042]

FIGURE 15　J. M. W. Turner, *Seashore, from Hastings*, c. 1830–35. Watercolor over pencil on buff paper, 5 ¼ x 7 in. (13.3 x 17.8 cm). Fogg Art Museum, Harvard University, Cambridge, Massachusetts [w927]

was the unremarkable everyday experiences of atmospheric and marine events such as these—and those in *Fishing Boats Becalmed off Le Havre* (fig. 14) and *Seashore, from Hastings* (fig. 15)—that Turner captured with so little apparent effort in rapid, gestural watercolor. Breathtaking as they are, it was the experience and exercise that they gave to Turner's eye and hand that kept him fully alive to the marine dramas that empower his oil paintings. Outstanding among these expressive watercolors is the ghostly white-on-white *Ship Leaving Harbor* (fig. 16), an image that is practically unreproducible, and almost not there.

A Power Supreme

FIGURE 16 J. M. W. Turner, *Ship Leaving Harbor*, after c. 1830. Watercolor on paper, 9 1/4 x 12 3/8 in. (23.5 x 31.4 cm). Tate Britain, London [TB CCCLXIV a 98]

The premature death from consumption of the painter Richard Parkes Bonington (1802–1828) greatly affected Turner and many other of his artist friends. Among Bonington's characteristic subjects was the wide seashore, flat and open, stretching apparently endlessly to the horizon and from side to side. Dutiful as he was in his homage to the Old Masters, Turner gave honor, too, to the young Bonington in the painting *Calais Sands, Low Water, Poissards Collecting Bait* (fig. 17), where he essays the Bonington theme of wide, level sands, adding a glorious sunset and cloudscape. The name "poissards," given to the

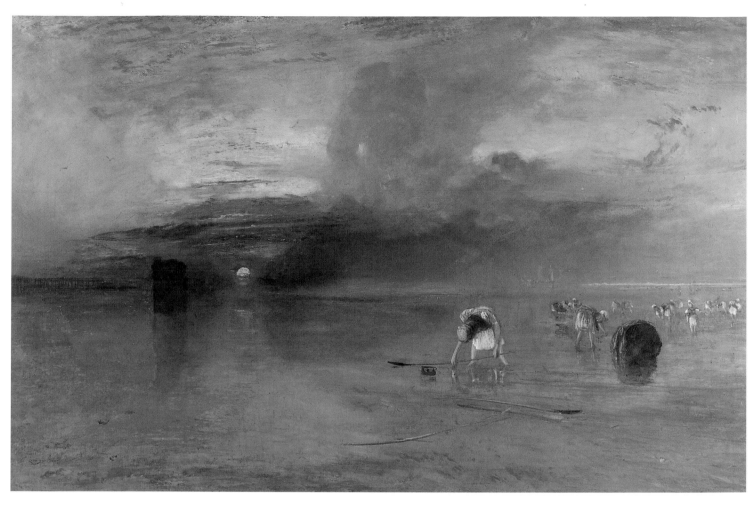

FIGURE 17 J. M. W. Turner, *Calais Sands,
Low Water, Poissards Collecting Bait*, exh. 1830.
Oil on canvas, 28 1/2 x 42 in. (72.4 x 106.7
cm). Bury Art Gallery and Museum, Greater
Manchester [BJ334]

figures on the right, bent double and deformed through their work,
is a derogative French equivalent of "fishwives."[32]

Turner's career as an artist is a series of zigzags through the change-
able waters of style and taste; he did not progress in a straight line. In
the early 1830s, only two or three years after he had so dramatically
raised the tonality of his palette, prompting expressions of concern
and dismay from his friends and followers, he appeared to change tack
yet again. If we take a dispassionate look at the series of seven Dutch-
inspired paintings exhibited between 1831 and 1833, of which there
are two in this exhibition (see figs. 19 and 20), we might be led to
believe that he had never traveled farther than Rotterdam, and that the
gilded, high-Baroque manner he evolved during and after his 1828–29

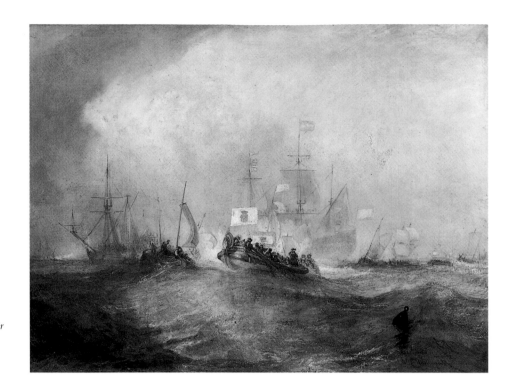

FIGURE 18 J. M. W. Turner, *The Prince of Orange, William III, Embarked from Holland, and Landed at Torbay, November 4th, 1688, after a Stormy Passage*, exh. 1832. Oil on canvas, 35 1/2 x 47 1/4 in. (90.2 x 120 cm). Tate Britain, London [BJ343]

Italian visit, and took to its apogee in *Ulysses Deriding Polyphemus* (exh. 1829; National Gallery, London; BJ330), had been only a dream.[33]

What unites these "Dutch" paintings is that they all look back at seventeenth-century Holland in their titles, content, and homage, and further carry a historicizing narrative message. In the early 1830s Britain was a nation in political turmoil as the Reform Bill made its stormy passage into law, finally being given Royal Assent in June 1832. The reforms that the bill affirmed included the abolition of "Rotten Boroughs," the widening of the franchise into industrial areas of Britain, and the curtailing of aristocratic and landed patronage. Turner's painting *The Prince of Orange, William III, Embarked from Holland, and Landed at Torbay, November 4th, 1688, after a Stormy Passage* (fig. 18) makes a direct comment on the intertwined nature of Dutch and British history, most specifically reminding his audience that during an earlier period of crisis the Dutch had supplied Britain with a new monarch, King William III, and thus concluded the Glorious (and peaceful) Revolution of 1688.

Both this picture and *Van Tromp's Shallop, at the Entrance of the*

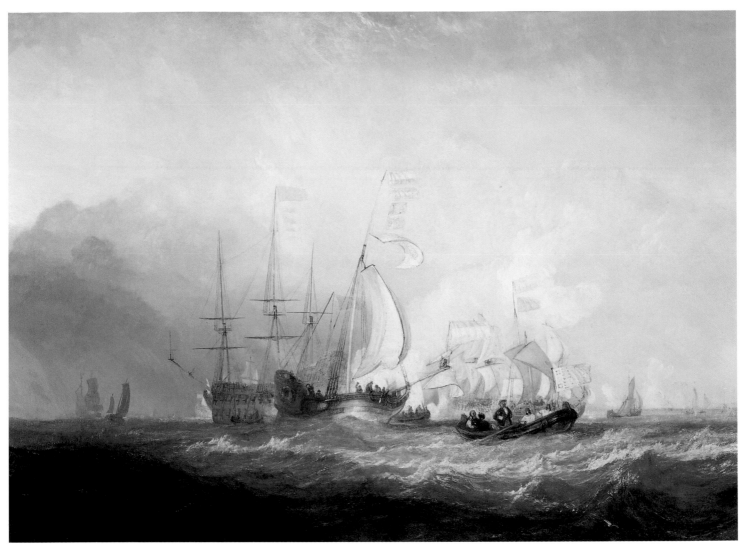

FIGURE 19 J. M. W. Turner, *Van Tromp's Shallop, at the Entrance of the Scheldt*, exh. 1832. Oil on canvas, 35 x 47 in. (89 x 119.5 cm). Wadsworth Atheneum, Hartford, Connecticut. The Ella Gallup Sumner and Mary Catlin Sumner Collection Fund, Endowed by Mr. and Mrs. William Lidgerwood [BJ344]

Scheldt (fig. 19) were on public display in the Royal Academy from April 1832, precisely during the time in May when Earl Grey resigned as prime minister, when the Duke of Wellington failed to form a government, and when rioters controlled parts of London. We may profitably read something more into the gnomic message in the title of *The Prince of Orange* than the simple facts of a prince, a landing place, a significant date, and a weather report. Turner had a habit of making silent (and at the time barely noticeable) historical and political points in his paintings.[34] In this title he may be likening the stormy weather that William III and his party endured during their crossing from Holland to Torbay, and the subsequent events that led to the

A Power Supreme

abdication of James II, with the stormy era that politics in Britain had been passing through for some years. Although the Reform Bill was the all-consuming political issue in Britain when the 1832 Royal Academy exhibition opened, there seems to have been nobody in London able to recognize a message in Turner's picture. Thus, the *Athenaeum* remarked: "The painter has made this picture somewhat poetical: he has squandered the finest hues and the finest perspective upon a subject that has lost somewhat of its feverish interest in the hearts of Englishmen."[35] That was precisely not the case: Turner made a point of topicality.

Turner further emphasized his Dutch metaphor in 1832 with his other historicizing picture of that year, *Van Tromp's Shallop, at the Entrance of the Scheldt*. The artist's historical recall, though picturesque, was hit-or-miss. The Dutch sailor of the title was not just one Van Tromp, but an amalgam of Tromps: Admiral Maerten Harpertszoon Tromp (1597–1653) and his son Cornelis (1629–1691), both of whom fought against the Spanish and British fleets.[36] Here, "Van Tromp" has disembarked from his ship and has set sail for shore in a shallop, a light, shallow sailing boat that larger ships used as a tender. The cheery Dutch sailors, to a man enemies of the British state during the time in which the picture is set, underline Turner's pro-Dutch message. There is a further event in contemporary history that may help to account for the plethora of affectionate Dutch subjects from Turner's brush. This was Foreign Secretary Lord Palmerston's decision to allow Belgium to secede in 1830–31 from the Kingdom of the Netherlands —the union of what is now Belgium, Holland, and Luxembourg, created after 1815—against Dutch wishes, thus severely weakening Holland politically and economically.[37] Turner, who had visited Holland in 1817 and 1825, and had come to love it through its landscape and its artists, instinctively sided with Holland and felt that the Dutch had been betrayed.

The sparkling light in *Van Tromp's Shallop*, and its overall airiness and greenish hue, owes much to the van de Veldes and Jan van Goyen. In *Rotterdam Ferry Boat* (fig. 20) the cloudscape has the same

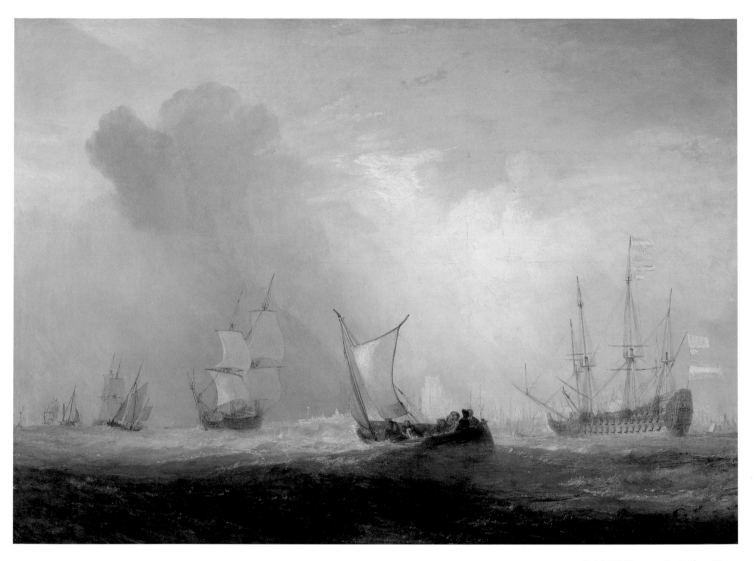

FIGURE 20 J. M. W. Turner, *Rotterdam Ferry Boat*, exh. 1833. Oil on canvas, 36 3/8 x 48 1/4 in. (92.3 x 122.5 cm). National Gallery of Art, Washington, D.C. Ailsa Mellon Bruce Collection [BJ348]

central role in the composition that it had in *Port Ruysdael*, to the extent that it becomes increasingly misleading to bracket such pictures as "marines"; they are just as reasonably "cloudscapes." The sailor in Turner noticed a momentary change in the wind and depicted it in this painting—the flags on the anchored man o' war show the wind blowing from left to right, while the ferryboat of the title is batting along under full sail, blown by a gust from somewhere on shore. The two-master in the middle ground, however, is struggling with the changeable wind that is making its sails flap, and is heralded by the rearing rain cloud.

None of the seven "Dutch" pictures of 1831–33 was commis-

sioned—three or perhaps four were bought from the artist at their first exhibition, at least two were bought from Turner's studio by the whale oil merchant Elhanan Bicknell in 1844, and only one was left in his studio at his death to come to the British nation through the Turner Bequest in 1856. Thus there seems to have been some real commercial and critical pressure on Turner to paint them when he did, because, being a canny and commercially minded artist, he rightly guessed that they would sell. This success is in marked contrast to the commercial fate of the large-scale Italy-inspired paintings of these same few years, in which he invested huge emotional, creative, and critical capital, notably *Ulysses Deriding Polyphemus* (exh. 1829), *Caligula's Palace and Bridge* (exh. 1831; Tate Britain, London; BJ337), and *Childe Harold's Pilgrimage—Italy* (exh. 1832; Tate Britain, London; BJ342), all of which remained unsold at his death.

With many active collectors and such influential dealers as John Smith specializing in Dutch pictures, the market was buoyant in the 1820s and '30s.[38] In what looks like a calculated commercial decision, Turner reveals a timely and fascinating union between the artist's head and his heart as the motivating force for these pictures. His head told him that they would make him some money, and they did; his heart prompted him to paint them with all the historical narrative, dramatic meaning, and political timing that he could orchestrate.

Eleven years after this extended Dutch incursion into his art, Turner returned to the manner once more with *Van Tromp, Going about to Please His Masters, Ships a Sea, Getting a Good Wetting* (exh. 1844; see fig. 54). This painting, like those before it, sold promptly.[39] Once again the sea was the stage for Turner's historical dramatics, with a member of the Tromp family in the starring role. Like a Hollywood movie director, Turner willingly (or unknowingly) dispensed with historical accuracy for artistic effect, putting the debonair Tromp in white, so that he would show up, rather than in the funereal black that all Calvinist sea captains wore. Further, to identify Tromp, Turner painted "VT" on the burgee flying from the mast, a practice that did not begin until the nineteenth century.[40] It is not really clear what

story Turner is telling, or which of the Tromps is involved. In the most likely interpretation, suggested Bachrach, Tromp the younger was dismissed from the Dutch navy in 1666 for dereliction of duty after having a bitter quarrel with his admirals. With William III's intercession, however, Tromp was reinstated seven years later. So here he is "going about to please his masters," and waving his hat as he does so. He is also, as the title tells us, getting his comeuppance after his disobedience, "shipping a sea" (that is, taking water on board by leaning over too far), and "getting a good wetting."

Perhaps the greatest of the introductory masterpieces in the exhibition is *Wreckers—Coast of Northumberland, with a Steamboat Assisting a Ship off Shore* (fig. 21), a dramatic painting whose evanescence, the liberal use of orange, and the uncertainty of its horizon prefigure Turner's 1840s evocations of the sea. There is melodrama and gravity in the picture—the wreckers, people who made their living from stealing the wreckage and cargo of beached ships, are waiting with ropes on the shore for the ship to founder. So murderous were some bands of wreckers that they would lure ships into danger with lights or rockets, and to counter that real threat ship owners used guard and rescue vessels to give assistance when necessary. The presence of the steamboat waiting in the distance is clear enough on the canvas, and it is significantly heralded by Turner in the title—along with details of where we are, who the people are, and exactly what is happening. The drama that Turner presents has many oppositions within it that add to the tension: the stricken sailing ship, with its sails struck against the storm, is countered by the security of the presence of the modern steamer. A battle between good and evil is being played out in which the mood of the sea will be a decisive factor, as will the skill of the seamen against the luck of the wreckers. A further opposition is the fury of the wind and the sea on a lee shore against the permanence of Dunstanburgh Castle, a relic of English history and an immutable presence in the background. This antiphonal quality, strongly present in *Wreckers*, is later exercised with great intensity by Turner in his series of pendant paintings of the 1840s.

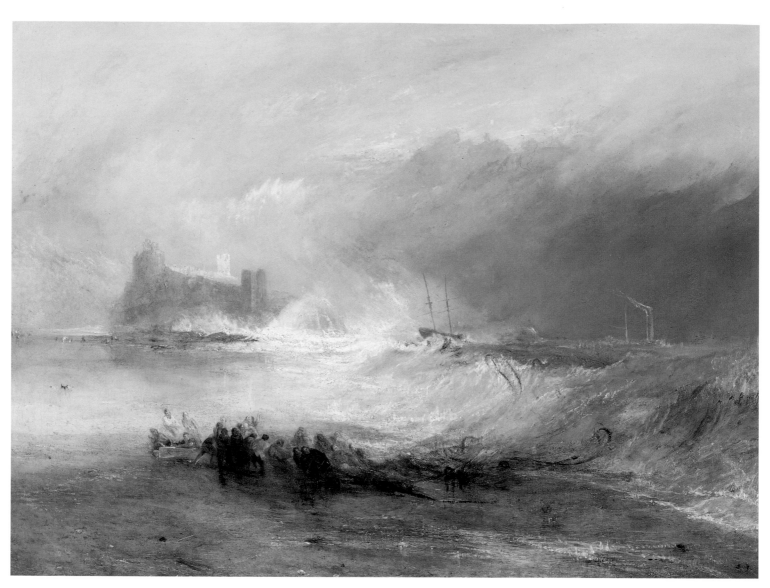

FIGURE 21 J. M. W. Turner, *Wreckers—
Coast of Northumberland, with a Steamboat
Assisting a Ship off Shore*, exh. 1834. Oil on
canvas, 35 5/8 x 47 9/16 in. (90.4 x 120.7 cm).
Yale Center for British Art, New Haven,
Connecticut. Paul Mellon Collection
[BJ357]

Critics in the London newspapers ebbed and flowed in their opinion of Turner's marine art: unfavorable comment on *East Cowes Castle . . . the Regatta Beating to Windward* (see fig. 10) was balanced by buoyant praise for *"Now for the Painter"* (see fig. 8) in *The Times*, which remarked that the painting of the water "has perhaps never been surpassed."[41] *Wreckers* was praised highly in the *Spectator* for combining "the truth of nature with the splendour of Turner."[42] One of the difficulties facing contemporary critics trying to assess Turner's marine pictures fairly was that a landsman's knowledge of the sea was not fed daily, as it is now, by television, film, and travel, but held in the memory from personal experience. We cannot really know, but in responding to Turner's evocations of sea types as expressed across his lifetime's experience, land-bound early nineteenth-century critics had only other painters' efforts, literary description, and dimming memory to go on. So when a critic talks of sea "like marble-dust" or the famous remark about *Snowstorm — Steamboat off a Harbor's Mouth . . .* (see fig. 89) being like "soapsuds and whitewash," he is fumbling with words, laced more or less with abuse, and lacking the objectivity that twentieth- and twenty-first-century critics ought to be able to bring. The breakthrough in understanding and communication of Turner's intentions in his sea paintings came with Ruskin, whose expressive insights may be seen against the background of his rich, deep, and varied writings, and through the focus of his experience, nervous energy, and incomparable vocabulary.

We will see in Chapter 2 how Turner introduced, as a significant part of his working and storytelling practice, the use of pendants: that is, two paintings designed to hang together and balance and oppose each other in form, color, and content. A precursor, with the two *East Cowes* paintings, of this late flourish of paired pictures is *Venice: The Dogana and San Giorgio Maggiore* (fig. 22) and *Keelmen Heaving in Coals by Moonlight* (fig. 23), both painted, a year apart, for the Manchester cotton-spinner Henry McConnell. The first opposition within the pictures is that the one represents a city of luxury and unreformed laws and customs, now in decline as a trading and maritime power; while

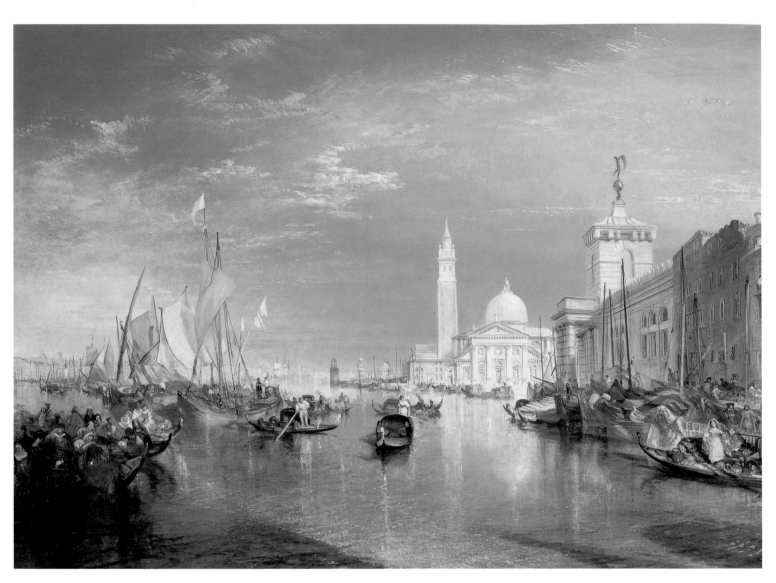

FIGURE 22 J. M. W. Turner, *Venice: The Dogana and San Giorgio Maggiore*, exh. 1834. Oil on canvas, 35 1/2 x 48 in. (90.2 x 121.9 cm). National Gallery of Art, Washington, D.C. Widener Collection [BJ356]

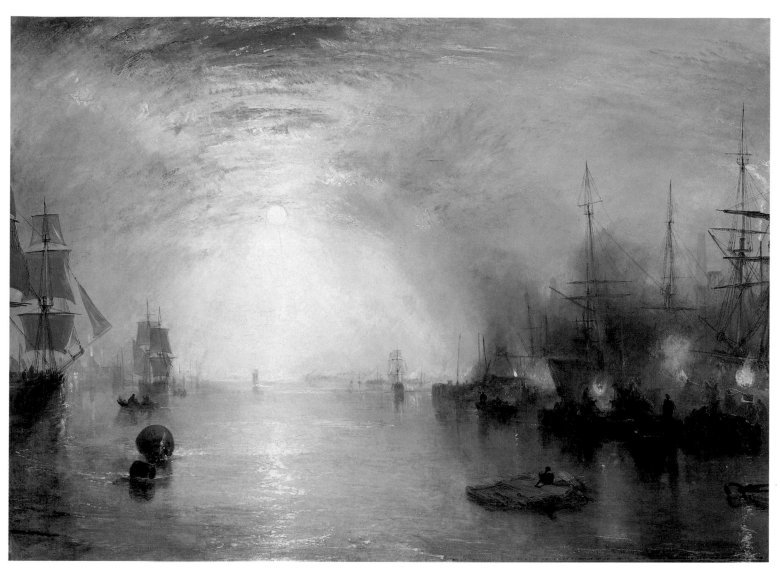

FIGURE 23 J. M. W. Turner, *Keelmen Heaving in Coals by Moonlight*, exh. 1835. Oil on canvas, 35 1/2 x 48 in. (90.2 x 121.9 cm). National Gallery of Art, Washington, D.C. Widener Collection [BJ360]

the other, the sooty and unregarded South Shields on Tyneside in northeast England, is busy, well-organized, and even works at night. With its sparkling moonlight, furnaces, and oil lamps, the light in *Keelmen* is nearly as bright as the afternoon (and thus waning) light of Venice. What the keelmen are doing is loading from their flat-bottomed barges, locally known as keels, the ships that sailed around the clock for London with Tyne coal, to keep Londoners luxuriously warm. These workaday vessels contrast with the Venetian kind of flat-bottomed boats, the gondolas, which idle on the Grand Canal. A common factor in this pendant pair, as in many sea or river paintings by Turner, is the open foreground defined by gathering boats, which adds to the illusion of the stage, where figures fall back to await, or participate in, a coming action.

Turner practiced what might be called a "mixed economy" in the way he programmed his work as an artist. At any one time in the 1820s, for example, he might be working on a group of three or four oil paintings for the coming Royal Academy exhibition. In addition to these he would be working out, and then working up, designs for watercolors, perhaps half a dozen at a time, for the series of images of Britain that he had been commissioned to produce for commercial engravers such as the Cooke brothers and Charles Heath. To generate these he would need to have beside him at his work table some of the hundreds of sketchbooks he used on his travels, which he titled and numbered carefully, and which he referred to constantly for the detail and information they supplied. The sketchbooks were Turner's memory bank.[43] He might also be touching up or otherwise commenting on proofs sent to him by engravers as part of the long process of translating a Turner watercolor into an image for wide consumption, or working on paintings that were not intended to be seen at the Royal Academy. An important example of this category of his work is the eight-foot-by-twelve-foot canvas *The Battle of Trafalgar* (1822–24; National Maritime Museum, Greenwich; BJ252), commissioned by the king.

The business and busy-ness of Turner's house and studio in Queen Anne Street West was intense, and for that reason it was run like clockwork with the largely silent but willing assistance of his housekeeper, Hannah Danby, and of his father, William Turner the elder. Turner disliked having visitors to his studio and gallery without proper appointments (which were hard to get), and he tended to treat visitors brusquely unless he knew they were going to spend money with him.

The pressure and variety of the work in the studio led to subjects, subject matter, and themes flowing freely from one medium and kind of painting to another, and this may explain why works such as *Wreckers* found formal parallels in the watercolors that Turner was painting at much the same time for engraving: *Folkestone, Kent* (fig. 24), *Dunwich, Suffolk* (fig. 25), and *Lyme Regis, Dorset* (fig. 26) are examples. In each of these works the integration of sea, sky, shipping, people, and history is masterly: no one theme dominates. Like the movements of a great symphony they counterpoint, harmonize, and resolve each other in an enthralling whole. Although diminutive in scale, Turner's watercolors have all the passion and energy of his marine oils, and they explore similar concerns, such as the vortex of weather effects in the sky, the variety of wave patterns, and the marriage of land and sea that are constant themes of Turner's oil paintings.

Dunwich, Suffolk, for example, with its cliff-top ruins, is hugely evocative of British history, the town having been, in the thirteenth and fourteenth centuries, the largest port in Europe. It had more than fifty churches, dozens of windmills, and a merchant fleet of eighty vessels; it was the main staging post for trade with the known world. The town, sited on a soft, gravelly coastline with fast and unpredictable currents, was severely damaged in a great storm in 1285. It was finally swept away in another huge storm in 1328. What appears in Turner's watercolor is all that remained in the early 1830s, and in painting a sharp, scouring sea undermining the cliff Turner is graphically suggest-

FIGURE 24 J. M. W. Turner, *Folkestone, Kent*,
1822. Watercolor on paper, 5 3/8 x 9 1/2 in.
(15 x 24.2 cm). Taft Museum of Art, Cincin-
nati, Ohio. Bequest of Mr. and Mrs. Charles
P. Taft [w480]

ing the fragility and temporality of the landscape. The ruined church
on the cliff in Turner's picture fell into the sea in 1919.[44]

The driving force of Turner's watercolors in particular is their
narrative. Each element in each picture has its purpose and meaning
in relation to another. So it is through meticulous pictorial planning
that in *Folkestone, Kent* the figures of the foreground smugglers, bury-
ing casks of spirit, offset and strengthened as they are by the dark
mass of the cliff, have as a counterpoint in the top right quadrant
the harbor that they so determinedly avoid. Small boats enter and
depart the distant harbor in a spirit of fair and legal trade, something
that the smugglers flout. The lines in the calm, rippling sea are taken
up throughout the painting in the complex but peaceable pattern of
the clouds and the wavelike flow of the foreground cliff. Turner's

FIGURE 25 J. M. W. Turner, *Dunwich, Suffolk*, c. 1830. Bodycolor on blue paper, 6⅞ x 10⅛ in. (17.4 x 25.7 cm). Manchester Art Gallery [w900]

watercolors can be read like a book, and all it takes to do so is the realization that this is indeed the case, and for each reader to keep his or her eyes open.

The pictorial elements in *Lyme Regis, Dorset* unite around the central stormy vortex, through which the sun plays on the town of Lyme Regis. The drama of the painting balances the broken and sinking ship in the middle distance with the urgent activity of the figures on the shore, two of whom struggle with a floating mast and sodden sail. Everything in the picture, from the two washed-up sailors left for dead on the rocks to the brightly lit Cobb (the town's harbor) on the horizon, evokes the battle between man, the sea, and the weather at a dramatic interface on the southern coast of England. The sunlight

A Power Supreme

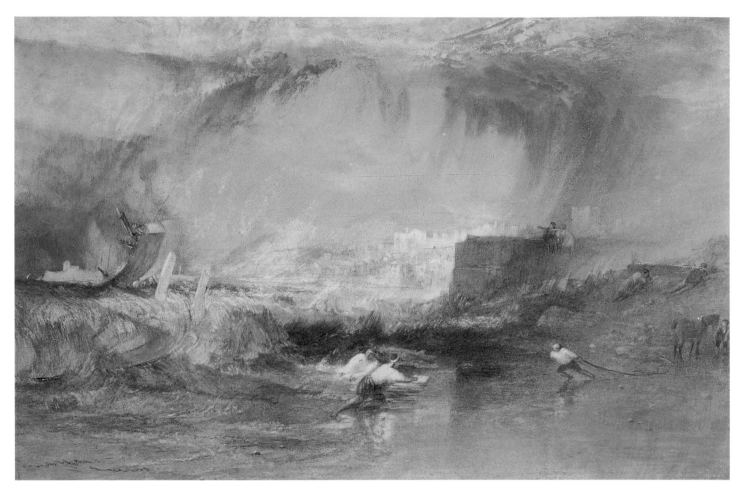

FIGURE 26 J. M. W. Turner, *Lyme Regis, Dorset*, c. 1834. Watercolor and bodycolor with scraping out on paper, 11 1/2 x 17 5/8 in. (29.2 x 44.8 cm). Cincinnati Art Museum. Gift of Emilie L. Heine in Memory of Mr. and Mrs. John Hauck [w866]

on the Cobb suggests that the storm will pass; the cold and fearsome sea proposes that it may not. Turner the dramatist makes his art play on the tension in the uncertainty.

Traveling further in his intellectual life than almost any other artist, Turner gave an added dimension to the drama and poetry in his paintings through the poetry that he himself wrote. He composed verse compulsively, and his sketchbooks and the edges and margins of many watercolor studies, such as *"Lost to All Hope . . . "* (see fig. 87), are laced with it. Poetry was a variant art for him in which he expressed ideas and urges that painting and drawing, even in his hands, were not fully competent to articulate. Turner's handling of language was lumpy, and he was more often than not ill at ease when trying to write poetry; but enthusiasm, spirit, and a touching hope of publica-

Chapter One

tion drove him to the extent that he concluded a long poem of 1811, about Britain and its history, with a vivid description of the Cornish shore. This makes a fine epigraph to Turner's unrivaled production of breathtaking marine paintings:

> *Howling the wild south west with boistrous sweep*
> *Lash the rude shore that rising from the deep*
> *Presents a bristled front Basaltic like or ranged*
> *Rock piled on rock in many forms arranged*
> *Disjointed looks and seeming promiscuous thrown*
> *By nature's hand yet the water owns*
> *A Power supreme on the upmost stones.*[45]

THE MULTITUDINOUS

SEAS INCARNADINE

Expression of the lively sense of drama that ran through all aspects of Turner's creative life reached its apogee in the later sea subjects. Turner's understanding of the strength and application of drama was so thorough that it becomes possible to use one side of his expressive personality to measure the power of another. Turner's poetry, so ruthlessly disregarded as literature in his day and beyond, now has considerable value in providing insight into the vigor and authority of his painting. Turner himself knew this, and he used snatches of his own verse as epigraphs to paintings, sometimes turning himself into a figure of fun when he did so. But the mind that made the paintings was the same mind that wrote the verse, and some of this verse holds a key to the passions that ignite the pictures.

There is an operatic quality in Turner's later paintings that finds an echo, however strangled it may be, in his poetry. One example among many is the tragic story of the sea captain and arctic explorer Sir Hugh Willoughby, who froze to death with his crew off the coast of Lapland in 1554 in a fruitless search for a passage to India. Willoughby's story engaged Turner's literary attention briefly around 1808. Nearly forty years later Turner returned in his mind to the "icy seas," albeit to the Southern rather than the Arctic Ocean, and painted the series of four whaling subjects that will be discussed in Chapter 4.

Other examples in which Turner's poetry and painting circle each other include his objections to the demolition in 1807 of Alexander Pope's house in Twickenham, which he expressed in verse and paint; his fixation on serpents and dragons in the 1800s; and his painted and written reflections on the history and geography of Britain in 1811.[1] Turner's imaginative life was so strongly entwined with the dramatic possibilities of narrative that it is only through acknowledging the power that poetry and drama held over him that we can begin to understand some of the "problem" pictures in Turner's output, such as *Vision of Medea* (exh. 1828; Tate Britain, London; BJ293),[2] *Fountain of Indolence* (exh. 1834; Beaverbrook Art Gallery, New Brunswick, Canada; BJ354/376),[3] *Slave Ship (Slavers Throwing Overboard the Dead and Dying—Typhon Coming On)* (see fig. 28), and *Undine Giving the Ring to Massaniello, Fisherman of Naples* (see fig. 34).

Turner's sense of narrative was the driving force behind the form of presentation that he revived in the 1830s and 1840s: the pendant pair of paintings. In his youth, his ambition and self-esteem had led him to pit himself against European Old Masters by being so bold as to paint pictures to hang beside examples of their work. Thus, in 1801 he painted *Dutch Boats in a Gale: Fishermen Endeavoring to Put Their Fish on Board* (Private collection, on loan to the National Gallery, London; BJ14), otherwise known as "The Bridgewater Sea-piece." This was commissioned to pair with the Duke of Bridge-water's *Rising Gale* by Willem van de Velde the Younger. Other artists he attempted to outdo for one client or another, or for himself, included Claude, Rubens, Rembrandt, and Cuyp. This show of proclamatory genius culminated in a novel, self-confident variation on the role of the pendant when he bequeathed *Sun Rising through Vapor* (exh. 1807; BJ69) and *Dido Building Carthage* (exh. 1815; BJ131) to the National Gallery on condition that they be hung in perpetuity beside two Claudes. Examples of paintings he made specifically to hang together as pendants include the pair of *East Cowes* pictures he painted in 1827 for John Nash (figs. 9 and 10), and *Venice* and *Keelmen* (figs. 22 and 23).

In the late 1830s and the 1840s Turner's use of the pendant form became a characteristic of his art and exhibiting stance. The first pair in this period are *Modern Italy—The Pifferari* (Kelvingrove Museum, Glasgow; BJ374) and *Ancient Italy—Ovid Banished from Rome* (Private collection; BJ375), both exhibited in 1838 and both bought by his loyal patron H. A. J. Munro of Novar, Scotland. These were succeeded the following year by *Ancient Rome* (Tate Britain, London; BJ378) and *Modern Rome* (Private collection, on loan to the National Galleries of Scotland; BJ379). Year by year other pairs came into being, exhibited in 1840, 1841, 1842, 1843, 1845, 1846, and 1850, each pair so determined that together they might be regarded as part of Turner's culminating final statement.[4]

Turner's guiding principles behind the later sets of pendants were that they should be the same size and shape, should be of contrasting color values—hot and cold, red and blue—and should balance contrasting or antiphonal ideas in their subject matter. It is the chance coming together in Massachusetts of perhaps the greatest of Turner's late pendant pairs that prompted this exhibition. The two paintings, exhibited together at the 1840 Royal Academy exhibition, are *Rockets and Blue Lights (Close at Hand) to Warn Steamboats of Shoal Water* (fig. 27) and *Slave Ship (Slavers Throwing Overboard the Dead and Dying—Typhon Coming On)* (fig. 28). The idea that they are pendants has only recently been suggested and may not be fully accepted.[5] Although this idea may be weakened by the fact that *Rockets and Blue Lights* was shown in 1841 at the British Institution—without *Slave Ship*—the case for the proposal is outlined in this exhibition.[6]

The only time that the paintings were referred to together in print in their early existence was in a review in *Blackwood's Magazine* of September 1840, which was published shortly after the Royal Academy exhibition closed. The unnamed author, known now to have been the Reverend John Eagles, a consistently virulent critic of Turner, described the paintings as "these absurd extravagances [that] disgrace the Exhibition not only by being there, but by occupying conspicuous places" (see Appendix). They were shown with four other Turners,

FIGURE 27 J. M. W. Turner, *Rockets and
Blue Lights (Close at Hand) to Warn Steam-
boats of Shoal Water*, exh. 1840. Oil on
canvas, 36 1/16 x 48 1/8 in. (91.8 x 122.2 cm).
Sterling and Francine Clark Art Institute,
Williamstown, Massachusetts [BJ387]

FIGURE 28 J. M. W. Turner, *Slave Ship
(Slavers Throwing Overboard the Dead and
Dying—Typhon Coming On)*, exh. 1840. Oil
on canvas, 35 3/4 x 48 1/4 in. (90.8 x 122.6 cm).
Museum of Fine Arts, Boston. Henry Lillie
Pierce Fund [BJ385]

and it is possible that when describing the works as "absurd extravagances" Eagles was referring to Turner's entire 1840 showing rather than just to *Rockets and Blue Lights* and *Slavers*.[7] The paintings appear to have remained in Turner's studio and, later, with his dealer Thomas Griffith until December 1843, when John Ruskin suggested to William Wethered, a collector and dealer from King's Lynn, Norfolk, that he buy both works.[8] This was clearly an effort to keep the pictures together, and it may have been the last in a series of attempts by Turner, Griffith, and Ruskin to sell them as a pair. Wethered bought neither, and within two weeks *Slavers* was bought by John Ruskin's father, the sherry importer John James Ruskin, who gave it to his son as a New Year's present. So from January 1844 until 1872, when John Ruskin sold it, *Slavers* hung in the family home in Denmark Hill, south London, where it came to have a profound cumulative effect on Ruskin. He expressed his first feelings about the work in intense and symbolic paragraphs in the first volume of *Modern Painters*, published in 1843 (see Appendix).[9] As John McCoubrey has pointed out, Ruskin's widely read description acted as a surrogate for the unseen picture for fifty years.

In the meantime, *Rockets and Blue Lights*, bought in 1850 by the colliery owner Charles Birch, made its way to Harborne, Birmingham. Within six years Birch had sold the work to John Naylor of Leighton Hall, Welshpool, Wales, who consented to lend it to the 1857 Art Treasures exhibition in Manchester. While traveling to that exhibition the wagon carrying the painting was involved in a collision with a railway engine at a level crossing, and the painting was badly shaken and damaged. It never made it to the exhibition. Between 1850 and 1900 *Rockets and Blue Lights* changed hands thirteen times, settling briefly in private and dealers' collections in Britain and Paris until it was bought by the painter and collector James Orrock (1829–1913). It then crossed the Atlantic to New York, where it was owned by a succession of seven dealers and private owners, including Knoedler, Duveen, George Eastman, and C. M. Schwab. In 1932 it was bought by Sterling and Francine Clark, whose collection formed the nucleus of

the Clark Art Institute's holdings when the museum opened in 1955.

The decades up to the early 1930s were turbulent ones for *Rockets and Blue Lights*, passing as it did from hand to hand, never settling anywhere for long. *Slavers*, however, crossed the Atlantic immediately after Ruskin sold it to the New York lawyer John Taylor Johnson. From him it went in 1876 to Alice Hooper of Boston, who exhibited it publicly in New York and Boston in 1877. After a short period in the collection of the Bostonian W. H. S. Lothrop it was bought in 1899 by the Museum of Fine Arts, Boston, where it has remained.

It is remarkable that after so many changes of ownership the two works should finally settle in public collections only 130 miles apart. Nonetheless, the paintings have not been exhibited together since 1840. In addition to having the standard pendant ingredients of identical size and shape and contrasting color, *Rockets and Blue Lights* and *Slavers* have the antiphonal subject matter that points very clearly to their having been painted by Turner to hang together in perpetuity. Both works tell of the terrors of the sea, but in vividly contrasting voices and approaches: *Slavers* is concerned with an unspeakable evil of the recent past, while *Rockets and Blue Lights* celebrates the ad hoc systems of coastal safety being set up in the 1830s and 1840s along Britain's shores to warn mariners of the particular dangers in local waters.

One of the compulsions on Turner to paint *Slavers* was the rise in public awareness in 1839 of the horrors of slavery. This awareness was prompted by the publication that year of the second edition of Thomas Clarkson's *History of the Rise, Progress, and Accomplishment of the Abolition of the Slave Trade*, and of Thomas F. Buxton's book *The African Slave Trade*. Buxton's work was serialized in *The Times* during the summer of 1839. Another new publication in 1839 that raised public consciousness was a biography of William Wilberforce, one of the driving personalities behind the abolition of slavery.[10] A particularly shocking aspect of the "management" of slave-trafficking was the practice of "jettison," that is, throwing living slaves overboard. Buxton relates a story that carries the same impact now as it did the

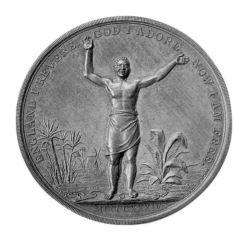

FIGURE 29 Charles Frederick Carter,
*Medal Commemorating the Abolition of Slavery
in the British Colonies*, 1836. Bronze. British
Museum, London

day it was written: Captain Luke Collingwood, of the slave ship *Zong*, fearing a shortage of water en route from West Africa to Jamaica in 1781, gave orders that the sick, dying, and dead slaves be thrown overboard. Collingwood would then claim insurance compensation for them.[11] The underwriter's rules were that the slaves lost overboard could be claimed against insurance, while those who died en route could not. According to Buxton, who was himself reporting a story told to him, 132 slaves were thrown into the sea across three days in an apparently determined instance of mass murder.[12] They were jettisoned in "parcels" of about forty men and women, the final ten deciding to take matters into their own hands by jumping into the shark-infested sea before they were pushed. There were other "jettison" stories current, and the possibility that Turner used the *Zong* incident as a source has been doubted, not least by McCoubrey, who points out that Buxton describes the jettison happening in calm weather. For that reason, McCoubrey says, it could not have been the source for Turner's stormy scene. However, we might confidently reflect that the storm may be seen as a dramatic device rather than as a literal description.

The presence in the painting of floating chains and of hands imploring in terror caused consternation in 1840, and it continues to do so. McCoubrey has shown that one of the sources for the hands was the figure of a freed slave raising his arms in a gesture of hope on the medal struck in 1836 to commemorate the abolition of slavery in the British colonies (fig. 29).[13] As introduced within the waves by Turner, the raised hands are a mark of final victory, while the floating chains may suggest that evidence of evil will not go away.

In *Rockets and Blue Lights* Turner followed a line of approach that repeated something of the motives behind his 1831 painting *Lifeboat and Manby Apparatus Going off to a Stranded Vessel Making Signal (Blue Lights) of Distress* (fig. 30). The latter was painted to hang in the Royal Academy exhibition at the same time that Captain George Manby (1765–1854), a difficult and eccentric inventor and campaigner for safety at sea, was being proposed for election as a Fellow of the Royal

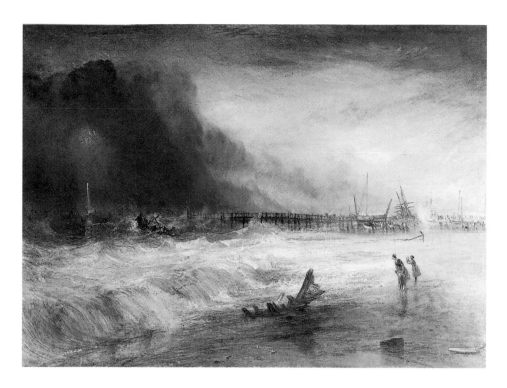

FIGURE 30 J. M. W. Turner, *Lifeboat and Manby Apparatus Going off to a Stranded Vessel Making Signal (Blue Lights) of Distress*, 1831. Oil on canvas, 36 x 48 in. (91.4 x 122 cm). Victoria and Albert Museum, London [BJ336]

Society in a further attempt to raise the public profile of his shore-to-ship safety rocket system.[14] Both paintings have characteristically Turnerian titles, lengthy and didactic, concise lessons in seamanship in themselves. As a counterpoint to *Slavers*, which marks the passing of a barbaric practice carried out using the old technology of the sailing ship, *Rockets and Blue Lights* features steamboats, machines of the future, whose secure hulls and efficient huffing steam engines will counter the worst effects of a storm at sea, aided by a clear, regulated system of rocket-signaling implemented by people on shore.

The parallels between both the form and the content of *Rockets and Blue Lights* and *Slavers* make a compelling case for them to be accepted as pendants. The instructive tone of the full title of *Rockets and Blue Lights* is balanced by the use in *Slavers* of the archaic word "Typhon," at once the Greek Father of the Wind and a variant of "typhoon"—though we cannot rule out the notion that this may be a spelling error, perpetuated for 160 years. For reasons that are not entirely clear, but may partly explain, or be explained by, the fact that it changed hands so many times before the early 1930s, *Rockets and*

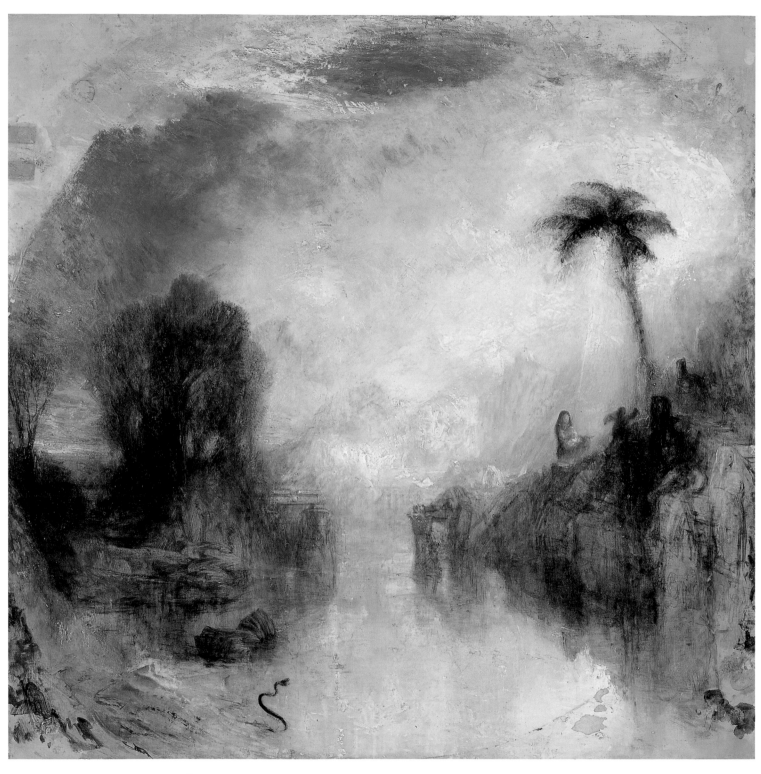

FIGURE 31 J. M. W. Turner, *Dawn of Christianity (Flight into Egypt)*, exh. 1841. Oil on canvas, diam. 31 in. (78.5 cm). Ulster Museum, Belfast [BJ394]

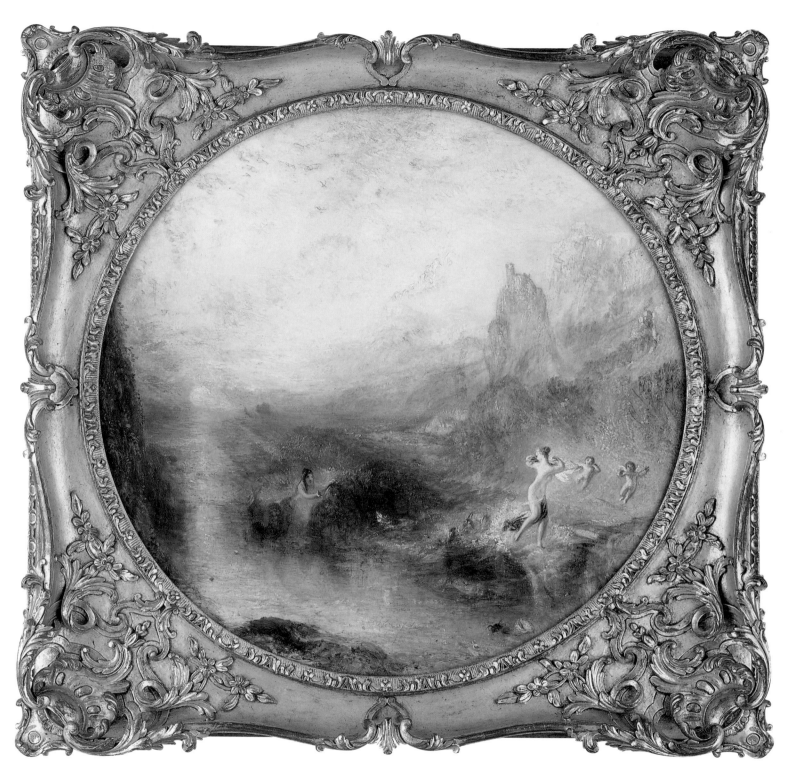

FIGURE 32 J. M. W. Turner, *Glaucus and Scylla*, exh. 1841. Oil on panel, 31 x 30 1/2 in. (78.3 x 77.5 cm) rectangular (exhibited as a circle). Kimbell Art Museum, Fort Worth, Texas [BJ395]

Blue Lights was a shadow of its former self before it was scrupulously restored for this exhibition, as discussed in Chapter 4, by David Bull in 2002. Turner's notoriously experimental late technique, combined with the effects of the unspecified shock the canvas received in the train wreck in 1857 and the stress of being moved from owner to owner, give the painting a serious and complicated structural condition, requiring it to be an inpatient for long periods of time with picture conservators.

The pendant pair of 1841, *Dawn of Christianity (Flight into Egypt)* and *Glaucus and Scylla* (figs. 31 and 32) are both square but framed and were first exhibited as circles; the former is softly blue, the latter violently red. Their subjects revolve around the issues of flight in Christian and in pagan classical literature: the former the flight of the holy family from Palestine into Egypt after the birth of Christ, the latter a story from Ovid's *Metamorphoses*. This tells of Typhon's daughter Scylla being surprised naked by the sea god Glaucus on the eastern shores of Sicily, near Mount Etna. Scylla fled up the mountain at the sight of the ungainly man-fish and, in a later part of the story, was poisoned by Circe (who loved Glaucus). She threw herself into the sea, where she was transformed into the rock that bears her name in the Straits of Messina between Sicily and Italy. Mount Etna and the nearby hill town of Taormina are both visible in the background of the painting.

Turner flagged the twin sources for these pictures in the Royal Academy catalogue, giving the former the epigraph "'That Star has risen': Rev. T. Gisborne's Walks in a Forest," and the latter the chapter and line reference to *Metamorphoses*.[15] There is little doubt that Turner expected the more literate members of his audience to pick up the balanced meanings of the paintings from the textual references he gave. *Walks in the Forest* by the Reverend Gisborne (1758–1846), an evangelical writer and preacher, an abolitionist, and a close friend of Wilberforce, was widely read in the early nineteenth century. By 1819 his book had reached nine editions. *Walks in the Forest* is a long poem in blank verse in the manner of William Cowper. It uses the

moods of a forest in the changing seasons as a setting for commentary on the life of Christ and on human conduct, and for arguments supporting political reform and the abolition of slavery. The phrase that Turner chose for his epigraph comes from Gisborne's celebratory allusion to the life of Christ:

> . . . and the impatient East,
> Shouting for joy, the Day-star's advent hail'd.
> That star has risen, and with a glow that shames
> The sun's meridian splendour, has illumed,
> Eternity! . . .

There is a further trace of the painting's title, *Dawn of Christianity*, in the final line of the poem: "And hail the dawn of evangelic day."[16]

Turner's choice of the rare (for him) Christian subject, with its specific textual reference and classical companion, leaves us with a conundrum. One of his closest friends in the 1830s was the Reverend Edward Daniell (1804–1843; fig. 33), curate of St. Mark's Chapel, Mayfair, a preacher who shared Turner's interest in classical art and architecture, and who inspired Turner to attend his church services. Daniell and Turner met socially in London on many occasions. Daniell, a collector of paintings, owned Turner's *Mortlake Terrace . . . Summer's Evening* (exh. 1827; National Gallery of Art, Washington, D.C.; BJ239) and aspired to buy, for a price specially reduced by the artist, *Modern Italy—the Pifferari* (exh. 1838, Kelvingrove Museum, Glasgow; BJ374). Daniell gave up his curacy in 1840 to travel in the Middle East to paint and record classical remains, but he kept in touch with Turner and their mutual friends in correspondence.[17] When the news that Daniell had died of malaria in Lycia reached London in 1843, Turner was devastated.[18] While too early to be a posthumous homage to Daniell, this pair of pictures, which encompass both Daniell's religious beliefs and his classical interests, and which were displayed at the Royal Academy during Daniell's travels in Asia Minor, may be considered a farewell to the young Christian preacher who did not, in the end, return home.

FIGURE 33 John Linnell, *Portrait of the Reverend E. T. Daniell*, undated. Pencil on paper, 8 15/16 x 7 7/8 in. (22.7 x 19.9 cm). Norwich Castle Museum and Art Gallery

The Multitudinous Seas Incarnadine

In *The Dawn of Christianity* and *Glaucus and Scylla* the presence of the sea is a mere token. There is little spirit apparent in either waters, and the Red Sea, crossed by the holy family on their way to Egypt, is represented in *Dawn of Christianity* by a river, while the Straits of Messina are shown as the lurid poem of reds and oranges that characterizes Turner's many sunrise or sunset seas of the 1840s, such as figure 61. Played down as it is in both paintings to a cypher, the sea in *Dawn of Christianity* and *Glaucus and Scylla* is the background scenery or setting to a pair of stories of human trial, rather than an expression of the power of nature. Turner's sea paintings do not always have waves in them, but as thĕ power of their narratives shows, this does not make them any the less sea subjects. The added value of the artist's intention that these pictures be seen as a pair is reflected in the fact that they were both bought from the 1841 exhibition by the prominent Turner collector B. G. Windus, and they hung together in his house for many years.

As two contemporary pairs, the pendants of 1840 and 1841 together exemplify Turner's reflections on modern and ancient history. In setting up his contrasts in a balancing pair of works Turner illuminated the crowded walls in the Royal Academy exhibitions by the stark use of blue and red, elbowing a generous space for his work. The shock value of Turner presenting his work in this way can be measured by the extremes of expression, both favorable and unfavorable, used by the critics who wrote about the Academy exhibitions. Eagles's remark, specifically directed at *Rockets and Blue Lights* and *Slavers*, that they were "absurd extravagances . . . occupying conspicuous places," is symptomatic, as is the opinion of the *Athenaeum's* critic, whose words were intended to carry considerable hurt, that *Dawn of Christianity* and *Glaucus and Scylla* were "the fruits of a diseased eye and a reckless hand."[19] The *Spectator*, by contrast, spotting the point of the color balance in the 1841 pair, made the startled but refreshing comment that the "two circular studies of a warm and cool effect are brilliant rondos of harmony in prismatic hues."[20]

A further instance of Turner drawing on his sense of the theatrical

FIGURE 34 J. M. W. Turner, *Undine Giving the Ring to Massaniello, Fisherman of Naples*, exh. 1846. Oil on canvas, 31 1/8 x 31 1/8 in. (79 x 79 cm). Tate Britain, London [BJ424]

in the pendant form is his use of the subject *Undine Giving the Ring to Massaniello, Fisherman of Naples* (fig. 34) as a pendant to *The Angel Standing in the Sun* (exh. 1846; Tate Britain, London; BJ425). In *Undine* Turner pulls together two quite separate stories, both current and popular on the London stage in the early 1840s: the fable of the water nymph Undine and the story of the historical figure Massaniello (Tomaso Aniello, 1620–1647). English translations of *Undine* (1811) by Friedrich de la Motte Fouqué were published in 1818, 1844, and 1845, and Jules Perrot's ballet *Ondine* was performed in London from 1843 to 1848. Further, Auber's opera and Deshayes's ballet, both titled *Massaniello*, were staged in London from 1829 to great public acclaim. Turner had every opportunity to see any or all of the productions, and in his painting he wove the fictional Undine into the story of Massaniello, the fisherman who led a brief insurrection against the

Spanish invaders of Naples in 1647 but became intoxicated by his sudden apparent power. Massaniello's story had a topicality in the mid-1840s, the years of insurrection and revolution in Britain and Europe, which was one reason it was repeatedly staged.[21]

Waves are subordinate in *Undine*, being suggested by the shoals of water nymphs, of leaping fish, and of the shimmers beneath the erupting Vesuvius, a sign that we are in Naples. As in *Dawn of Christianity* and *Glaucus and Scylla*, the sea is present in *Undine* by inference and as a dramatic signpost rather than as a study in water movement.

———————

Slavers and *Undine* underline the notion that the sea in Turner is a stage for human activity—literary, historical, and everyday. Ruskin, running too fast, perhaps, in his hero-worship of Turner, foretold in the first volume of *Modern Painters* (1843) that "within the next fifty years" Turner's name would be "placed on the same impregnable heights with that of Shakespeare."[22] One hundred and fifty years on, it may be time to consider whether Ruskin was correct. The English-speaking world now has its Shakespeare memorial theaters, its international touring Shakespeare productions, its Shakespeare prizes, its Shakespeare scholars, its Shakespeare societies, its Shakespeare industries. So, too, it has its Turner Gallery, its international touring Turner exhibitions, its Turner Prize, its Turner scholars, its Turner Society, its Turner industry. But there is more. Text, the currency of Shakespeare, is also crucial in Turner—his titles have to be read to their every last nuance for one to reach the fullest understanding of the meaning of the pictures. His poetry, regardless of its "quality," takes us deep into his creative core. Turner's subjects, as Shakespeare's, have a universality, as works in this exhibition amply remind us. There are many examples of moments of Shakespearean grandeur in Turner's work that reveal the artist's role as dramatist: a sea monster slowly evolving out of the mist of a sunrise at sea (see fig. 61); the immediate aftermath, handled with allusion and imagination, of a slave-ship captain's decision to throw living men and women overboard to perish (see fig. 28); the drawing

together of the stories of Undine and the revolutionary fisherman (see fig. 34); and the exciting and awe-inspiring events of whaling expeditions in the Southern Ocean (see figs. 56–58).

Furthering his argument for a shared Shakespeare/Turner pinnacle on Mount Parnassus, Ruskin turned to Shakespeare when he felt his own words to be insufficient. Reaching for *Macbeth*, Ruskin wrote of Turner's "yeasty waves" when evoking *Snowstorm—Steamboat off a Harbor's Mouth* (exh. 1844; see fig. 89).[23] And reaching the heights of his powers of prosody when writing of *Slavers*, Ruskin toys with Macbeth's lines:

> *Will all great Neptune's ocean wash this blood*
> *Clean from my hands? No, this my hand will rather*
> *The multitudinous seas incarnadine,*
> *Making the green one red.*[24]

He rearranges Shakespeare at the end of his paragraphs on *Slavers* in a single sentence that takes the reader, horror-struck, to its end. It is a sentence that also suggests in its depth and rhythm that Ruskin himself had some Shakespearean ambitions:

> *Purple and blue, the lurid shadows of the hollow breakers are cast upon the mist of the night, which gathers cold and low, advancing like the shadow of death upon the guilty ship as it labours amidst the lightning of the sea, its thin masts written upon the sky in lines of blood, girded with condemnation in that fearful hue which signs the sky with horror, and mixes its flaming flood with the sunlight, and, cast far along the desolate heave of the sepulchral waves, incarnadines the multitudinous sea.*[25]

But Turner has little need of Ruskin's advocacy; he can write his own Shakespeare, as in the Bard-like lines he appended to *Slavers* at its first exhibition:

> *Aloft all hands, strike the top-masts and belay;*
> *Yon angry setting sun and fierce-edged clouds*
> *Declare the Typhon's coming.*

Before it sweep your decks, throw overboard
The dead and dying—ne'er heed their chains.
Hope, Hope, fallacious Hope!
Where is thy market now?

————

A notable event for artists in 1840 was the publication of Charles Eastlake's translation of Goethe's *Farbenlehre, or Theory of Colours.* Turner, who knew Eastlake well, obtained a copy and picked through it paragraph by paragraph, making annotations and comments here and there on the text.[26] Goethe's theories were frowned upon by many British scientists, most notably by David Brewster, who attacked them in *Fraser's Magazine* and the *Edinburgh Review.* Many of Turner's annotations to Goethe were critical—he had an innate distrust of theory—but nevertheless he did go along with Goethe's ideas about warm-and-cold and light-and-dark color scales, something he had been experimenting with in *Slavers* and *Rockets and Blue Lights.*

Turner's comments in the margins of his copy, however, reveal that he was well versed in the technical language of optics. He uses in his marginalia the terms "dioptrics" and "catoptrics," which refer to the processes of refraction and reflection, and ones that do not enter everyday talk. He remarks in another place that Goethe is writing specifically about a double-prism, and then explains to himself in his notes that the particular effect referred to when a mirror reflects a double image is known as the "opaque reflection." He takes issue with Goethe by disagreeing with his analysis of how sunlight falls on an aperture—a camera aperture, as it might be. Goethe, he wrote, was wrongly "treating the sun as a plane" in that example; Turner himself read the sun correctly as a sphere. Near the paragraph where Goethe discusses an experiment of placing light-sensitive paper under yellow-red and blue-red glass and looking at the difference on exposure, Turner has written the word "Daguerreotype."[27]

The vocabulary that Turner uses in his annotations suggests a number of things, but principally it reflects the extent of his reading

and his conversation by the early 1840s. He was already fully aware of the Newtonian and anti-Newtonian theories of light, the former supporting the old idea that light was made up of streams of particles, the latter that it was some kind of wave. The words he is using, and the concepts he clearly understands, are just the terms that the scientist Michael Faraday and others were using in the Friday Evening Discourses in the Royal Institution in London. They were becoming common coin among interested and intelligent members of the public as scientific advance interacted with artistic understanding.

An event that preceded the publication of Goethe's translated text by about a year, and whose effect was infinitely more extended, was the announcement early in 1839 of the principles of photography. Photography was discovered rather than invented: among the pioneers were Louis-Jacques Daguerre, William Henry Fox Talbot, and Dr. John Adamson. Too many people had been involved in searching for ways to fix an image—across two or three decades and in many countries—for the principles to be patented. In presenting a way of changing humanity's perception of the world, photography sent artists, that inchoate guild of image-makers whose practice went back to antiquity, into consternation. While many artists were thrown into despair at the news of photography, and others saw opportunities beyond the threats, Turner, older and worldly wise, seems not to have committed himself one way or the other.

His own approach to his art was, independently, undergoing subtle changes in the late 1830s, as we have seen. It may or may not be a coincidence that as photography crept in—the art of the single, crystal-clear reproduced monochrome image perceived through the single glass eye—so Turner's art moved into orchestrated prismatic colors, the double image, the indistinct, the operatic; that is, everything that photography could not do.

Turner took a serious and constructive interest in optics, lens-making, and the uses of photography in the 1840s. Evidence for this is not only amply shown in his intelligent responses to the Goethe translation but in his friendship with and attentiveness toward the

FIGURE 35 *Portrait of John J. E. Mayall, 1846.*
Daguerreotype. Chester County Historical
Society, West Chester, Pennsylvania

young photographer John J. E. Mayall (1813–1901; fig. 35), who set up a photographic portrait studio in London in 1847. Mayall's studio was just one manifestation of the flowering of commercial photographic businesses in London in the late 1840s, which came in the wake of the discoveries of the principles of photography. Mayall was a Yorkshireman who had studied photographic processes in Philadelphia in the mid-1840s and had been a partner in a photographic business there. He had traveled in the eastern United States, most notably photographing Niagara Falls and other landscape subjects.[28] Turner became a regular visitor at Mayall's shop in West Strand, off Trafalgar Square, and sat many times for his photograph.[29] He watched Mayall grind lenses, and on one occasion he stayed for "some three hours, talking about light and its curious effect on films of prepared silver."[30] Progress in photography in the 1840s was as much about technical improvements in optics and chemistry as it was about image-making, and it is significant that Turner showed as profound an interest in Mayall's lens-making and chemical activities as he did in his practice of photography. Turner discussed the spectrum with Mayall, was fascinated by photographs of Niagara Falls (in which Mayall had caught the fleeting impression of the rainbow), and whenever Turner came to the shop he always seemed to have "some new notion about light" to discuss with the proprietor. Turner's friendship with Mayall is a compelling instance of the depth of his engagement with this particular aspect of science.

Whether significant earlier paintings by Turner are foreshadowings of his interest in lenses is doubtful, but it is the case that paintings from Turner's early career, rooted in Claude, have a significant central lens-like focus in the presence of the sun. Examples include *Dido Building Carthage* (exh. 1815; Tate Britain, London; BJ131), where there is a white-hot central sun precisely the relative size and position of the aperture if the picture space were a camera. There too is the dominating lens in *Snowstorm: Hannibal and His Army Crossing the Alps* (exh. 1812; Tate Britain, London; BJ126); and in *Mortlake Terrace . . . Summer's Evening* (exh. 1827; National Gallery of Art, Washington, D.C.; BJ239)

there is not only the lenslike sun but also the burning away by light of the parapet—the effect that photographers came later to call "halation." Turner and many other artists, such as Richard Wilson and J. R. Cozens, had pulled that trick long before—Turner, for example, showed how light dissolved form in his painting of *The Eruption of the Souffrier Mountains* (exh. 1815, University Art Collection, Liverpool; BJ132), a painting guided by another man's sketch but otherwise entirely from Turner's imagination. The imagery of the lens returns with a much greater intensity for Turner in such paintings as *The Evening of the Deluge* of c. 1843 (see fig. 67), *The Angel Standing in the Sun* of 1846, and its pendant *Undine Giving the Ring to Massaniello, Fisherman of Naples* (see fig. 34). The insistent circularity of all these compositions, even their graininess, and their refractory quality prepare the ground for a lively relationship with lenses and lens-making.

There is an enormous significance in the fact that Turner's prismatic harmonies came in the 1840s after the introduction of photography. They are no knee-jerk reactions to the new discoveries, because of the many threads from Turner's later manner that run deep into his painting of the 1820s and '30s. Such paintings were perhaps inevitable from him in the 1840s, with or without photography. But it does appear that the new science had a liberating effect on Turner, giving him "permission" to do what photography could not, and providing a further impulse to move on from imagery such as *Folkestone, Kent* (see fig. 24) to the elemental abstractions of the later seascapes, discussed in Chapter 4, which were never exhibited in his lifetime. Turner knew photography to be real, and it is the nature of his genius that he took it in his stride and made a virtue of a necessity by giving what time he had left to completing his exploration of the nature of light, the stuff that is the common ingredient of art, and photography, and life.

Three

INTERLUDE: TURNER
THE ELDERLY TRAVELER

As a Briton, Turner began every continental journey with a sea cross-ing. We should therefore view the oil paintings and watercolors of continental subjects that he made in the late 1830s and 1840s knowing that to reach those subjects, and to return from them, he was obliged to spend some hours on a boat "[hanging] over the stern, watching the effects of the sun and the boiling of the foam," as the journalist Alaric Watts put it.[1] Turner used the port of Dover on his first visit to the continent in 1802. He traveled from London via Margate when he left Britain for the second time in August 1817, visiting Ostend and returning from Rotterdam to Harwich a few weeks later. In 1826, traveling to Dieppe and thence around Brittany and up the Loire, he chose Brighton, or possibly nearby Shoreham, as his departure point.[2] Other British ports that we know he used include Folkestone, Portsmouth, Cowes, Plymouth, Leith, and Tobermory. This personal knowledge of many of Britain's ports and harbors sharpens Turner's descriptions in paintings such as *Ship Aground: Brighton* (see fig. 13) and *Folkestone, Kent* (see fig. 24).

He knew weather conditions of all kinds at sea, and poor weather, or its risk, had kept him and his fellow passengers at sea and in some danger from time to time. He seems to have taken it all in his stride: his landing at Calais in a storm in 1802 might have been his first and

last: "Nearly swampt," he laconically put in the "Calais Pier" sketch-book.[3] Turner took a tourist trip in 1831 to the island of Staffa, off the west coast of Scotland, and reported some years later on the suspicious weather: "The sun getting toward the horizon, burst through the rain-cloud, angry, and for wind; and so it proved, for we were driven for shelter into Loch Ulver, and did not get back to Tober Moray before midnight."[4]

The British experience of leaving the coast and then, when coming home, of seeing the cliffs rise up through the mist, has been evoked, explained, and returned to in literature, music, and art for more than five hundred years. It is noteworthy that, in Turner's surviving oil paintings from the period 1835–50, the English landscape as a subject has all but disappeared. In its place are continental scenes and subjects from classical myth and contemporary history, and, in the far greater majority, seascapes. The same pattern emerges in a loose analysis of the works on paper. This suggests that during Turner's latter period his interest and imagination swung from the sea to the continent and back again, leading us to consider, as this exhibition does, the nature and meaning of the link between the two.

The watercolors in this section, in marked relief from sea subjects, are principally of lakes and mountains. But the element that many of them share with the sea paintings is the extreme turbulence in Turner's expression of atmosphere, water, and geology. Turner breathes life into mountains and makes them move, to the extent that the only reasonable comparison they bear is with powerfully moving water. This is a phenomenon that is not new to late Turner. Even in so quintessentially rural a watercolor as *The Vale of Ashburnham* (fig. 36) the living rhythms of the Sussex landscape run across the picture like the waves of the sea. An irony in this work is that there, in the far distance, is indeed the sea, in a calm, narrow line of blue. In a later watercolor, *Loch Coruisk, Skye* (c. 1832; National Galleries of Scotland, Edinburgh), the range of Scottish mountains and an approaching storm come together in an explosion of energy that makes rock and air coalesce into something that neither of them is:

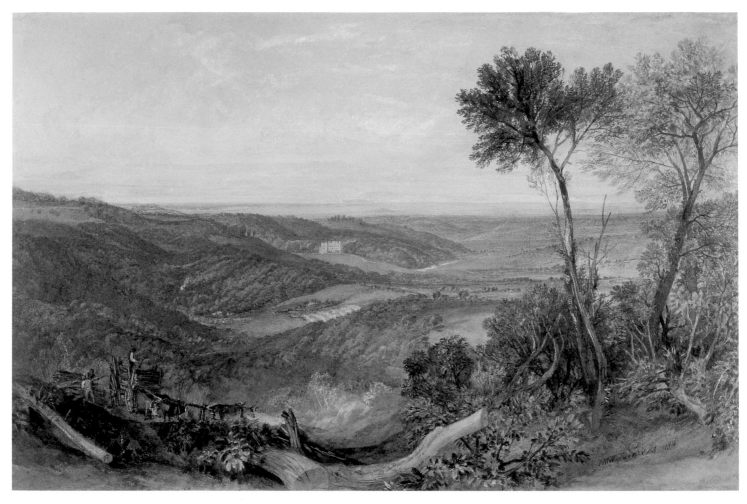

FIGURE 36 J. M. W. Turner, *The Vale of Ashburnham*, 1816. Watercolor on paper, 15 x 22 1/4 in. (38 x 56.4 cm). British Museum, London [W425]

an unimaginably powerful sea storm. This is the strength of the poet in Turner, using metaphor to convey an idea of the power that formed the mountains way back in early geological time and to help us imagine what it might have been like to have been there. Nor is it a new idea in art—Leonardo da Vinci's drawings of deluges, which liken the powers of water and collapsing rock, are examples of the way farseeing artists have discerned a vivid parallel between the solid and the liquid. A literary root of the metaphor comes in a passage that Turner would have known from Milton's *Paradise Lost*:

> *On heavenly ground they stood, and from the shore*
> *They viewed the vast immeasurable abyss,*
> *Outrageous as a sea. Dark, wasteful, wild,*

Interlude: Turner the Elderly Traveler

Up from the bottom turned by furious winds
And surging waves, as mountains to assault
Heaven's height, and with the centre mix the pole.[5]

Travel was an essential component of Turner's art—the first ingredient, before paper, pencil, and watercolor wash could properly come into play. Subject matter and imagery were clearly generated for him only after the coach wheel had spun and the steamboat had crashed through the breaking waves. Turner required evidence, and he traveled to seek it out. He had been on the move all his life: in his childhood in the 1780s he made journeys, over which he had no control, to Brentford, Margate, and Oxford, and, when he was sixteen or seventeen and making his own decisions to travel, he went to places distant from his home in London, such as Bristol in the autumn of 1791 and South Wales in 1792.

Turner was driven by the excitement of his journeys—by the approaching destination and what he would see on the way, and by the money he would make from drawings done in the open air. He would work up his drawings later for sale to patrons and engravers. His annual pattern of work and travel gradually settled into studio work from the autumn to April, reaching a pitch of activity in late April as the Royal Academy exhibition opened. He generally remained in London until July or August, by which time both the Academy and the exhibition in his own gallery in Harley Street, and later in Queen Anne Street West, had closed; and then off he went to the country or to Europe with his pencils, watercolors, and sketchbooks. By the time he was fifty years old, in 1825, the approximate starting point of this exhibition, Turner had traveled to North and South Wales, to the English Midlands, to Yorkshire, to Lancashire and the North of England (east and west), to Scotland (three times), all round the Devon and Cornwall peninsula (twice), many times south to the coast of Kent, Sussex, Hampshire, and the Isle of Wight, and to East Anglia. There is hardly a town in Britain which his feet or spinning coach-wheel did not pass through; barely a major highway

that did not feel the clatter of the horses carrying him.

Then there was foreign travel. Only war managed to keep him out of Europe; but the sudden halt in military activity between England and France, the short-lived Peace of Amiens, allowed him to take a packet boat at Dover in July 1802 and sail with a friend to Calais. From there he went to Paris, through France to the Alps, then over the mountains and across the border into Italy, where he had his first sight of a Roman city, Aosta. The party returned home at the end of September, and Turner did not leave his native shores again for fifteen years. Then, in 1817, he went to Germany and the Low Countries, and in August 1819 he set off on his formative six-month journey to Italy—Venice, Rome, Naples, and Florence—where his taste for traveling in Europe, and the business of this exhibition, begins.

Turner would also travel vicariously. In 1815 he exhibited an oil painting of the erupting volcano La Souffrière in St. Vincent, West Indies, after a lost drawing by the traveler Hugh P. Keane.[6] He always acknowledged his sources, and never (as far as we know) pretended that he had been somewhere when he had not. In 1818, Turner went to Italy in his mind when he made a series of twenty watercolors after pencil drawings by the architect James Hakewill (1778–1843); these were for engraving.[7] Other examples of this kind of armchair travel include "trips" to Greece, Turkey, the Holy Land, India, and, for his vignette illustrations to Thomas Campbell's *Poetical Works* (1837), to the Pacific coast of South America, where the Andes meet the sea, and inland in the United States to Wyoming, Pennsylvania (see fig. 52).[8] This exhibition includes one example of Turner's use of another's work as his source material: his painting from Julia Gordon's drawings of the view from the terrace of her villa at Niton on the Isle of Wight (see fig. 3).

From the early 1830s Turner was able to live at the seashore and come and go as he pleased. He took rooms in a house overlooking Margate harbor, rented to him by Mrs. John Booth, who was to figure hugely in Turner's later years. By this time regular steam packet services

were in operation from wharves on the Thames in London to Margate and to the coastal towns further round the North Foreland of Kent, Broadstairs, Ramsgate, Deal, and Folkestone. The journey by steamboat to Margate took eight hours, a revolutionary improvement over the tub-like "Margate hoy" sailing boats, which could keep the passenger at sea for up to seventy-two hours.[9]

The insight by Alaric Watts of Turner the elderly traveler hanging over the steamer's stern, watching the sun and foam, continues with Watts's observation that at two o'clock Turner would go down into the cabin, take his meat out of his bag, and settle himself down next to "one with whom he was in the habit of chatting" and touch him or her for a clean plate, a hot potato, and a glass of wine, "but would never accept two. It need hardly be said that he was no favorite with the waiters."[10]

———

Turner's responses to the sea at Margate embraced every kind of weather effect, the more so because of the depth of his lifelong experience of the town and its hinterland. The "Wilson" sketchbook (1796–97),[11] in use when Turner was twenty-two years old, contains some vibrant studies of the bay at Margate. But despite his lifetime's exposure to its light and air, Turner could still, near the end of his life, be excited by an everyday atmospheric effect at Margate: "May 30 Margate: a small opening along the Horizon marked the approach of the *Sun*'s orb[?] setting *yellow*." Then turning the page round in a hurry to find space for his words: "*Gone* and with a flash of Light to show its . . . [three illegible words]."[12] Such intimate, delighted remarks in the face of ever-changing nature is the part of the rich harvest that we can now receive from the elderly Turner's travels. In the same sketchbook he continues: "May. Blossoms—Apple Cherry Lilac / Small white flowers in the Hedges / in Clusters, Dg [?dancing] Blue Bells / Butter cups and daisies in the fields. / Oak. Warm Elm G. Ash yellow . . . " [final line illegible].[13]

There are yet more expressions of joy in the sketchbooks he took

with him on his continental travels. Pausing to look around himself in an olive grove near Loreto, on the east coast of Italy, in 1819, he takes in the sea, the sunlight, the colors, harmonies, and features in the landscape. In an expression of the thrill of being alive there, in Italy, a thousand miles from wet, cold, smelly London, Turner writes:

> the Sea quite Blue, under the Sun a warm vapour, from the Sun Blue relieving [?] the shadow of the olive Trees dark, while the foliage light or the whole when in shadow a quiet grey. Beautiful dark green yet warm, the middle Trees, yet Bluish in parts, the distance; the aqueduct reddish, the foreground light grey in shadow.[14]

In his continental sketchbooks Turner also makes notes about his itineraries, the food he needed, the names of suitable hotels. His notes show how hard he tried to grasp the principles of French, Italian, and German grammar and vocabulary. They also reflect his nervousness at becoming ill when traveling, the most dramatic precaution being what was "Said to be an infallible cure for the bite of a Mad Dog,"[15] and a robust recipe of ipecacuanha and laudanum, a powerful emetic and opiate.[16] At around fifty years of age, Turner was a highly experienced traveler who took care to be self-sufficient.

His appearance and bearing as a traveler are recorded in a handful of accounts. The French painter Delacroix, writing more than twenty years later, remembered Turner's visit to his Paris studio in 1829 or 1832, and his "appearance of an English farmer, black clothing, quite coarse, big shoes and a cold hard demeanour."[17] This recollection is probably colored by the fact that Delacroix had taken an instant dislike to Turner. In *A Century of British Painters*, published in 1865, Richard and Samuel Redgrave summed up the aspect of Turner that remained in their memory, that of the professional traveler:

> In the last twenty years of his life, during which we knew him well . . . his face, perhaps from continual exposure to the air, was unusually red, and a little inclined to blotches. His dark eye was bright and restless— his nose aquiline. . . . His ruddy face, his rollicking eye, and his continu-

ous, although, except to himself, unintelligible jokes, gave him the appearance of one of that now wholly extinct race—a long-stage coachman.[18]

But it is the artist at work that the surviving reports of Turner describe most vividly. In the late 1820s an unknown American amateur artist met Turner while sketching at Caen, Normandy. He told how Turner

sketched standing, painting the scene in water-colors, laying it in, in a broad sombre manner, manipulating with surprising celerity, and producing in half an hour a most surprising effect. . . . I afterwards saw him dizzily perched in the crumbling turret of an old wind-riddled tower, shaded by an overhanging ivy, and surrounded by a cloud of complaining rooks. He was laboriously sketching the minutest detail of a group of carved stones half hidden in moss and leaves.[19]

Twenty-five years later his speed had not slackened, as the landscape painter turned photographer William Lake Price reported when he saw Turner on a steamer on Lake Como in the early 1840s:

Turner held in his hand a tiny book, some two or three inches square, in which he continuously and rapidly noted down one after another of the changing combinations of mountain, water, trees &c., which appeared on the passage, until some twenty or more had been stored away in the hour-and-a-half's passage. This example of so consummate an artist shows the engrossing love of the pursuit, with which excellence in it must be accompanied.[20]

The painter William Callow, who came upon Turner in Venice in 1840, saw him sitting in a gondola busily "sketching San Giorgio, brilliantly lit up by the setting sun."[21] Ruskin gave an account of a less energetic sketching method that Turner adopted on his later tours:

Turner used to walk about a town with a roll of thin paper in his pocket, and make a few scratches upon a sheet or two of it, which were so much shorthand indication of all he wished to remember. When he got to his inn in the evening, he completed the pencilling rapidly, and added as much colour as was needed to record his plan of the picture.[22]

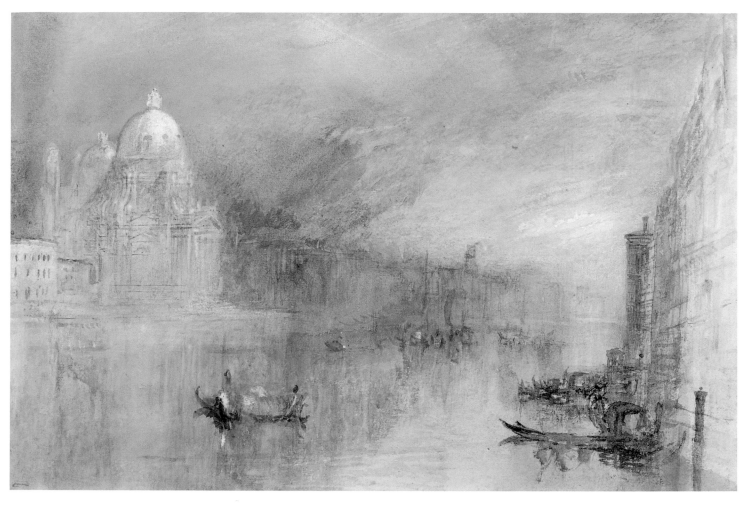

FIGURE 37 J. M. W. Turner, *Entry to the Grand Canal, Santa Maria della Salute, Venice*, 1840. Watercolor with bodycolor and scraping out over pencil on paper, 8 9/16 x 12 1/2 in. (21.8 x 31.8 cm). Private collection [W1368]

Between 1835 and 1845, in nearly every year throughout his sixties, Turner made nine separate trips into northern Europe, going as far south as Switzerland. Occasionally he had a traveling companion: in 1836, traveling through France, Switzerland, and the Val d'Aosta in northern Italy, it was his friend and patron H. A. J. Munro of Novar; and in 1840 he went as far as Bregenz in Austria with fellow travelers whom we know only as "E. H." and his wife before Turner himself turned east for Venice.[23] A companion on part of Turner's 1844 trip into the Alps was possibly the painter, pioneer, travel writer, and amateur scientist William Brockedon.[24] Far from being exhausted by his tours, Turner threw himself directly into his work when he returned home. "A few hours," as he described it, after getting back from Venice in October 1840 he was writing to his solicitor George Cobb about

Interlude: Turner the Elderly Traveler

a possible meeting,[25] and the day after his evening homecoming from his 1841 tour of Switzerland he wrote to the engraver William Miller with a long critique of an engraving proof.[26]

Venice was the quiet muse that lay in wait for Turner. He first saw the watery city in 1819, again in 1833, and for the third and final time in 1840. Both in the city and in his studio Venetian imagery occupied his mind's eye, to the point of obsession. He produced dozens of watercolors, such as *Entry to the Grand Canal, Santa Maria della Salute, Venice* (fig. 37), and thirty-four surviving oil paintings, twenty-five of which he exhibited. Many Venetian oils were left incomplete at his death. The sea in Turner's Venice pictures is invariably calm and reflective. Storms and floods are nowhere to be seen. *The Dogana and Santa Maria della Salute, Venice* (exh. 1843; see fig. 82) is a fine example of the series in which the viewer is presented with an indissoluble union of water, air, and architecture. The softening buildings, which suggest both the grandeur of the architecture and that Turner has left his cake out in the rain, are named specifically in the title, leading us to the conclusion that it is the reality of Venice that Turner is seeking to evoke, rather than some kind of misty myth.

In the final pair of Venetian pictures that Turner exhibited, *Going to the Ball (San Martino)* and *Returning from the Ball (St. Martha)* (figs. 38 and 39), Venice itself has practically vanished into a subtly chromatic distant misty haze. Lacking tangible human reference, these near-abstractions have a wistful, threnodic quality that suppresses the reality of Venice into a milky light. Affected though these paintings are in places by irreversible darkening caused by Turner's personal recipe for megilp (a combination of spirit varnish and linseed oil), they remain substantial and moving works. The pair are identical subjects, with near-identical titles, to the pair exhibited at the 1845 Academy exhibition: *Venice, Evening, Going to the Ball* and *Venice, Returning from the Ball, San Martino* (Tate Britain, London; BJ416 and BJ417). Thoroughly confusing though this may be, it appears from two letters from Turner of 1845 and 1846 that the artist intended the two *Going* pictures to be one pair, and the two *Returning* to be another.[27]

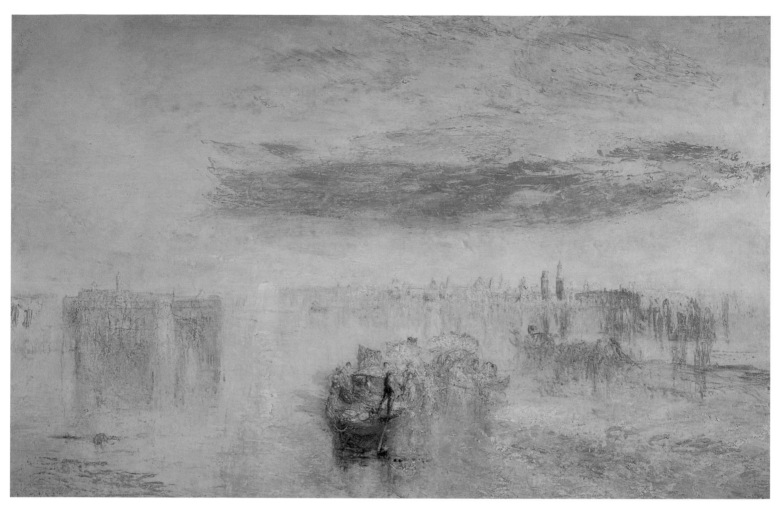

FIGURE 38 J. M. W. Turner, *Going to the Ball (San Martino)*, exh. 1846. Oil on canvas, 24 x 36 in. (61 x 91.4 cm). Private collection, courtesy of Mallett, London [BJ421]

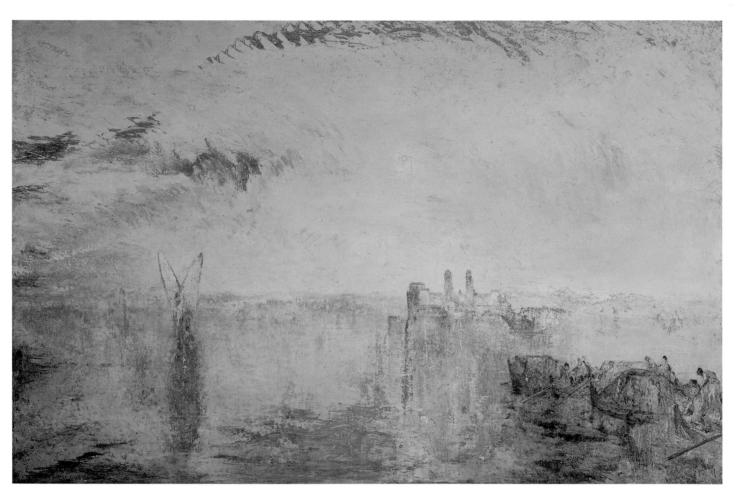

FIGURE 39 J. M. W. Turner, *Returning from the Ball (St. Martha)*, exh. 1846. Oil on canvas, 24 x 36 in. (61 x 91.4 cm). Private collection, courtesy of Mallett, London [BJ422]

Like all travelers of his generation, Turner suffered coach upsets and breakdowns, foul weather, and bad food and worse hotels, and it may be that an awareness of his age and state of health meant that he did not discourage the company and assistance of others when offered. But his energy is still remarkable for a man of his age, who could take in his stride all the inconveniences that weather and circumstances could throw at him. Writing to Hawkesworth Fawkes, the son of Walter Fawkes, Turner recalled in December 1844 his recent journey in Germany and Switzerland:

> *I went . . . to Lucerne and Switzerland, little thinking or supposing such a cauldron of squabbling, political or religious, I was walking over. The rains came on early so I could not cross the Alps, twice I tried, was set back with a wet jacket and worn-out boots and after getting them*

heel-tapped I marched up some of the small valleys of the Rhine and found them more interesting than I expected.[28]

Although Turner got about Europe fairly efficiently, made friends en route, tried to learn the local language, and put up with hardships, we must not assume that in his case practice as a traveler made perfect. He found himself without the proper clothes, which he had to procure in a hurry on at least two occasions: in Naples in 1819, when invited to dine with the British ambassador, and in northern France in 1845, when King Louis-Philippe summoned him to his château at Eu. His long-standing friend Clara Wells (Mrs. Wheeler) despaired of his abilities as an organized traveler, advising a mutual friend not to ask Turner to carry some books home to England: "I should be quite sorry to trust him, for he would be quite sure to lose your books, as he invariably does, more than half his baggage in every tour he makes, being the most careless personnage [*sic*] of my acquaintance."[29]

Turner took supplies of sketchbooks, pencils, pigments, and brushes with him, buying more as required en route, and, as they came available on the market, cakes of watercolor in traveling packs. His equipment as an artist on the move was lightweight, uncomplicated, replaceable, and easy to wash up. Turner lived in the era in which the availability and variety of public transport had been transformed from the eighteenth-century limitations of the horse, stagecoach, and sailing boat to include the steamboat, the steam train, and the ever-extending network of tarmacadam roads in Britain and Europe. Napoleon, the King of Roadmakers, as Turner called him,[30] had been the driving force behind the building of the new roads linking cities in France and Italy. The young Michael Faraday, on his first visit to France in 1813, had noticed the extent to which the quality of Napoleon's roads would speed their traffic: "They are paved in the middle of Paris to an extent of 20, 30, 40 miles outwards continuously and are in general preserved in excellent repair. . . . A road will go in a straight line for four or five miles and then on turning an angle another length equal to the former presents itself.[31]

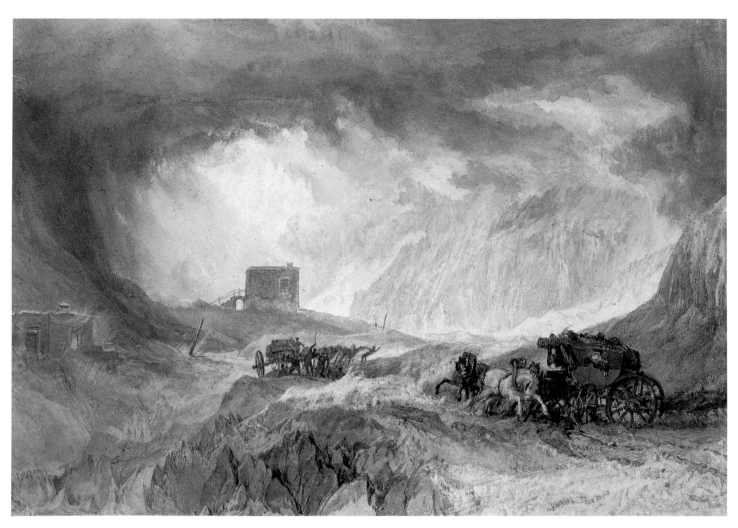

FIGURE 40 J. M. W. Turner, *Snowstorm,*
Mont Cenis, 1820. Watercolor on paper,
11 x 15³/4 in. (29.2 x 40 cm). Birmingham
Museums and Art Gallery [w402]

But such road quality could not be maintained far from Paris,
and a decade after Napoleon's defeat French roads had deteriorated
markedly, as Maria Callcott, the wife of the painter Augustus Wall
Callcott, revealed: "We do not find travelling in France half so well
as travelling in Italy—The Inns here less comfortable the roads bit-
ten to dreadfully rough being all made & [. . .] with such shingle as
lies on the sea beach & quite as ill bound together."[32]

The new road over the Mont Cenis Pass in the Alps allowed Turner
to make crossings by carriage when returning from Italy in January
1820 and, as if he was asking for trouble, again in January 1829. This
was the worst possible time of the year to make such a journey. Dur-

FIGURE 41 J. M. W. Turner, *Messieurs les Voyageurs on Their Return from Italy (par la diligence) in a Snow Drift upon Mount Tarrar, 22nd January 1829*, 1829. Watercolor with bodycolor on paper, 21 1/2 x 29 3/8 in. (54.5 x 74.7 cm). British Museum, London [W405]

ing both crossings he found the danger he seemed so expertly to have courted, and as a result of coach crashes on both crossings—one is tempted to suggest that he had hoped for some kind of calamity— he found dramatic subject matter for watercolors with titles that tell their own exciting travelers' tales: *Snowstorm, Mont Cenis* (fig. 40), which is inscribed "PASSAGE of Mt Cenis Jan 15 1820," and the watercolor exhibited at the Royal Academy in 1829 with the title (showing Turner having fun with French) *Messieurs les Voyageurs on Their Return from Italy (par la diligence) in a Snow Drift upon Mount Tarrar, 22nd January 1829* (fig. 41). The later watercolor study *Eu by*

Interlude: Turner the Elderly Traveler

FIGURE 42 J. M. W. Turner, *Eu by Moon-light*, 1845. Watercolor on paper, 9 x 13 3/8 in. (22.8 x 33.3 cm). Tate Britain, London [TB CCCLIX 1]

Moonlight (fig. 42) suggests that not all of Turner's coach journeys were calamitous, depicting as it does journey's end approaching as the coach rolls into Eu, Normandy.

In Britain, roads had improved and spread so that by 1840, all towns and cities were linked by a network of wide, weatherproof roads. The railway was also extending across Britain in the 1840s, and as it grew there is evidence that Turner itched to travel behind a steam loco-motive as soon as he could. Writing to George Cobb in Brighton in October 1840, he mused on traveling by train: "having locomotive Engines in Progress towards you, we may meet again ere long—by rail-road, either at Brighton or London."[33] Turner's *Rain, Steam, and Speed* (exh. 1844; National Gallery, London; BJ409), the classic image

of the explosion of the railway into rural Britain, was painted, so the anecdote goes, after Turner had stuck his head out of a railway carriage traveling at speed in a rainstorm.[34]

The inescapable common factor in Turner's oil paintings and watercolors of "traveling" subjects is that they all demonstrate his extraordinary need for physical involvement: the head out of the railway carriage in *Rain, Steam, and Speed*; the legend, that he put about himself, that he had been tied to the mast of the ship in *Snowstorm— Steamboat off a Harbor's Mouth* (see fig. 89); the thrill as he expressed it both in words and in paint of being upset in a carriage in some of the most hostile conditions then available to the traveler—on top of the Alps in winter. Painting the coach in the snowstorm in 1820 and the crash in Mont Cenis Pass in 1829 was not enough; he also had to write about them. Among the pencil sketches he made in January 1820 while waiting for the coach to be righted are some notes describing what he saw: "Men shovelling away Snow from the Carriage. Women and children hugging. The sky pink—the light and the cast shadows rather warm. Trees all covered with the snow. The Trees in the distance and wood getting darker."[35]

Memories of the excitements in 1820 stayed with him for six years, when he described them, perhaps with embellishments, to James Holworthy:

> *We were capsized on the top. Very lucky it was so; and the carriage doors so completely frozen that we were obliged to get out at the window . . . we had to march or rather flounder up to our knees nothing less in snow all the way down to Lanceslyburgh [Lanslebourg] by the "King of Road-makers" Road, not the Colossus of Roads, Mr. McAdam, but Bonaparte, filled up with snow and only known by the precipitous zig-zag.*[36]

When this passage is set next to the following, written in 1829, we can see what a sucker for punishment, at fifty-four years old, Turner still was:

> *at Sarre-valli the diligence zizd into a ditch and required 6 oxen, sent three miles back for, to drag it out; this cost 4 Hours, that we were 10*

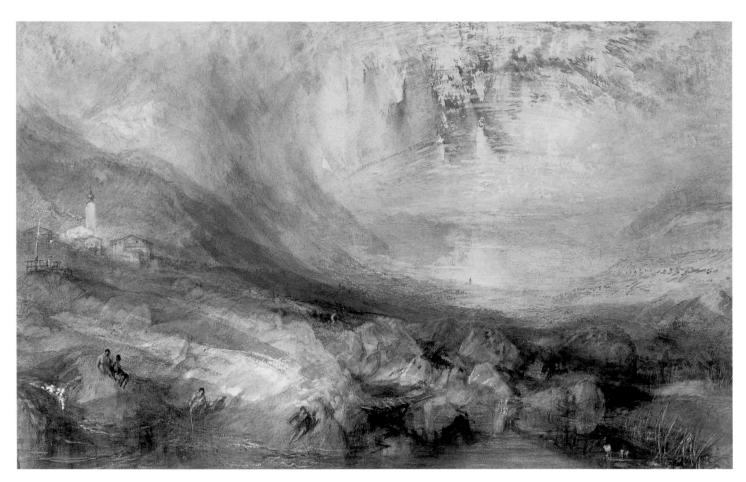

FIGURE 43 J. M. W. Turner, *Goldau*, 1843.
Watercolor on paper, 12 x 18 ½ in.
(30.5 x 47 cm). Private collection [W1537]

Hours beyond our time at Macerata, consequently half starved and frozen we at last got to Bologna, where I wrote to you . . . crossed Mont Cenis on a sledge—bivouaced in the snow with fires lighted for 3 Hours on Mont Tarate while the diligence was righted and dug out, for a Bank of Snow saved it from upsetting—and in the same night we were again turned out to walk up to our knees in new fallen drift to get assistance to dig a channel thro' it for the coach, so that from Foligno to within 20 miles of Paris I never saw the road but snow! [37]

The watercolor *Goldau* (fig. 43) represents the aftermath of an event in which it may be said that rock ran through a devastated landscape like water: the Swiss village of Goldau was buried by an avalanche of rock in 1806 when the Rossberg mountain collapsed, killing more than 450 people. Turner sets his view in the present, after a new Goldau (visible left) had been built, and presents a blood-red sunset, as fear-

FIGURE 44 J. M. W. Turner, *Falls of the Rhine, Schaffhausen*, 1841? Watercolor, pen, and red ink over gray wash on paper, 8 7/8 x 11 1/4 in. (22.6 x 28.6 cm). Indianapolis Museum of Art. Bequest of Kurt F. Pantzer, Sr. [W1461]

some as the sunset in *Slavers* (see fig. 28), which refers metaphorically to the terrible events of the avalanche. While the exclamatory shapes in the sky echo the forms of the rocks in the central foreground, there are further vaporous atmospherics in the water moving over rock to the left and the turbulent sky above it. So fluid, indeed, is the left-hand side of the work that even the nature of the element depicted is unclear—Is it rock? Is it water? Reality in *Goldau* has been thoroughly disturbed, just as real life in Goldau village had been so radically disturbed by the avalanche.

In *Falls of the Rhine, Schaffhausen* (fig. 44) and *The First Steamer on*

FIGURE 45 J. M. W. Turner, *The First Steamer on Lake Lucerne*, 1841? Watercolor with scraping out on paper, 9 1/8 x 11 3/8 in. (23.1 x 28.9 cm). University College, London [W1482]

FIGURE 46 J. M. W. Turner, *Swiss Pass*, 1843? Watercolor and pencil with some scratching out on paper, 9 1/4 x 11 1/2 in. (23.2 x 29.1 cm). Manchester Art Gallery [W1513]

Lake Lucerne (fig. 45), Turner paints foreground water that has none of the unspecified turbulence of *Goldau* but is stuff that does nevertheless live and move. But for the cliffs, we could be on the seashore at Margate, and in figure 44 the form of the falling water at Schaffhausen echoes and elides itself with the form of the mountain over which it passes. In other German and Swiss watercolors of the 1840s, of which *Swiss Pass* (fig. 46), *Alpine Landscape* (fig. 47), and *Brunnen, from the Lake of Lucerne* (fig. 48) are prime examples, Turner's conception of water, mountain, and air has a unity that parallels the unity of water and air that the artist expresses in his late sea paintings. A similar equivoca-

Interlude: Turner the Elderly Traveler

FIGURE 47 J. M. W. Turner, *Alpine Landscape*, 1843? Watercolor over pencil on paper, 9 x 11 3/8 in. (23 x 28.9 cm). Manchester Art Gallery [W1496]

FIGURE 48 J. M. W. Turner, *Brunnen, from the Lake of Lucerne*, 1845. Watercolor and bodycolor on paper, 11 3/8 x 18 7/8 in. (29 x 47.7 cm). Sterling and Francine Clark Art Institute, Williamstown, Massachusetts [W1545]

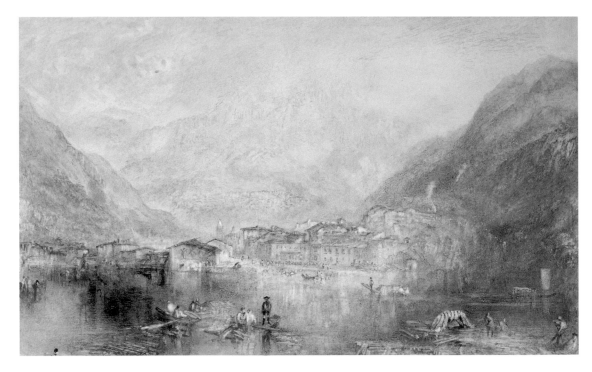

FIGURE 49 J. M. W. Turner, *Bellinzona, from the Road to Locarno*, 1843. Watercolor with scraping out on paper, 11 1/2 x 18 1/2 in. (29.2 x 45.7 cm). Aberdeen Art Gallery and Museums [W1539]

FIGURE 50 J. M. W. Turner, *Town and Lake of Thun*, 1841? Watercolor on paper, 9 x 11 3/8 in. (22.7 x 28.7 cm). Trustees, Cecil Higgins Art Gallery, Bedford, England [W1505]

FIGURE 51 J. M. W. Turner, *Valley of Aosta: Snowstorm, Avalanche, and Thunderstorm*, 1836–37. Oil on canvas, 36¹/₄ x 48 in. (92.2 x 123 cm). The Art Institute of Chicago. Frederick T. Haskell Collection [BJ371]

tion is apparent in *Bellinzona, from the Road to Locarno* (fig. 49), where the River Brenno, seething in the middle ground, reflects the unearthly light in the sky above the town of Bellinzona. The whole is uncertain and shifting, inhabiting an atmosphere that might turn from air to water, as rain clouds do, at any moment. Yet another atmospheric equivocation in Turner's Swiss watercolors is present in *Town and Lake of Thun* (fig. 50), where the distant mountain takes on the shape and substance not of rock but of a climbing wave.

Perhaps the apotheosis of the balancing act that Turner performs in his later paintings of water and mountains, to the extent that the subject and whatever kind of reality it may have are uncertain, is the oil *Valley of Aosta: Snowstorm, Avalanche, and Thunderstorm* (fig. 51). As the title reveals, this is a catalogue of cataclysms, wave upon wave of snow, or water (or is it rock?), pouring down into the river valley with a power so great that the distant village and the fleeing people must be doomed. This is a storm like none other in Turner, in which he uses the only metaphor that can adequately convey for him the ultimate force of furious nature on land, the power of the raging sea.

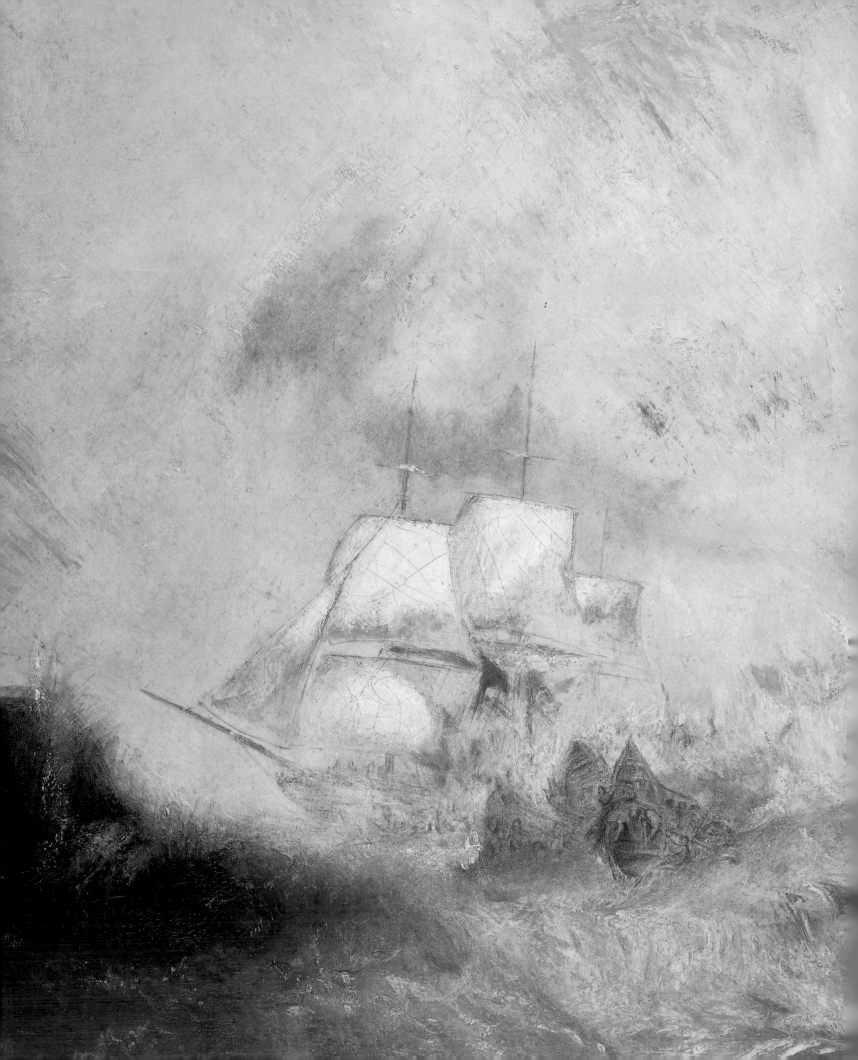

THE DEEP

In spite of his familiarity with the sea and ships around Britain and northern Europe, Turner had no personal experience of deep ocean voyages, nor of being away from the sight and comfort of land for more than a day. And although he had "long entertained the idea of going to see it [American scenery] for himself," in the event he had to travel the Atlantic vicariously.[1]

We know of meetings and friendships with a handful of Americans, each of whom in different ways whetted Turner's appetite both for American scenery and for the unavoidable transatlantic crossing. Meeting an unknown American artist while sketching at Caen, Normandy, in the late 1820s, Turner admitted a curiosity about American landscape, particularly the "autumn tints of our foliage. He thought it was vain to attempt to paint it, for our colours now could not reach the brilliancy of ordinary nature . . . [he] admitted that he had seen one or two very beautiful pictures from America, of this kind of scenery."[2] His two fantasy views of Wyoming, Pennsylvania (National Galleries of Scotland, Edinburgh), vignettes painted to illustrate a poem by Thomas Campbell in 1837, are his responses to what little he knew of the wide-open landscapes of the United States (fig. 52). A close friend who had spent his early years in America was the painter C. R. Leslie (1794–1859), a colleague at the Royal Academy

and a regular fellow guest with Turner at Petworth, among many
other places and social gatherings. Turner's friendship, late in life, with
the English photographer John Mayall, who had himself spent some
years in the early 1840s on the American East Coast, has already
been discussed.

A significant, highly romantic figure in Turner's late life was the
American sea captain Elisha Ely Morgan (1805–1864; fig. 53), who
crossed the Atlantic countless times (his first taste of the sea was as a
cabin boy on a New York–London packet ship) until his retirement

as owner of the Black X Line in the 1850s. Throughout the 1830s and 1840s Morgan was the master of a series of vessels, principal among which were the *Philadelphia*, the *Hendrick Hudson*, and the *Victoria*, which was built to Morgan's own designs in Connecticut. *Victoria* made her maiden voyage to London in July 1843, where her arrival and reception were warmly reported in the *Illustrated London News*.[3] Morgan was a good friend of Charles Dickens, who called him "one of the most honest and skilful mariners in the World," and had been Dickens's captain on the *Philadelphia* when the writer crossed the Atlantic.[4] Morgan made such an impression on Dickens that he found his way into Dickens's fiction; he was the inspiration for Captain Jorgan in "A Message from the Sea" (1860), from *Christmas Stories*:

> *He was American born, was Captain Jorgan,—a New Englander,—but he was a citizen of the world, and a combination of most of the best qualities of most of the best countries. For Captain Jorgan to sit anywhere in his long-skirted blue coat and blue trousers without holding converse with everybody within speaking distance was a sheer impossibility.*[5]

While Morgan was in London, his interest in art and letters, and his loquacity, brought him into easy contact with members of the London Sketching Society, of which he became an honorary member.[6] Among the many friends he made in London were Clarkson Stanfield, Edwin Landseer, W. M. Thackeray, C. R. Leslie, and Turner. Leslie's son Robert gave Ruskin a vivid picture of the nature of Captain Morgan's friendship with Turner, and of their interest in each other. Remembering a visit that the Leslies, father and son, had made to Turner's studio in the company of a "Yankee sea captain" (Morgan), Robert Leslie recalled that Turner was very polite to Morgan,

> *evidently looking up to the sailor capacity, and making many little apologies for the want of ropes and other details about certain vessels in a picture. No one knew or felt, I think, better than Turner the want of these mechanical details, and while the sea captain was there he paid no attention to anyone else, but followed him about the gallery, bent*

FIGURE 53 Captain Elisha Ely Morgan

upon hearing all he said. As it turned out, this captain and he became good friends, for the Yankee skipper's eyes were sharp enough to see, through all the fog and mystery of Turner, how much real sea feeling there was in him and his work. Captain Morgan, who was a great friend of Dickens, my father, and many other artists, used to send Turner a box of cigars almost every voyage after that visit to Queen Anne Street.[7]

In Morgan, Turner had met his match as a witness of the actions of the seas, and had found a man whose experience he could test reliably against his own. Generous though Morgan was to his many friends in the English art and literary world, his regular inclusion of Turner in the group of men to whom he sent boxes of cigars indicates a particular depth of friendship and mutual understanding. A reasonable date for the beginning of the meetings between Turner and Morgan is the mid-1830s, when Robert Leslie was about ten years old, and when Turner's own engagement with the sea was reaching its final expression. Although in the absence of further evidence we can only surmise, it is worth considering Morgan as one of the sources of information, encouragement, and insight that Turner could draw on while contemplating his later stormy seascapes and, in particular, the series of whaling subjects that are his only expression of human activity on the deep ocean. The extent of the change in Turner's art that took place in the 1840s can be measured by a comparison between the Dutch-inspired sea paintings of the early 1830s (see figs. 18–20) and *Van Tromp, Going about to Please His Masters, Ships a Sea, Getting a Good Wetting* (fig. 54) of 1844. Not only are sea and sky in *Van Tromp, Going about* alive with a tremendous show of natural power comparable to the sea in *Snowstorm—Steamboat off a Harbor's Mouth* (see fig. 89), but the majesty of their effect has the consequence of showing up the behavior of Tromp and his sailors to be something of a pantomime.

The appearance of two whaling subjects from Turner's brush at the 1845 Royal Academy exhibition was one more apparent change in direction for the artist. The works had, however, their own recent precursor in the intense little vignette *The Whale on Shore (The Great*

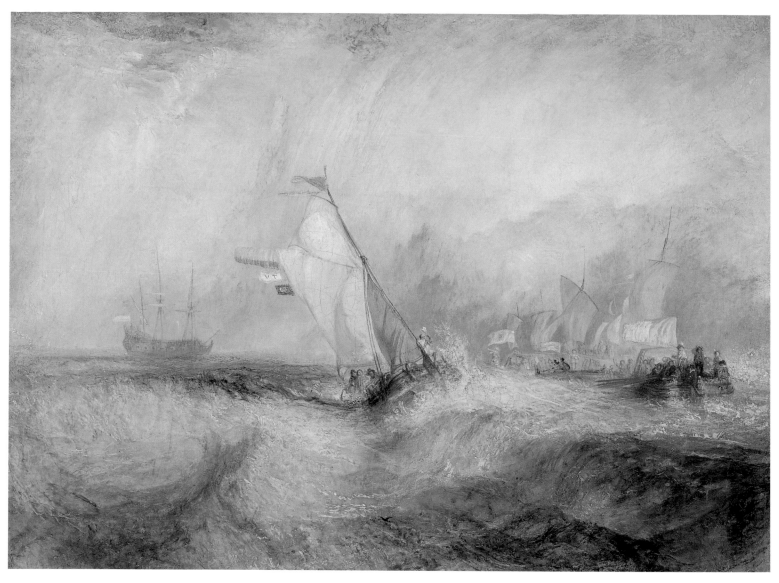

FIGURE 54 J. M. W. Turner, *Van Tromp, Going about to Please His Masters, Ships a Sea, Getting a Good Wetting*, exh. 1844. Oil on canvas, 36 x 48 in. (91.4 x 121.9 cm). The J. Paul Getty Museum, Los Angeles [BJ410]

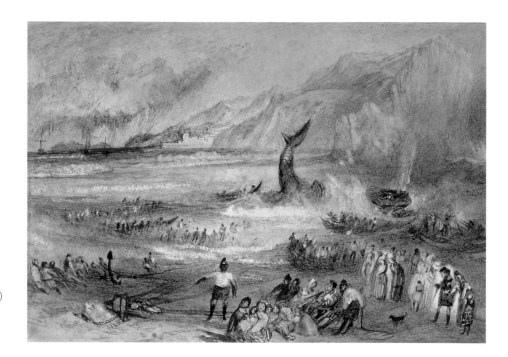

Whale) of c. 1835–37 (fig. 55), a work that, within its tiny compass, manages to squeeze in a distant rainstorm, a moderate sea, a receding mountain range, half a dozen small boats, an anchor and a winch, and up to a hundred figures who are involved in the exciting operation of capturing, subduing, and killing an enormous whale which thrashes and blows in shallow water. The watercolor is an illustration to a passage in Sir Walter Scott's novel *The Pirate*, having been commissioned (but not used) to be engraved for an anthology of Scott's writings.[8] Despite its modern literary source and the intense Turnerian detail it carries, it retains an archaic nature that relates it more to postmedieval bestiary woodcut illustrations than to the work of the man who painted *Port Ruysdael* or *Wreckers*.

To the press and public Turner was by the mid-1840s at best unpredictable, at worst unintelligible. Writing of the two paintings, both titled in the 1845 exhibition *Whalers* (figs. 56 and 57), *The Times* was thoughtful about Turner's "free, vigorous, fearless embodiment of a moment. To do justice to Turner, it should always be remembered that he is the painter, not of reflections, but of immediate sensations."[9] *Punch* rolled out one of the culinary metaphors that clung so tenaciously to reports of Turner's later paintings, suggesting that *Whalers* "embodies

FIGURE 56 J. M. W. Turner, *Whalers
(The Whale Ship)*, exh. 1845. Oil on canvas,
36 1/8 x 48 1/4 in. (91.8 x 122.6 cm). The
Metropolitan Museum of Art, New York.
Catharine Lorillard Wolfe Collection,
Wolfe Fund, 1896 [BJ415]

FIGURE 57 J. M. W. Turner, *Whalers*, exh. 1845. Oil on canvas, 35⅞ x 48 in. (91.1 x 121.9 cm). Tate Britain, London [BJ414]

one of those singular effects which are only met with in lobster salads and this artist's pictures."[10] To the outside world, Turner's whaling pictures came from nowhere, being entirely disassociated with any familiar Turnerian subject. The perceived whiteness of the paintings was unsettling, particularly because Turner's audience had only just begun to get used to the artist's overextended passages of strong red and yellow, as in *Slavers*. The *Times* critic further recognized that Turner "has found a new field for his peculiar style in the whale fishery. . . . The greater portion of the picture is one mass of white spray, which so blends with the white clouds of the sky, that the spectator can hardly separate them, while the whiteness is still continued by the sails of

the ship, which are placed in defiance of contrast."[11] "Splintered rain-bows thrown against the canvas" was the conclusion of the *Literary Gazette*, "a better comparison than the deteriorating one of lobster-sauce, which some crusty critic has applied as an accompaniment to the Leviathan. There are atmospheric effects of magical talent."[12]

Turner's engagement with whaling subjects had roots running deeper than the 1837 vignette. One reached back to 1808–9, when he wrote his extended verse about the sixteenth-century Arctic explorer Sir Hugh Willoughby and the pursuit "in icy seas" of the Greenland whale. The story of Willoughby's ill-fated search for a northern route to the East had been told by Richard Hakluyt in the first volume of his *English Voyages*, first published at the end of the sixteenth century.[13] This was almost certainly the source for Turner of the story that he wove into a poem in his "Greenwich" sketchbook:

O Gold thou parent of Ambitions ardent blush
Thou urge the brave to utmost danger rush
The rugged terrors of the northern Main
Where frost with untold rage does widely reign . . .
Slumbers for ages till Britain daring grown
Sent valour tried, in search of climes unknown
Thy keel O Willoughby with solitary sound
First broke the limits of the vast profound . . .
For thee he braves the rugged northern skies
Explores the Greenland icey bay
To ope to golden shore another shorter way.
With stiffening sails the congelating tied
But Willoughby in frozen regions died. . . .
And in southern enfeebling climes afar
Should carry conquests bleeding spear
To every shore to strain the adventurous sail
And pursue in icy seas the Greenland whale
But you insidiously have given them pride
To dare these realms by mortals yet untry'd.[14]

Another root was opportunism, divining perhaps the possibility of a commission or exhibition purchase of a whaling picture by Elhanan Bicknell (1788–1861), an enthusiastic collector of British painting who had made his fortune through the whaling industry. Bicknell had bought his first paintings by Turner, two uncharacteristic watercolors of Himalayan subjects, in 1838, and in 1841 and 1842 commissioned two oil paintings of Venetian scenes.[15] In all, Bicknell came to own ten oils by Turner, including *Port Ruysdael* and *Wreckers* (see figs. 5 and 21). Although Bicknell and Turner never became close friends, they did visit each other frequently in the 1840s, Turner being a guest at Bicknell's house in Herne Hill, and Bicknell returning calls to Turner's studio.

Under the circumstances of Bicknell's business interest in whaling, and his taste for Turner, which stretched across the range of the artist's work, from an early topographical study of *Winchester Cross* to the late watercolor *The Blue Rigi* (1842)[16]—it was entirely reasonable that Turner might expect Bicknell to be engaged by a whaling subject. In a transparently worded letter of advertisement sent early in 1845, Turner the entrepreneurial artist encouraged Bicknell the entrepreneurial whale-oil merchant to call at Queen Anne Street "at your earliest convenience for I have a whale or two on the canvas."[17] Bicknell did briefly take *Whalers* home with him to Herne Hill after the Royal Academy exhibition, but he and Turner very soon fell out when Bicknell returned the painting to the artist—he had tried to rub some of Turner's watercolor finishing touches away with his handkerchief, and then expected Turner to rectify the matter.[18] What Turner probably did not realize, and Bicknell did, was that by the mid-1840s the British whaling industry was in terminal decline, and paintings of the subject may not have been readily saleable to whaling men facing loss of income.

A third root lay in Turner's reading, in particular of Thomas Beale's *A Few Observations on the Natural History of the Sperm Whale, with an account of the rise and progress of the fishery, and the modes of pursuing, killing and "cutting in" that animal, with a list of its favourite places of resort.*

The author was a ship's surgeon who had spent two or more years on whalers and had in 1835 published an account of his adventures. Four years later he revised and expanded the book, adding a section titled *A Sketch of a South-Sea Whaling Voyage; embracing a description of the extent, as well as the adventures and accidents that occurred during the voyage in which the author was personally engaged* (1839).

The particular event in Beale's narrative on which Turner based *Whalers* (fig. 56) is a daylong chase off Japan in 1832 between a whale ship's three boats and a huge sperm whale that successfully evaded its pursuers until late afternoon. The whaler captain harpooned the beast at 4:30 P.M., and it dived. It returned, bleeding from its blowhole, to ram one of the boats:

> The whale, after a last lance, immediately descended below the surface, and the captain felt certain that he was going to "sound," but in this he was much mistaken—for a few minutes after his descent he again rose to the surface with great velocity, and striking the boat with the front part of his head threw it high into the air with the men and every-thing contained therein, fracturing it to atoms and scattering its crew widely about.[19]

After diving again and being harpooned once more, the whale died and sank out of reach of the hunters.

Turner may have talked to Captain Morgan about the sighting and hunting of whales, and similarly Bicknell may have told him what he knew. However, Turner's acquaintance Captain George Manby did have whaling experience, as Barry Venning has pointed out, having traveled to Greenland in 1821 with Captain William Scoresby to test a new harpoon gun. Manby's account of that voyage was published in 1822.[20]

From the evidence of the sketchbooks, Turner did see small whales in the English Channel, and there are watercolor studies in the Turner Bequest (for example, fig. 58) and elsewhere that have whalelike shapes within them.[21] These are either sea studies made as a whale surfaced in Turner's sight, or studies for the whaling paintings drawn from

FIGURE 58 J. M. W. Turner, *Storm Clouds,
Looking out to Sea*, 1845. Watercolor on
paper, 9³/₈ x 13³/₄ in. (23.8 x 33.6 cm).
Tate Britain, London [TB CCCLVII 12]

the artist's tutored imagination. Further, as Jack Lindsay has suggested, Turner had the opportunity to see a fourteen-and-a-half-foot-long whale that was stranded and killed on the beach at Deptford in October 1842, a few hundred yards downriver from Turner's east London haunt at Wapping.[22]

A fourth root that made whaling such an attractive subject for Turner was his lifelong interest in industry, and in the dramatic and purposeful visual and narrative potential that industrial subjects invariably carried. *Keelmen Heaving in Coals by Moonlight* (1835; see fig. 23) is an example illustrated here, and other important instances across Turner's career include the Rembrandtesque *Limekiln at Coalbrookdale* (c. 1797; Yale Center for British Art, New Haven; BJ22) and the water-

Chapter Four

color *Dudley, Worcestershire* (c. 1832; Lady Lever Art Gallery, National Museums and Galleries on Merseyside, Port Sunlight, U.K.; w858). Industrial activity appears symptomatically within Turner's landscapes as a greater or lesser part of their pictorial-historical narrative, to the extent that people doing some kind of work is a leitmotif in a Turner painting. Perhaps the most immediately dramatic and, here, highly relevant rendering of an industrial subject in late Turner is *Hero of a Hundred Fights* (c. 1806–7, reworked and exh. 1847; Tate Britain, London; BJ427), in which the startlingly dramatic central splash of red and yellow heat just fails to consume the shimmering form of the cast bronze equestrian statue of the Duke of Wellington, the "Hero" of the title.[23] This picture was reworked from a canvas of forty years earlier and exhibited the year after Turner showed his final pair of whaling oils. In *"Hurrah! for the Whaler Erebus! Another Fish!"* (fig. 59) the central narrative and pictorial focus is the decapitated head of a sperm whale hanging in the ship's shrouds, mistily visible in the freezing air. In both paintings, the object of the industrial activity is distanced from the viewer by both depth of image and orchestrated atmospheric effect.

As Robert Wallace has shown, the "Erebus" of the title is HMS *Erebus*, which, with HMS *Terror* sailed to the Southern Ocean on a voyage of exploration from 1839 to 1843.[24] Under the command of Captain James Clark Ross (1800–1862), the central achievement of the voyage was the discovery of the Ross Sea, the Ross Ice Shelf, and Victoria Land. The volcano Mount Erebus, on Victoria Land, was named after Ross's ship. A further commission to Ross, on instructions from the Royal Society, was that specimens of marine invertebra, fishes, reptiles, birds, and mammalia be collected. Scientific findings resulting from collections made on the voyage were published in succeeding parts as *The Zoology of the Voyage of H.M.S. Erebus and Terror* (1844–75), edited by John Richardson and J. E. Gray. Turner owned part 5, Richardson's account of the Antarctic *Fishes* (1845), while part 6, Gray's *On the Cetaceous Animals*, a full account of the whales, porpoises, and dolphins found in southern waters, was published late the following

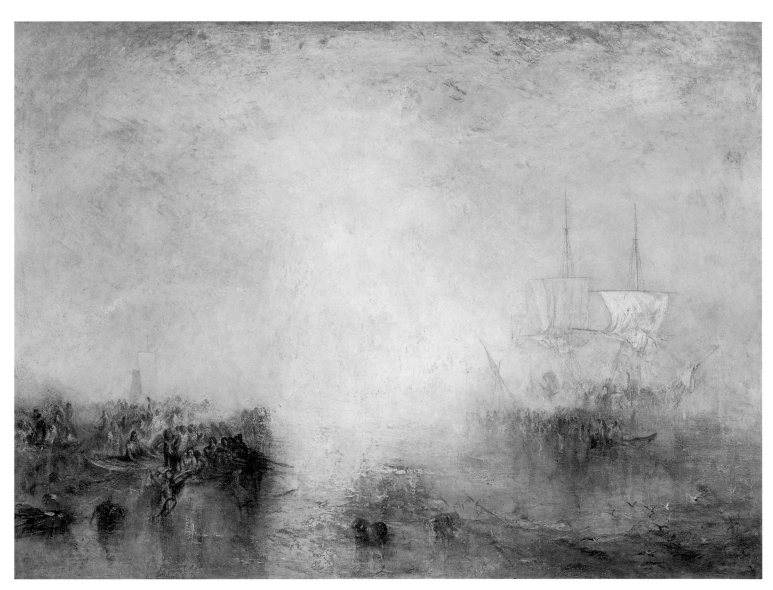

FIGURE 59 J. M. W. Turner, *"Hurrah! for
the Whaler Erebus! Another Fish!"* exh. 1846.
Oil on canvas, 35 1/2 x 47 1/2 in. (90 x 121 cm).
Tate Britain, London [BJ423]

A SPERMACETI WHALE, IN THE AGONIES OF DEATH.

year.[25] Buried in the title of Turner's picture is a long-evaporated joke, which makes gentle fun of the fact that a whale is not a fish; although the use of "fish" for "whale" is a characteristic seafaring term, effectively a colloquialism at the time.[26] The joke is clearly and elaborately analyzed by Wallace, who unwraps meanings and allusions that regrettably are far too long and involved to rehearse here but can be enjoyed in the article cited.

A particular iconographical source for *Whalers (The Whale Ship)* (see fig. 56) is the lithograph *A Spermaceti Whale, in the Agonies of Death* (fig. 60). The immediate formal relationship between the print and Turner's *Whalers* is unmistakable, and it is likely that it was this lithograph that was in Turner's mind when he was composing *Whalers*.[27] A proof of the lithograph, inscribed "Presented to me by C. Stokes, Jan 1835," is held with the Buckland Papers in the University Museum, Oxford.[28] "C. Stokes" is Charles Stokes (1785–1853), a stockbroker, amateur geologist, and print collector who knew Turner very well and, from the 1820s, helped him look after his money and investments. As Stokes owned the *Spermaceti Whale* print, was a compulsive collector of Turner's prints, and was the first cataloguer of the "Liber Studiorum," it is reasonable to venture that

Stokes may also have brought that particular lithograph whale to Turner's attention.[29]

Stokes was a fellow of the Society of Antiquaries and of the Royal Society, and a fellow, secretary, and later vice-president of the Geological Society. In the artistico-scientific milieu in early nineteenth-century London, he was also an intimate friend of the distinguished geologist Dean William Buckland (1784–1856), who, in his turn, knew Turner well enough to send him ideas for subjects. The nature of one particular suggestion survives in a letter from Turner to Buckland, in which the artist thanked Buckland for his "kindness and intention of finding me a subject."[30] The subject that Buckland thought might inspire Turner was the wreck of HMS *Thetis*; the ship was lost in 1830 carrying treasure in a storm off Cape Frio, Brazil. But it would not do for Turner—the ship was at the bottom of the sea, the gold was out of sight, and in Turner's view the paraphernalia of derricks and rigging set up on the cliff by salvagers, as illustrated in two lithographs in the book that Buckland had sent to Turner, was too complicated to make a satisfactory painting.[31]

What this episode does tell us, however, is that Turner was open to suggestions for subjects from his friends, and, as his decisions to paint the events on the slave ship *Zong* and Thomas Beale's south sea whaling observations make clear, he depended heavily on contemporary and above all newsworthy published sources to make his final choice of subject. We shall probably never know whether he came across Buxton's *African Slave Trade* or Beale's *Observations* himself, or whether they were recommended to him by friends; but the point is that even in his seventies his mind was wide open to new subjects, new ideas, new directions even while he was returning again and again to old subjects, old ideas, old directions in an effort to find both new angles and new security in familiar tales, characters, and faces.

The title *"Hurrah! for the Whaler Erebus! Another Fish!"* is bizarre even by Turner's standards. The jolly, companionable tone of the title reflects the celebratory nature of the subject, the boatloads of whaling men cheering as their whale's head is hoisted aloft. Although there

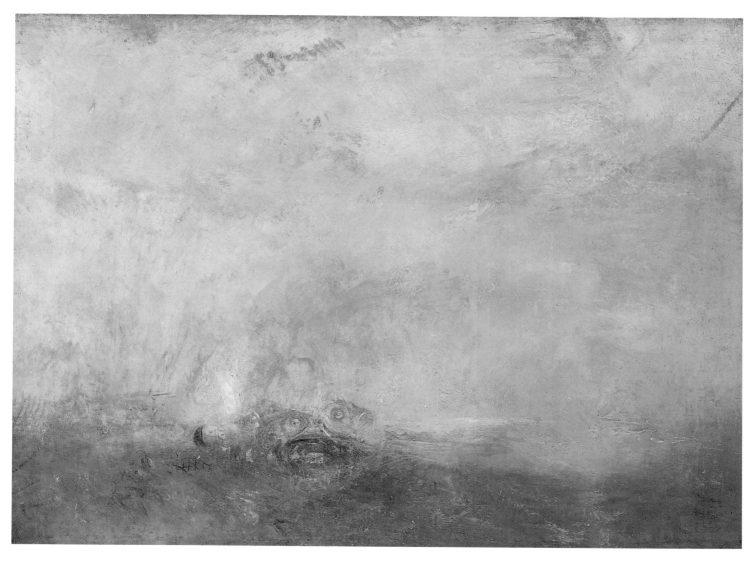

FIGURE 61 J. M. W. Turner, *Sunrise with Sea Monsters*, c. 1845. Oil on canvas, 36 x 48 in. (91.5 x 122 cm). Tate Britain, London [BJ473]

are very few similar "speech bubble" titles in Turner's exhibited oils, many of his set marine pieces do have crowds of people talking or cheering—*The Decline of the Carthaginian Empire* (exh. 1817; Tate Britain, London; BJ135) has people gathered at the sea's edge talking together, and other examples out of many include *The Battle of Trafalgar* (1822–24; National Maritime Museum, London; BJ252), *East Cowes Castle, the Seat of J. Nash Esq.; the Regatta Starting for Their Moorings* (see fig. 9), and *Ulysses Deriding Polyphemus* (exh. 1829; National Gallery, London; BJ330), in all of which the voices are practically audible. This certainly indicates something of the extent to which Turner saw the sea as a place for social gathering and human

The Deep

FIGURE 62 J. M. W. Turner, *Sketch of Three Mackerel*, c. 1835–40. Watercolor on paper, 8 ³/₄ x 11 ³/₈ in. (22.4 x 28.7 cm). Ashmolean Museum, Oxford [W1399]

cooperation, a further extension of the idea of the sea as a stage for human drama. Determined verbal expression is a recurrent theme of Turner's marine paintings. The way he arranges his speaking (or cheering) figures is akin to the way a chorus might stand on an operatic stage or in an oratorio: flanking the main action, preparing to move to center. The nature of the stagey discourse in Turner is, further, collective: it is not one or two people talking together, but crowds.

At about the same time as Turner was painting and exhibiting his four Whaler subjects, he made the work that we now know as *Sunrise with Sea Monsters* (fig. 61). That title is an invention of the early twentieth century, when the painting was first listed in the Turner Bequest, and is not one of the artist's own. In its size, paint handling, narrow color range, and, to an extent, its subject matter, it is related more to the Whaler series than to any other group of the artist's work, and may indeed be a "Whaler" that went wrong, or at least remained unfinished. Certainly, like the Whalers, it has a low horizon and twin centers of interest for the eye, the fishy creatures on the left and the aura around the low-lying sun on the right. The sea

monsters of the title are not really monsters at all, but an amalgam of two or three fairly unremarkable fish, which began perhaps as pieces of natural observation, much as were Turner's studies of mackerel (fig. 62) or gurnards (figs. 63 and 64). In the event, however, the single eyes of the two fish become the two eyes above the gaping mouth of the monster, all bathed in the light of the putative sunrise. The watercolor and chalk study *Sea Monsters and Vessels at Sunset* (fig. 65) from the "Whalers" sketchbook is a comparable work which shows fish that are neither sea monsters nor whales but living, flapping fish. The traditional identification of the structure on the left of the picture is also dubious, as it reads rather more like a pier with fishermen on it, being too low in the water and flat-topped to be convincing as a seagoing ship.

One aspect of *Sunrise with Sea Monsters* that may indicate a fragile connection not with the distant Southern Ocean but with Margate is the series of crosses in the bottom left quarter. To the left of Mrs. Booth's house in Margate stood Jarvis's Landing Place from 1824 until it blew down in 1978. In Turner's day this was a fifty-yard-long wooden structure reaching out into deep water where steamboats could berth. It appears in some late watercolors as a diagonal feature, more or less described. To give *Sunrise with Sea Monsters* a geographical location is to be too rigorous about so poetic and intangible a picture, but in taking the canvas as far as he did, Turner is returning to some of the visions of monsters that entered his painting and poetry as a young man and may also have entered his thoughts and dreams then and later. Reaching back to 1802, Turner exhibited his *Jason* (Tate Britain, London; BJ19), in which a writhing serpent is a central character, and nine years later he showed *Apollo and Python* (exh. 1811; Tate Britain, London; BJ115) with a similarly monstrous dragon. With its suggestions of Alpine landscape, *Apollo and Python* is a more knowing response to imagined horrors that might be found lurking in the mountains. From the same decade there are many sketchbook studies of serpents,[32] and, on the back of a letter from the Royal Academy, a snatch of verse that contains the lines

FIGURE 63 J. M. W. Turner, *Study of a Gurnard*, c. 1840. Watercolor and gouache on blue-gray wove paper, 7 1/2 x 10 3/4 in. (19 x 27.4 cm). Fogg Art Museum, Harvard University, Cambridge, Massachusetts. Gift of Meta and Paul J. Sachs

FIGURE 64 J. M. W. Turner, *Study of a Gurnard*, c. 1840. Watercolor and bodycolor on paper, 7 5/8 x 10 7/8 in. (19.3 x 27.6 cm). Victoria and Albert Museum, London [W1404]

> *Portentous horrible so proud*
>
> *Struck by thy darts the monster coil'd*
>
> *His snake like form voluminous and vast*
>
> *and writhing turns his wounds 'ore the moist earth*
>
> *Till the moist Earth een blackens in his gore . . .* [33]

Turner's early-career monsters are romantic visions of the sublime and horrible, products of the same area of artistic imagination that also produced Mary Shelley's *Frankenstein* (1818). By the time we reach the 1840s the monsters in Turner's art have evolved into a different kind of creature. The reality of his engagement with whales, and his lifetime love of fishing, have caused the "real" in his art to be more terrifying than the "imaginary." This is to such an extent that

the nearest artistic relation of the creatures in *Sunrise with Sea Monsters* may be found not in the sketchbook serpents but in the naturalistic studies of fish (see figs. 62–64) and also in Turner's published vignettes, such as *Cod on the Beach* (fig. 66), where the main figure of these intense and tiny watercolors is surrounded by many square inches of white space.[34]

Another late painting in which monsters (of a kind) appear is *The Evening of the Deluge* (fig. 67). In the far distance, melting into the light like the suspended whale head in figure 58, is Noah's Ark. Toward it, from stage right, birds and animals make their way. Identifiable are a crocodile-like beast, a horse, a bear, and, in the middle distance, a giraffe and some decreasingly distinct elephantine and leonine creatures. Conflating two episodes in the Genesis account, Noah is in a drunken sleep, surrounded by bottles, in his tent in the foreground.[35] Turner made two versions of this subject, this probably being an earlier version of *Shade and Darkness—The Evening of the Deluge* (exh. 1843; Tate Britain, London; BJ404), the companion painting in the pendant pair with *Light and Color (Goethe's Theory)—the Morning after the Deluge—Moses Writing the Book of Genesis* (exh. 1843; Tate Britain, London; BJ405). Among the artist's intentions in painting this pair was his wish to demonstrate a public response to Goethe's color theories as translated by Eastlake. Concerning us here, however, is Turner's further intention: that of depicting a living, breathing earth, teeming with life, at a moment of crisis in its historical, religious, and physical evolution. The wheeling birds and gathering storm make a vortex about the sun of a form comparable to the storm in *Snowstorm—Hannibal and His Army Crossing the Alps* (exh. 1812; Tate Britain, London; BJ126), and the curving line is picked up and returned in a figure eight through the line made by the "crocodile." The sea, presently calm, will be transformed into a teeming flood when the rains start. The text for the painting is less Genesis, more the poetry of J. M. W. Turner himself, or indeed of the Reverend Thomas Gisborne, the source for Turner's earlier *Dawn of Christianity (Flight into Egypt)* (see fig. 31); Gisborne had written a series of lines on the Deluge in

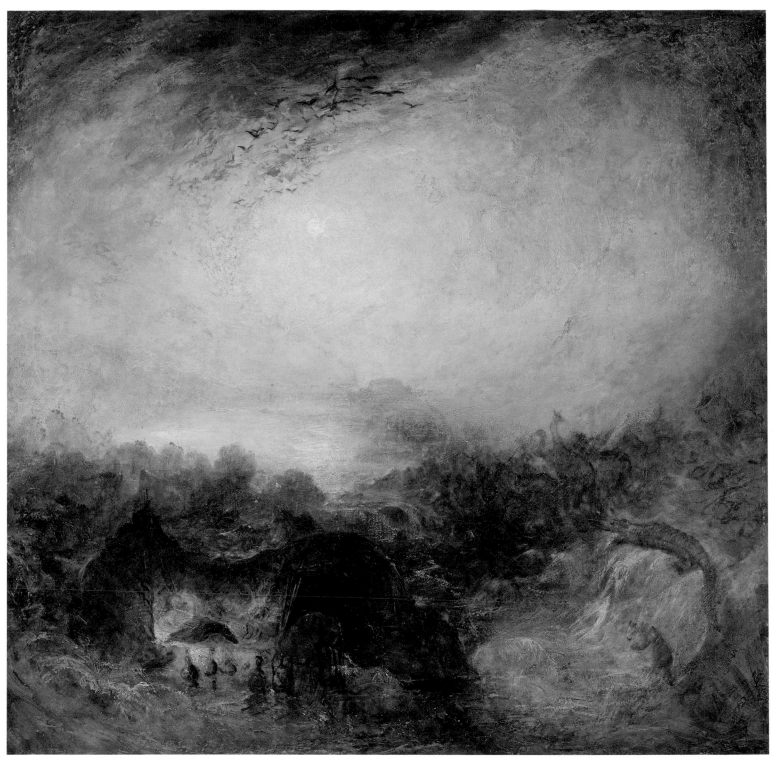

FIGURE 67 J. M. W. Turner, *The Evening of the Deluge*, c. 1843. Oil on canvas, 29 7/8 x 29 7/8 in. (76 x 76 cm). National Gallery of Art, Washington, D.C. Timken Collection [BJ443]

FIGURE 68 John Martin, *The Country of the Iguanodon*, frontispiece to Gideon Mantell, *The Wonders of Geology* (London, 1838). Bodleian Library, Oxford

Walks in a Forest.[36] The exhibited version of the subject came with lines extracted from the fragmentary Turner poem "Fallacies of Hope":

> *The moon put forth her sign of woe unheeded;*
> *But disobedience slept; the dark'ning Deluge closed around,*
> *And the last token came: the giant framework floated,*
> *The roused birds forsook their nightly shelters screaming*
> *And the beasts waded to the ark .*[37]

The most compelling intellectual controversy of the early 1840s was the nature of creation: the Bible said one thing—that the earth was created in six days, that the flood came to smother it all, and that as the waters receded the rainbow signaled redemption—but geological inquiry was beginning to suggest something else entirely. The rapidly growing fossil record, assembled by scientists across Europe and America, showed unmistakably that the earth was countless millions of years old. These findings set visible evidence against theological belief. One of the leading figures in the debate was Turner's friend and correspondent William Buckland, the pioneering geologist whose writings attempted to reconcile the irreconcilable, notably in his Bridgewater Treatise *Geology and Mineralogy Considered with Reference to Natural Theology* (1836). Turner's friendships with scientists,

Chapter Four

along with his own intellectual curiosity, were such that he would have had some awareness of the geological-theological debate,[38] and that in painting his two versions of *Evening of the Deluge* he was making a personal reference to these complex issues. How deep he goes into them is hard to judge, but a glance at the clearest of the creatures entering the ark, the "crocodile," with its narrow pointed snout and eyes on the side of its head, reveals that it is not a crocodile at all but nearer in form to the sea monsters drawn by his fellow artist John Martin (1789–1854) as the frontispieces to Gideon Mantell's *The Wonders of Geology* (fig. 68) and to Thomas Hawkins's *Book of the Great Sea Dragons* (1840). History, religious belief, time, and humanity are woven together with a premonition of imminent momentous change in *The Evening of the Deluge*, a drama played out by the shore of a pregnant sea that remains as enigmatic now as it was when it was painted.

The seashore, and buildings beside the sea, provided Turner with a rich series of settings for dramatic subjects from myth and literature that he worked up into exhibited paintings. The Carthaginian pictures of the second decade are prime examples, as are *The Bay of Baiae, with Apollo and the Sybil* (exh. 1823; Tate Britain, London; BJ230) and *The Parting of Hero and Leander* (exh. 1837; National Gallery, London; BJ370). However, in the 1840s the frequency of such seashore settings seems to increase dramatically with the two versions of *Neapolitan Fisher-Girls Surprised Bathing by Moonlight* (exh. 1840; Huntington Library, Art Collections, and Botanical Gardens, San Marino, Calif., BJ388; and Private collection, BJ389), *Glaucus and Scylla* (see fig. 32), *War: The Exile and the Rock Limpet* (exh. 1842; Tate Britain, London; BJ400), *Queen Mab's Cave* (exh. 1846; Tate Britain, London; BJ420), *Undine Giving the Ring to Massaniello, Fisherman of Naples* (see fig. 34), and *Europa and the Bull* (fig. 69). In the last-named painting, which was not exhibited in Turner's lifetime, the subject is so vague that we can only take it on trust. In melting so thoroughly a classical narrative into a poem of oranges and blues, Turner is stretching the marriage of landscape and myth to the breaking point.

FIGURE 69 J. M. W. Turner, *Europa and
the Bull*, c. 1840–45. Oil on canvas,
35 7/8 x 47 7/8 in. (91.1 x 121.6 cm). Taft
Museum of Art, Cincinnati, Ohio. Bequest
of Mr. and Mrs. Charles P. Taft [BJ514]

FIGURE 70 J. M. W. Turner, *Wimereux*, 1845. Pencil and watercolor on paper, 9 3/8 x 13 3/4 in. (23.8 x 33.6 cm). Tate Britain, London [TB CCCLVII 4]

Turner's final statement, the four Aeneas paintings exhibited as a group in 1850 (see fig. 91), reprises events in ancient Carthage that had long become part of Turner's artistic life. When we add those 1840s seashore subjects that have no literary narrative, such as *The New Moon* (exh. 1840; Tate Britain, London; BJ386) and *Rockets and Blue Lights (Close at Hand) to Warn Steamboats of Shoal Water* (see fig. 27), it may become apparent that whereas in the past Turner had taken himself and his audience out onto the sea in ships, he is now remaining with them tentatively on the shore. Why should this be?

During the late 1830s and the 1840s Turner spent increasing amounts of time in Margate, Deal, Folkestone, and other towns on the east Kent coast. He also crossed the Channel to the French coast at Ambleteuse and Wimereux near Calais in 1845 (fig. 70). The large quantity of watercolors and small millboard oils of seashore and sunset subjects in the Turner Bequest and elsewhere (figs. 58, 61–76, and 85) shows the extent to which the shore and the views from it had renewed themselves as sources of inspiration. Turner paints with a freedom that could have come only after a lifetime's experience and practice in his art. Though he captures the many moods of the sea, he

The Deep

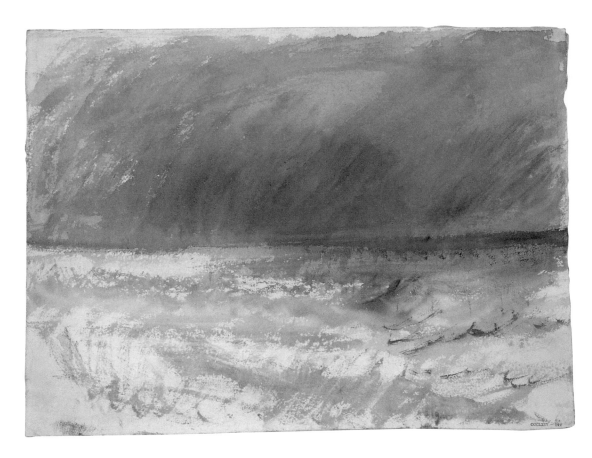

FIGURE 71 J. M. W. Turner, *Stormy Coast Scene*, after c. 1830, possibly 1840s. Watercolor on paper, 10 1/4 x 13 3/4 in. (26 x 34.9 cm). Tate Britain, London [TB CCCLXIV a 140]

FIGURE 72 J. M. W. Turner, *Sky Study*, c. 1845. Watercolor on paper, 11 1/2 x 17 1/4 in. (29 x 43.7 cm). Tate Britain, London [TB CCCLXV b 17]

FIGURE 73 J. M. W. Turner, *Beach Scene*, c. 1845. Watercolor on paper, 11 1/2 x 17 1/4 in. (29.1 x 43.8 cm). Tate Britain, London [TB CCCLXV b 18]

FIGURE 74 J. M. W. Turner, *Blue Sea and Distant Ship*, c. 1845. Watercolor on paper, 11 1/8 x 17 1/2 in. (28.2 x 44.4 cm). Tate Britain, London [TB CCCLXV b 21]

FIGURE 75 J. M. W. Turner, *Sunset*,
c. 1840–45. Watercolor on paper,
8³/₄ x 11³/₄ in. (22.2 x 29.8 cm).
Manchester Art Gallery [W1414]

FIGURE 76 J. M. W. Turner, *Sunset*,
c. 1845–50. Watercolor on paper,
9 x 12⁷/₈ in. (22.9 x 32.7 cm). Museum
of Fine Arts, Boston. Bequest of Mrs.
Henry Lee Higginson, Sr. [W1420]

is master of what the late nineteenth-century illustrator Randolph Caldecott called the "art of leaving out." A brilliant red cypher is enough to suggest a figure standing alone by the sea (fig. 73); a strip of blue watercolor with some expressive wrist-work (fig. 74) suggests a quiet sea on a warm day in an image that captures an aesthetic more readily associated with Whistler in the late nineteenth century. The mood changes in a watercolor in which scumbled gray wash with yellow and pink becomes a heavy mist over a cold, choppy sea (fig. 71).

The pattern of Turner's domestic life during this period is impossible to track, but with his health and strength inevitably beginning to decline, he depended more and more on the care and attention of his companion Sophia Booth, with whom he shared a house in Margate. Although Turner and Mrs. Booth also lived together in a cottage on the bank of the Thames in Chelsea from the autumn of 1846, he remained a regular passenger on the steamboat from London to Margate and back again until 1850, and he was spotted by fellow travelers from time to time. "I must go by steam," he wrote to the painter David Roberts (1796–1864) in 1847 when making arrangements for one particular journey.[39] An affidavit submitted to Turner's executors by his physician, David Price of Margate, reveals that Price traveled many times to see his patient in Margate and Deal in 1850, and we can reasonably conclude from this that Turner spent a lot of his time in Kent in the late 1840s.[40] Living in Mrs. Booth's house near Jarvis's Landing Place, Turner must have been a daily presence on the Margate foreshore when he was well enough to take a walk and able to look out over the sea when lying in bed.[41] The seashore perspective that was imposed on Turner by age and illness, and which is the recurring angle of view in the late watercolors and paintings on millboard, came to repeat itself in the perspective of the final exhibited oils, to the extent that we are now more at the sea's edge than we are at sea.

The group of late sea paintings that Turner did not exhibit are difficult to date precisely. Butlin and Joll put twenty paintings from the Turner Bequest into this category, as well as a handful of others

FIGURE 77 J. M. W. Turner, *Seascape with
Distant Coast*, c. 1845. Oil on canvas, 36 x 48 in.
(91.5 x 122 cm). Tate Britain, London [BJ467]

that seem to have escaped the Bequest soon after Turner's death. They date the majority of them to c. 1835–45.[42] One example in this exhibition, the so-called *Seascape with Distant Coast* (fig. 77), shows what appears to be a line of breakers running from the left onto a beach, but in the swirl of water and light even that is not clear (see also fig. 84). With little coastal or harbor reference, what these pictures do dramatically bring home is the power of the wind stirring the sea up into a moderately powerful storm. They do not depict uncontrolled power but instead the strength of the winter seas on the southern coast of England in normal seasonal weather. Thus, they are products of Turner's powers of observation and his respect for reality, rather than of his imagination, and are complete in themselves.

One, however, *Waves Breaking on a Lee Shore* (fig. 78), might tentatively be identified as a study for *Rockets and Blue Lights* on the evidence of the remarkable assonance between the foreground beach with its suggestions of figures, the background harbor with towers, and the ship in difficulties in the central distance. The angle of the breaking waves and the stormy sky completes the similarities between the two. If this is indeed a study for *Rockets and Blue Lights* we may reasonably bring its date forward from Butlin and Joll's suggested "c. 1835" to 1839–40. It would follow from this that the one other sea painting of the same unusual size, known as *Waves Breaking against the Wind* (fig. 79), may perhaps be considered a preliminary study for the setting of *Slave Ship (Slavers Throwing Overboard the Dead and Dying—Typhon Coming On)* (see fig. 28) and also redated 1839–40.

Rockets and Blue Lights is now effectively a new picture. What the conservator David Bull has revealed by removing varnish and overpaint is the vivid life and energy in Turner's brush strokes, particularly in the right-hand portion of the painting. The treatment amounts to the release of a work that had been traduced, clapped in irons, and petrified. Release has meant the appearance of clouds of smoke that flow in curls of wristy scumbling, and a new fluid and dynamic sea. Passages in *Rockets and Blue Lights* are comparable in their freedom to

FIGURE 78 J. M. W. Turner, *Waves Breaking
on a Lee Shore*, c. 1835. Oil on canvas,
23 1/2 x 37 1/2 in. (59.7 x 95.2 cm).
Tate Britain, London [BJ458]

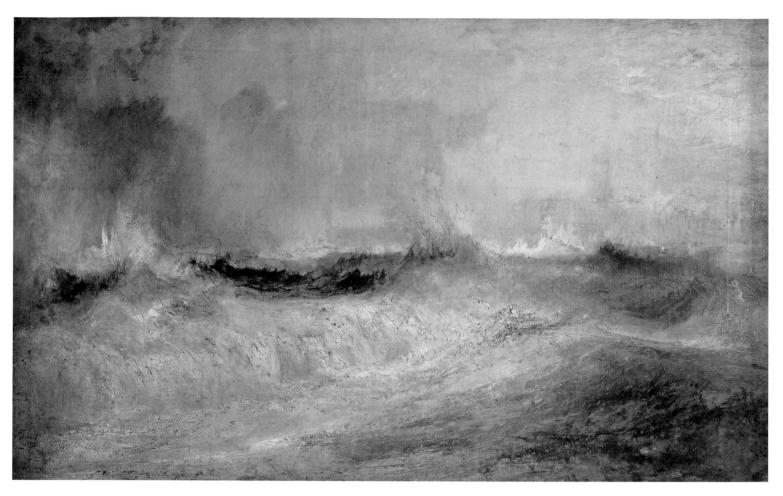

FIGURE 79 J. M. W. Turner, *Waves Breaking against the Wind*, c. 1835. Oil on canvas, 23 3/4 x 37 3/8 in. (60.4 x 95 cm). Tate Britain, London [BJ457]

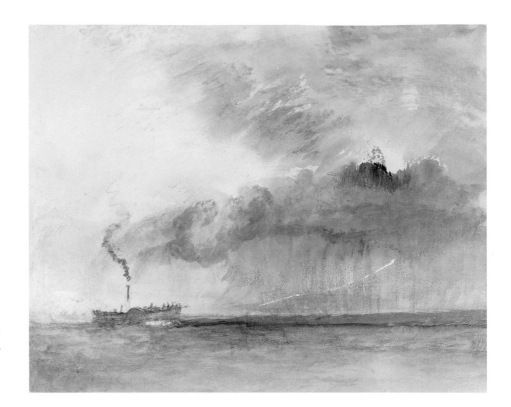

Turner's late watercolor technique, notably in *Steamboat in a Storm* (fig. 80), and stand in ready comparison with *Seascape with Distant Coast* (see fig. 77) and *Yacht Approaching the Coast* (fig. 81).

Of the later seascapes, the one that is nearest to completion by mid-nineteenth-century standards is *Yacht Approaching the Coast*, a title which is not Turner's own.[43] With its two diagonal movements, rushing out right and left from the central focus, the painting has at least three parallels in Turner's late work. The first, in chronological terms, is *Regulus* (1828, reworked and exh. 1837; Tate Britain, London; BJ294), in which the central Claudean fan of light spreads vertically and horizontally from the central sun, as it also does in *Yacht Approaching the Coast*. Both pictures make extensive use of impasto, though this is complicated by the fact that the white impasto present in *Regulus* was added when Turner reworked the picture in 1837 on Varnishing Day at the British Institution,[44] and *Yacht Approaching the Coast* has suffered by being flattened during relining.[45] The two further compositional parallels are *Slave Ship* and *Rain, Steam, and Speed,*

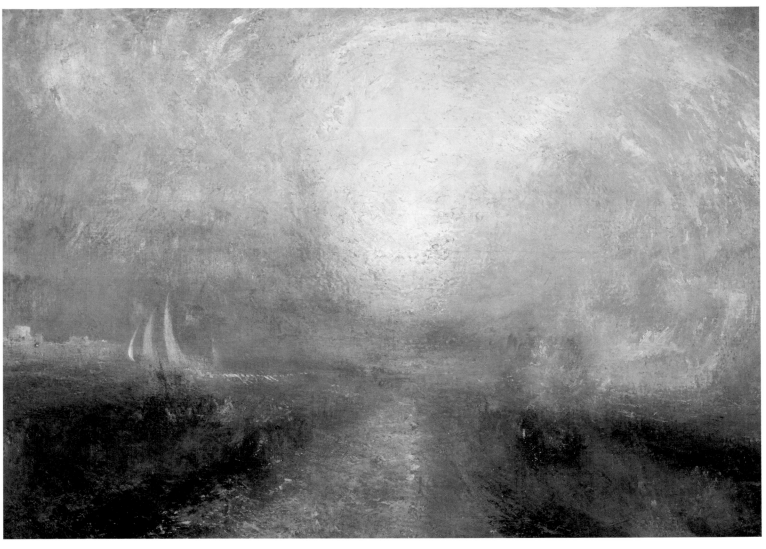

FIGURE 81 J. M. W. Turner, *Yacht
Approaching the Coast*, c. 1840–45. Oil on
canvas, 40¼ x 56 in. (102 x 142 cm).
Tate Britain, London [BJ461]

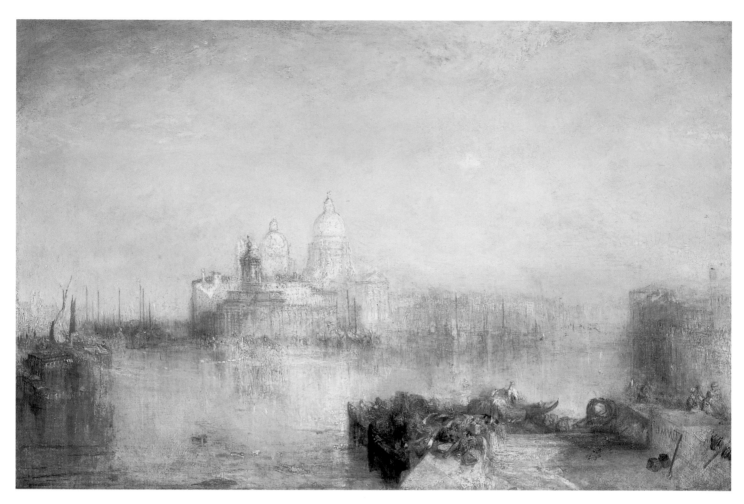

FIGURE 82 J. M. W. Turner, *The Dogana and Santa Maria della Salute, Venice*, exh. 1843. Oil on canvas, 24 3/8 x 36 5/8 in. (62 x 93 cm). National Gallery of Art, Washington, D.C. Given in memory of Governor Alvan T. Fuller by The Fuller Foundation, Inc. [BJ403]

a picture with which it shares a vibrant prismatic color range and vaporous atmospherics. Further affinities in *Yacht Approaching the Coast* may also be found in some of Turner's late Venetian subjects, such as *The Dogana and Santa Maria della Salute, Venice* (fig. 82). These connections appear to bring the date of this work forward a few years from Butlin and Joll's tentative c. 1835–40 to the early 1840s. Butlin and Joll have suggested that in form and presentation *Yacht Approaching the Coast* may be the "companion," as they term it, to *Stormy Sea with Blazing Wreck* (Tate Britain, London; BJ462).[46] If that were the case it would add yet another pair to the series of pendant paintings of the 1840s.

The distant hint of coastline, a favorite feature of Turner's seascapes, creates an immediate parallel between *Yacht Approaching the Coast*

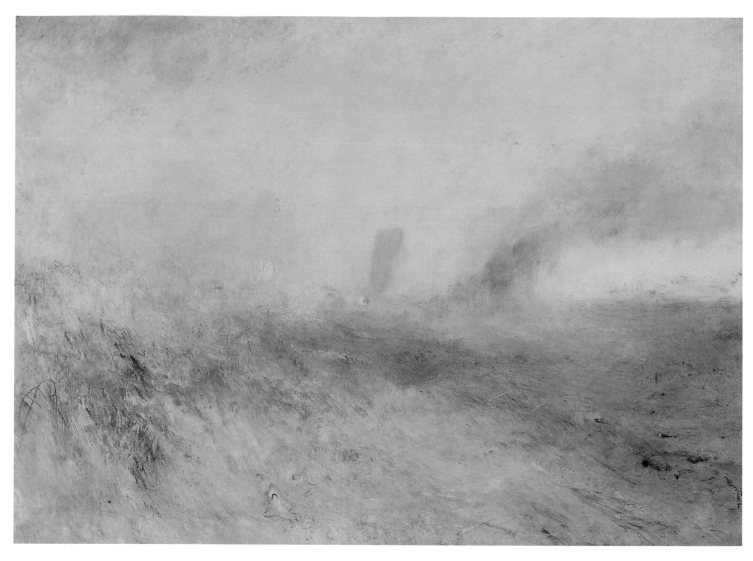

FIGURE 83 J. M. W. Turner, *Seascape, Folkestone,* c. 1845. Oil on canvas, 34³/4 x 46 ¹/4 in. (88.3 x 117.5 cm). Private collection [BJ472]

and *Seascape with Distant Coast* (see fig. 77). The sun-bathed strip of land on the left, built up in *Yacht Approaching the Coast,* creates a physical anchor for both paintings, locating them with a firm (though unidentifiable) horizon and giving a steadying effect to the sea. In *Seascape with Distant Coast* the bad weather is passing, blue sky is appearing, and, in the skillful modulation of yellow and white across the picture, the energy of the wind and waves is beginning to abate. Turner's gestural technique, which combines florid brush strokes with impasto and thick and thin paint, also involves watercolor, some of which has settled visibly on the surface in a string of globules around the center of the canvas.[47]

The Deep

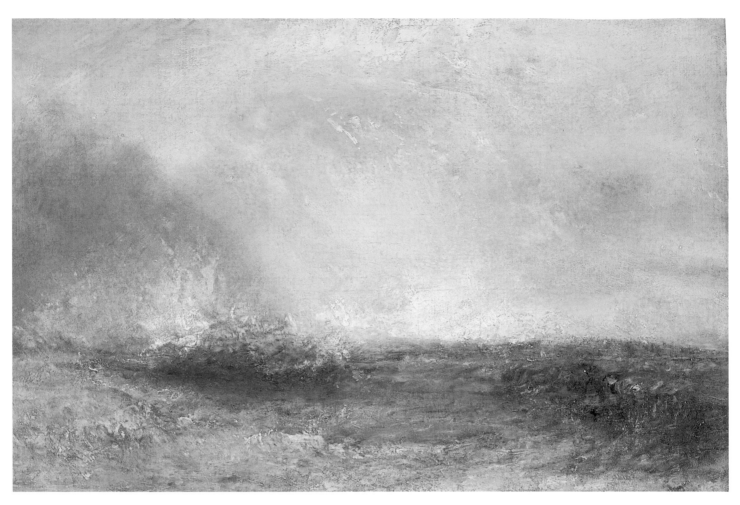

FIGURE 84 J. M. W. Turner, *Stormy Sea
Breaking on a Shore*, c. 1840–45. Oil on
canvas, 17 1/2 x 25 in. (44.5 x 63.5 cm). Yale
Center for British Art, New Haven, Con-
necticut. Paul Mellon Collection [BJ482]

There is a possibility that a small group of the late sea paintings
may be related to the Whaler series. This would help resolve the dat-
ing problem in those cases, tying them down to years around 1845–46.
Those that may be Whaler-related include *Seascape with Distant Coast*
(see fig. 77), *Seascape with Buoy* (Tate Britain; London; BJ468),[48] and
Sunrise with Sea Monsters (see fig. 61). This is not to say that they were
all intended to become whaling pictures but that they may have
been on the easel during Turner's Whaler period. A further group,
which are largely in the blue/green/brown/gray color range, include
Seascape with Storm Coming On,[49] *Wreck, with Fishing Boats,*[50] *Rough
Sea* (all Tate Britain, London; BJ466, BJ470, BJ471, respectively),[51] *Off
Ramsgate(?)* (Private collection; BJ479), *Seascape, Folkestone* (fig. 83),[52]
and *Stormy Sea Breaking on a Shore* (fig. 84). These may be related to

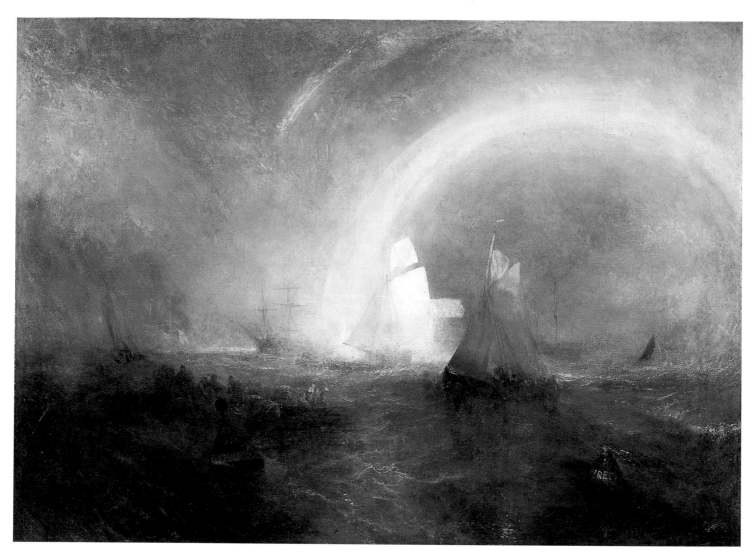

FIGURE 85 J. M. W. Turner, *The Wreck Buoy*, c. 1807; reworked and exh. 1849. Oil on canvas, 36 1/2 x 48 1/2 in. (92.7 x 123.2 cm). National Museums and Galleries on Merseyside (Walker Art Gallery), Liverpool [BJ428]

Ostend (exh. 1844; Neue Pinakothek, Munich; BJ407), an exhibited painting with a color range within those limits, and a mid-1840s date is reasonable for them.

A further clue in dating this group of sea paintings is the fact that Turner had intermittent attacks of fever in the late 1830s and became dangerously ill with cholera in the late 1840s. He exhibited only one picture at the 1847 Royal Academy, the early canvas that he reworked into *Hero of a Hundred Fights* (Tate Britain, London; BJ427). In 1848 he exhibited nothing, and in 1849 he showed another reworked canvas, *The Wreck Buoy* (fig. 85), and a forty-year-old painting, apparently unretouched, *Venus and Adonis* (c. 1803–5; Private collec-

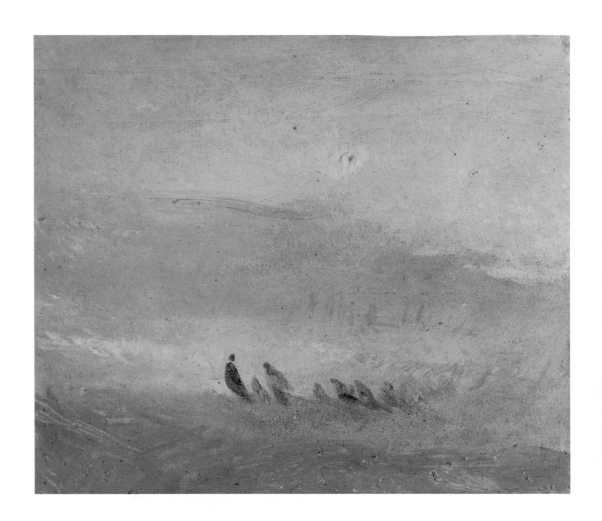

FIGURE 86 J. M. W. Turner, *Figures on a Beach*, possibly after 1845. Oil on mill-board, 10 1/4 x 11 3/4 in. (25.9 x 29.9 cm). Tate Britain, London [BJ496]

FIGURE 87 J. M. W. Turner, *"Lost to All Hope . . . ,"* c. 1845–50. Watercolor and graphite on wove paper, 9 1/16 x 12 13/16 in. (23 x 32.5 cm). Yale Center for British Art, New Haven, Connecticut. Paul Mellon Collection [W1425]

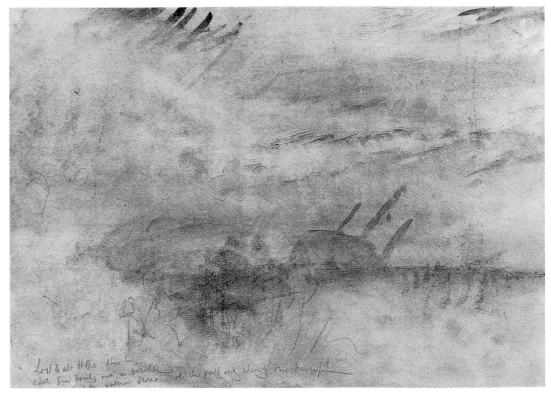

tion; BJ150). With the exception of the final brave flourish of the four Aeneas pictures exhibited in the 1850 Royal Academy exhibition (see fig. 91), we might suggest that Turner's career as an exhibiting artist came to an end in 1846. Thus, with his health declining, 1845–46 seems to be the latest possible date for these large and heavy-to-work oil paintings. In their place it may be that he moved to the smaller, lighter medium of oil on millboard, as in *Figures on a Beach* (fig. 86), and to watercolor for his final expressions of the movements of the sea. The steep increase in the number of sea paintings in Turner's oeuvre in the 1840s is a direct result of his greater presence in Margate and Deal in that decade. He paid his last visit to Venice in 1840, and that contributed to the fact that in the 1840s three-quarters of his traced oil paintings were of Venetian and seascape subjects.

Throughout the 1840s Turner made repeated farewells, which echoed and re-echoed in his work as the decade passed. The faint but eloquent watercolor *"Lost to All Hope . . . "* (fig. 87) depicts the shadowy hull of a three-masted sailing boat lying on her side awaiting destruction by the sea or by man, or by both. Turner has added some lines of his verse, barely legible, at the foot of the drawing. A transcription might be:

> *Lost to all Hope she lies*
> *Rough sea breaks over a derelict [?]*
> *On an unknown shore*
> *The sea folk only sharing the triumph.*[53]

Obsolescence and destruction were the fate that Turner saw for sailing ships, as is amply demonstrated in his resounding threnody on the demise of sail, *The Fighting "Temeraire" Tugged to Her Last Berth to Be Broken Up, 1838* (exh. 1839; National Gallery, London; BJ377). The title of that painting, a plangent fanfare of sentiment, says it all, and acknowledges, too, the part that sailing ships played in giving Turner the material that fueled his career. The watercolor *Dawn after the Wreck* (also known as *The Baying Hound;* fig. 88) carries similar sentiment—there is no wreck visible; that presumably has sunk or been washed away. What we are left with is one desolate dog, crying for

FIGURE 88 J. M. W. Turner, *Dawn after the Wreck (The Baying Hound)*, c. 1841. Graphite, watercolor, bodycolor, scraping, and chalk on paper, 9⅝ x 14¼ in. (24.5 x 36.2 cm). Courtauld Institute Gallery, Somerset House, London [W1398]

what had been. An unreconstructed pessimist might suggest that, by the evidence of *"Lost to All Hope . . . ," Dawn after the Wreck, The Fighting "Temeraire,"* and other works, Turner was himself deeply dismayed and despondent about the future. We can base conclusions only on the evidence he left behind, and it is salutary to note that throughout Turner's work, and particularly since the 1820s, when steamboats came into use, there are many paintings of wrecked sailing ships, but there are no wrecked steamboats in Turner.

Dubious practice though it may be to draw too many inferences from the negative, it is nevertheless the case that where steamboats come into Turner's art they are always cheerily at work, making smoke and steam and noise, buffeting the waves and getting on with their business. *Wreckers* (see fig. 21) shows us a steamboat nursing a

Chapter Four

FIGURE 89 J. M. W. Turner, *Snowstorm—Steamboat off a Harbor's Mouth . . .* , exh. 1842. Oil on canvas, 36 x 48 in. (91.4 x 121.9 cm). Tate Britain, London [BJ398]

sailing ship in difficulties; *The First Steamer on Lake Lucerne* (see fig. 45) is undoubtedly a celebration; and in *Rockets and Blue Lights* (see fig. 27) the steamer is going to make it to harbor, with a little help from her friends on shore. We might draw further conclusions from the existence of *The Wreck Buoy* (see fig. 85), a perfectly good greeny-gray marine subject of c. 1807 belonging to H. A. J. Munro of Novar, which Turner inexplicably insisted on having sent back to his studio in 1849 so that he could fiddle with it.[54] To its owner's horror, Turner heightened the colors of the sails of two of the boats, added a buoy to mark a wreck (of a sailing ship), rubbed blushing red into the sky, and added some highlights to the wave crests and an ecstatic rainbow arcing over the principal vessels. This is not the action of a pessimist to whom technical and scientific progress is anathema; it is an expression of an old man's delight in the continuance of life, light, and natural forces, and of human activity at sea.

The definitive statement of the power of the movement of the sea in Turner is *Snowstorm—Steamboat off a Harbor's Mouth Making Signals in Shallow Water, and Going by the Lead. The Author Was in this Storm on the Night the "Ariel" Left Harwich* (fig. 89). Once again we

The Deep

FIGURE 90 *Head of Ulysses.* Wax seal from back of an envelope, sealed by Turner. British Library, London (Add. MS 50119, fol. 45)

are given the extended didactic title, like a biblical text, as a starting point. The painting has long puzzled and enthralled gallery visitors, and has generated much literature. There is no room here to discuss the many interpretations of the work, but suffice it to say that there is no suggestion in the painting or its title that the steamboat is going to sink, or that we should read the image as a testament to the folly of man. The title makes clear that the captain is taking every seaman-like precaution to ensure that his ship gets home. Turner allowed the story to get around that he had been tied to the mast in the particular storm he depicted here. That at least indicates that the ship survived. Turner was sixty-seven when he painted it, and in indifferent health. Had he been tied to the mast to witness the storm he would have been dead by the time they cut him down. That story was never meant to be taken literally, though it may well be that at one time or another during his life he did get some sailors to tie him to a mast for safety as the ship rolled in a storm.

Turner, the intrepid traveler, identified himself with no other figure, mythical or historical, so much as Ulysses, the Greek hero of the Trojan Wars who sailed the Aegean and Mediterranean for many years on his erratic course for home. In one of his adventures Ulysses urged his sailors to tie him to the mast so that he could hear the music of the Sirens' song. He further commanded them to fill their ears with wax so that they would not hear his cries to be untied, nor be distracted themselves by the Sirens' unearthly music and steer their ship onto the rocks. In pretending to have been tied to the mast in the violent snowstorm of his painting, Turner is presenting himself as the modern Ulysses, the great traveler whose lifetime's experience of the British and European landscape was an Odyssey second to none. There is a further clue to Turner's involvement with his classical hero. On the back of an envelope among letters written by Turner that have found their way to the British Library is a wax seal that he used from time to time in the 1820s and 1830s: on it is a classical head, the head of Ulysses (fig. 90).

The year before he died, Turner was able to find the energy to paint a final series of four works, which constituted his last contribution to the annual Royal Academy exhibitions. These were not the reworked or old stock that he had been forced by ill health to show in 1847 and 1849, but a set of paintings on the theme of Dido, Aeneas, and the mythical roots of the bloody rift between Carthage and Rome. The interlinked stories of these characters of fable, and the real places that they inhabited, had been on Turner's mind, in his reading, and on perhaps a dozen great canvases since his young manhood. Turner's life was a binding of many threads: the images of Britain that he painted in series after series for engraving and distribution; his evocation of the physical power of mountains; his passion for the sea. A central thread, whose form encompassed the Britain he knew, the mountains he crossed, and the seas he sailed upon, was a love of the highly colored and populous stories from Greek and Roman myth as told by Homer, Virgil, Ovid, and other writers from the classical past.

The choice of Dido and Aeneas for his final production for the world of art was no mere whim. The four paintings, *Mercury Sent to Admonish Aeneas; Aeneas Relating His Story to Dido; The Visit to the Tomb;* and *The Departure of the Fleet* (all Tate Britain, London; BJ429– BJ432; *Aeneas Relating His Story to Dido* was destroyed) make up the final chapter in the story of the Trojan Wars' aftermath. Turner had tackled other parts of the story during his career, and further chapters remained in his sketchbooks as subjects unpainted. Aeneas, the Trojan hero of the wars, had, like his enemy Ulysses, taken years to reach home, and to fulfill his destiny to found Rome. On his way he had landed at Carthage on the north African coast, and he and the Carthaginian queen Dido had fallen in love. This gave Aeneas cause to dally, and to spend too much time assisting Dido in building up her city. Mercury, the messenger of the gods, was sent to remind Aeneas very forcibly of his duty, with the effect that although Dido begged him to stay with threats and curses, Aeneas and his fleet departed. Dido ran herself through with Aeneas's sword.[55]

FIGURE 91 J. M. W. Turner, *The Departure
of the Fleet*, exh. 1850. Oil on canvas,
35 3/8 x 47 3/8 in. (89.5 x 120.5 cm).
Tate Britain, London [BJ432]

These four paintings, from which *The Departure of the Fleet* (fig. 91) brings this exhibition to a close, are Turner's Last Quartet, his final message to the world. It is the last act in a grand opera, with the chorus of Carthaginians surrounding Dido on the left as the fleet sets sail in its gilded glory. It is painted with brush, knife, and probably also Turner's fingers; the image, its taproot running deep into the legacy of Claude, being seemingly carved out of light and deposited flickering on the canvas. The depth of color and resonance is profound in this final rally, a totally coherent concluding response to the classical world, and, perhaps, a preparation for the artist's entry into it. *The Departure of the Fleet* carries Turner away.

Appendix

Contemporary Accounts of Turner's Seascapes

The Reverend John Eagles's critical accounts of *Slave Ship (Slavers Throwing Overboard the Dead and Dying—Typhon Coming On)* and *Rockets and Blue Lights (Close at Hand) to Warn Steamboats of Shoal Water* when they were first shown at the 1840 Royal Academy exhibition. From *Blackwood's Magazine*, September 1840, pp. 374–86.

No. 203: "Slavers throwing over the Dead and Dying—Typhon coming on."
J.M.W. Turner, R.A.

> "Aloft all hands, strike the topmast and belay;
> Yon angry setting sun, and fierce-edged clouds
> Declare the Typhon's coming.
> Before it sweep your decks, throw overboard
> The dead and dying—never heed their chains.
> Hope, hope—fallacious hope!
> Where is thy market now?"
> —*MS. Fallacies of Hope*

Whether the MS was made for the picture, or the picture for the MS., they are very much alike, out of all rule and measure. The lines are, however, absolutely necessary to explain the piece—without them, past the imagination of man to find out. There is evidently a vessel riding in a chaos of red and yellow stuff, supposed to be meant for water, but that it quits the horizontal line and runs uphill. Of all the birds in the air, and all the fishes in the sea, what have we in the foreground? It is a black leg thrown overboard, and round it run fish great and small. There is a whale-like fish looming large in obscurity, which Mr Turner may mean to represent "Typhon's coming." Is it an allegory? Between the vessel and the fish there is an odd object that long puzzled us. We may be wrong; but we have conjectured it to be a Catholic bishop in canonicals gallantly gone overboard, to give the benediction to the crew, or the fish, or Typhon. Is it "Bishop Blaze," amid a dreadful conflict between sulphur and carmine? The fish claiming their leg-acy is very funny. What could have given rise to this dream of the colour pots? Here, too, is something quite miraculous—iron chains are floating! Is it meant to be poetical, that, as in the old woman's case, "water wouldn't quench fire," "fire

wouldn't burn sticks"—so water wouldn't swallow slavery's chains. There they are, however, and won't go down. They may make excuse that the water is no water after all, and has not an idea of liquidity. But it is too hard a task to account for anything in this unaccountable performance. (p. 380)

No. 419: "Rockets and Blue-Lights (close at hand) to warn Steam Boats of Shoal Water." J.M.W. Turner, R.A.

At a distance this appeared to have some harmonious colouring, blues, reds and yellows, not disagreeably distributed; but, on nearer the view, we are totally at a loss to know what it meant. A thing more without form and shape of any thing intended we never saw, excepting that we did discover a man, or we should hardly say the man, but the red-hot poker he is holding in his hand by the hot end. As the figure looks a little cindery, perhaps the poker has done its work. Mr Turner's representation of water is very odd. It is like hair-powder and pomatum, not over-well mixed; here a little more of one than the other, with occasional splatches of reds, blues and yellows. These absurd extravagances disgrace the Exhibition not only by being there, but by occupying conspicuous places. (p. 384)

John Ruskin's paragraphs about *Slave Ship*, first published in *Modern Painters*, vol. 1, 1843, pt. 2, section 5, chap. 3, para. 39 and 40. Ruskin nowhere wrote about *Rockets and Blue Lights*.

39. But, I think, the noblest sea that Turner has ever painted, and, if so, the noblest certainly ever painted by man, is that of the Slave Ship, the chief Academy picture of the Exhibition of 1840. It is a sunset on the Atlantic, after a prolonged storm; but the storm is partially lulled, and the torn and streaming rain-clouds are moving in scarlet lines to lose themselves in the hollow of the night. The whole surface of sea included in the picture is divided into two ridges of enormous swell, not high, nor local, but a low broad heaving of the whole ocean, like the lifting of its bosom by deep-drawn breath after the torture of the storm. Between these two ridges the fire of the sunset falls along the trough of the sea, dyeing it with an awful but glorious light, the intense and lurid splendour which burns like gold, and bathes like blood. Along this fiery path and valley, the tossing waves by which the swell of the sea is restlessly divided, lift themselves in dark, indefinite, fantastic forms, each casting a faint and ghastly shadow behind it along the illumined foam. They do not rise everywhere, but three or four together in wild groups, fitfully and furiously, as the under strength of the swell compels or permits them; leaving between them treacherous spaces of level and whirling water, now lighted with green and lamp-like fire, now flashing back the gold of the declining sun, now fearfully dyed from above with the undistinguishable images of the burning clouds, which fall upon

them in flakes of crimson and scarlet, and give to the reckless waves the added motion of their own fiery flying. Purple and blue, the lurid shadows of the hollow breakers are cast upon the mist of night, which gathers cold and low, advancing like the shadow of death upon the guilty*ship as it labours amidst the lightning of the sea, its thin masts written upon the sky in lines of blood, girded in condemnation in that fearful hue which signs the sky with horror, and mixes its flaming flood with the sunlight, and, cast far along the desolate heave of the sepulchral waves, incarnadines the multitudinous sea.

40. I believe, if I were reduced to test Turner's immortality upon any single work, I should choose this. Its daring conception, ideal in the highest sense of the word, is based on the purest truth, and wrought out with the concentrated knowledge of a life; its colour is absolutely perfect, not one false or morbid hue in any part or line, and so modulated that every square inch of canvas is a perfect composition; its drawing as accurate as fearless; the ship buoyant, bending, and full of motion; its tones as true as they are won-derful; and the whole picture dedicated to the most sublime of subjects and impressions (completing thus the perfect system of all truth, which we have shown to be formed by Turner's works)—the power, majesty, and deathfulness of the open, deep, illimitable sea.

*She is a slaver, throwing her slaves overboard. The near sea is encumbered with corpses.

Notes

Abbreviations

BJ	Turner's paintings are referenced by catalogue number in Martin Butlin and Evelyn Joll, *The Paintings of J.M.W. Turner*, rev. ed., 2 vols. (New Haven: Yale University Press, 1984)
Correspondence	*Collected Correspondence of J.M.W. Turner*, ed. John Gage (Oxford: Clarendon, 1980)
JMWT	Joseph Mallord William Turner
TB	Works in the Turner Bequest (Tate Britain, London) are referenced by Finberg number and are searchable on the Tate's website: www.tate.org.uk
W	Turner's watercolors are referenced by catalogue number in Andrew Wilton, *J. M. W. Turner: His Art and Life* (Fribourg, Switzerland: Office du Livre, 1979)

Chapter One. A Power Supreme

1. Works cited in the text are dated primarily by the year in which they were exhibited (and thus completed). Catalogue numbers correspond to the work's listing (for paintings) in Martin Butlin and Evelyn Joll, *The Paintings of J. M.W. Turner*, rev. ed., 2 vols. (New Haven: Yale University Press, 1984), and (for watercolors) in Andrew Wilton, *J. M.W. Turner: His Art and Life* (Fribourg, Switzerland: Office du Livre, 1979). Titles of works have been standardized according to American editorial guidelines for spelling and capitalization.

2. Curtis Price, "Turner at the Pantheon Opera House, 1791–92," *Turner Studies* 7, no. 2 (1987): 2–8. See also C. B. Hogan, ed., *The London Stage, 1600–1800* (Carbondale: Southern Illinois University Press, 1968), vol. 2, pt. 5, 1275–76, 1287–88, 1323–24.

3. There is a lively drawing of the interior of the King's Theatre, Haymarket (pencil, c. 1799) in the Turner Bequest (TB XLIV-w), reproduced in Andrew Wilton, *Turner in His Time* (London: Thames and Hudson, 1989), 44. See also John Gage,

J.M.W. Turner: "A Wonderful Range of Mind" (New Haven: Yale University Press, 1987), 197–98.

4. "Review at Portsmouth" sketchbook (TB CXXXVI); also drawings of 1844 in TB CCCLXIV, pp. 57, 138, 458.

5. Examples, out of many, include the oil painting *Calais Pier* (exh. 1803, National Gallery, London; BJ48); studies in "Small Calais Pier" sketchbook (TB LXXI 18a–22); and the watercolor *Gosport, the Entrance to Portsmouth Harbor* (c. 1829; Portsmouth Museums; W828).

6. TB XCIX.

7. Letters of JMWT to James Holworthy, 4 December 1826 and 21 April 1827 (*Correspondence*, 119 and 122).

8. Hilda F. Finberg, "With Turner in 1797," *Burlington Magazine* 99 (February 1957): 48–49.

9. The Orchard still stands, but it was damaged by a landslide in April 2001.

10. A watercolor by Lady Gordon, of the terrace and the shell fountain, is reproduced in Ian Warrell, *Turner on the Loire* (London: Tate Gallery, 1998), 181. See also Peter C. Sutton, *The William Appleton Coolidge Collection* (Boston: Museum of Fine Arts, 1995), 72.

11. For a full account, see Selby Whittingham, "What You Will; or Some Notes Regarding the Influence of Watteau on Turner and Other British Artists," *Turner Studies* 5, no. 1 (1985): 2–24, and no. 2 (1985): 28–48.

12. Ibid.

13. For more on Lady Gordon and her family, see Paul Oppé, "Talented Amateurs: Julia Gordon and Her Circle," *Country Life* (8 July 1939): 20–21. This article concentrates on the Gordons' artist daughter, also named Julia. The Isle of Wight Record Office, Newport, holds an extensive set of the journals of Julia Gordon the younger (ref. 75/25). See also R.V. Turley, "Swinburne and the Gordon Family," *Hampshire* 12, no. 6 (April 1972): 49–50; R.V. Turley, "Julia Gordon, Lithographer," *Wight Life* (August–September 1974): 41–45.

14. Discourse I (January 1769). Robert R. Wark, ed., *Discourses on Art: Sir Joshua Reynolds* (New Haven: Yale University Press, 1997), 17.

15. Joshua Reynolds, *Works . . . Containing the Discourses . . . [and] A Journey to Flanders and Holland*, corrected 2nd ed. (London, 1798), 2:359–64. The clearest modern edition is *Sir Joshua Reynolds: A Journey to Flanders and Holland*, ed. Harry Mount (Cambridge: Cambridge University Press, 1996), 110.

16. Walter Thornbury, *The Life of J.M.W. Turner, RA, Founded on Letters and Papers Furnished by His Friends and Fellow Academicians*, rev. ed. (London: Chatto and Windus, 1877), 8.

17. "Studies in the Louvre" sketchbook (TB LXXII 22 a); pencil study of picture by Turner on 81.

18. TB LXXII 23.

19. A.G.H. Bachrach, "Turner, Ruisdael, and the Dutch," *Turner Studies* 1, no. 1 (1981): 19–30; Fred G. H. Bachrach, *Turner's Holland*, exh. cat. (London: Tate Gallery, 1994), 20.

20. TB LXXII, 23.

21. Ibid.

22. John Ruskin, *The Works of John Ruskin*, ed. E. T. Cook and Alexander Wedderburn, Library Ed., 39 vols. (London: George Allen, 1903–12), 3:568.

23. A third with Dutch connections was *Rembrandt's Daughter* (Fogg Art Museum, Harvard University, Cambridge, Mass.; BJ238), which does not concern us here.

24. Letter of JMWT to James Holworthy, postmarked 5 May 1826 (*Correspondence*, 116).

25. Turner also included exotically dressed figures in the watercolor *Hastings: Fish-Market on the Sands*, 1824 (W510). See Eric Shanes, *Turner's Human Landscape* (London: Heineman, 1990), for a convincing discussion of this picture.

26. John Summerson, *The Life and Work of John Nash, Architect* (Cambridge: MIT Press, 1980), chap. 11.

27. Letter of JMWT to William Turner, August 1827 (*Correspondence*, 123).

28. "Windsor and Cowes, Isle of Wight" sketchbook (TB CCXXVI); "East Cowes Castle" sketchbook (TB CCXXVII a); "Yachts, etc., at Cowes" sketchbook (TB CCXXVIII).

29. TB CCXXVI.

30. *Morning Herald* (London), 26 May 1828.

31. A study of the mezzotint *Ship and Cutter*, c. 1825. See M.-E. Dupret, "Turner's 'Little Liber,'" *Turner Studies* 9, no. 1 (1989): 32–47, ill. 10.

32. Andrew Wilton, "Sublime or Ridiculous? Turner and the Problem of the Historical Figure," *New Literary History* 16 (1985): 343–76.

33. *Admiral van Tromp's Barge at the Entrance of the Texel, 1645* (exh. 1831; Sir John Soane's Museum, London; BJ339); *The Prince of Orange, William III, Embarked from Holland, and Landed at Torbay, November 4th, 1688, after a Stormy Passage* (fig. 18); *Van Tromp's Shallop, at the Entrance of the Scheldt* (fig. 19); *Helvoetsluys; the City of Utrecht, 64, Going to Sea* (exh. 1832; Private collection; BJ345); *Rotterdam Ferry Boat* (fig. 20); *Van Goyen, Looking out for a Subject* (exh. 1833; Frick Collection, New York; BJ350); *Van Tromp Returning after the Battle off the Dogger Bank* (exh. 1833; Tate Britain, London; BJ351).

34. For example, with *Spithead: Boat's Crew Recovering an Anchor* (exh. 1810; Tate Britain, London; BJ80) and *Lifeboat and Manby Apparatus Going off to a Stranded Vessel Making Signal (Blue Lights) of Distress* (exh. 1831; Victoria and Albert Museum, London; BJ336).

35. *Athenaeum* (London), 26 May 1832.

36. Bachrach, *Turner's Holland*, 20.

37. Ibid.

38. John Smith's *Catalogue Raisonné of the Works . . . of Dutch, Flemish and French Painters* was published in nine vols., 1829–42.

39. To Charles Birch, Birmingham colliery owner, who also was the first owner of *Rockets and Blue Lights* (fig. 27).

40. Bachrach, *Turner's Holland*, 53.

41. *The Times* (London), 11 May 1827.

42. *Spectator*, 10 May 1827.

43. See James Hamilton, *Turner: A Life* (London: Hodder and Stoughton, 1997), 203–4, 219, and passim.

44. There is an evocative description of Dunwich and its history in W. G. Sebald, *The Rings of Saturn*, trans. Michael Hulse (New York: New Directions, 1998), 154–60.

45. "Devonshire Coast no. 1" sketchbook (TB CXXIII), fol. 201v. Transcribed by Rosalind Turner in Andrew Wilton, *Painting and Poetry: Turner's "Verse Book" and His Work of 1804–1812* (London: Tate Britain, 1990), 176.

Chapter Two. The Multitudinous Seas Incarnadine

1. Turner's "Verse Book" (Private collection); "Cockermouth" sketchbook (TB CX); "Devonshire Coast no. 1" sketchbook (TB CXXIII). Turner's painting *Pope's Villa at Twickenham* (Sudeley Castle, Glos, U.K.; BJ72) was exhibited in 1808. See Wilton, *Painting and Poetry*.

2. See Cecilia Powell, "'Infuriate in the Wreckage of Hope': Turner's Vision of Medea," *Turner Studies* 2, no. 1 (1982): 12–18.

3. Gage, *J. M. W. Turner*, 224–27.

4. 1840: *Slave Ship (Slavers Throwing Overboard the Dead and Dying—Typhon Coming On)* (fig. 28) and *Rockets and Blue Lights (Close at Hand) to Warn Steamboats of Shoal Water* (fig. 27).

1841: *Dawn of Christianity (Flight into Egypt)* (fig. 31) and *Glaucus and Scylla* (fig. 32).

1842: *The Dogano, San Giorgio, Citella, from the Steps of the Europa* (Tate Britain, London; BJ396) and *Campo Santo, Venice* (Toledo Museum of Art; BJ397); also *Peace—Burial at Sea* (Tate Britain, London; BJ399) and *War: The Exile and the Rock Limpet* (Tate Britain, London; BJ400).

1843: *Shade and Darkness—the Evening of the Deluge* (Tate Britain, London; BJ404; see fig. 67) and *Light and Color (Goethe's Theory)—the Morning after the Deluge—Moses Writing the Book of Genesis* (Tate Britain, London; BJ405).

1845: *Whalers* (Tate Britain, London; BJ414) and *Whalers* (also known as *The Whale Ship*; fig. 56).

1846: *Venice, Evening, Going to the Ball* (Tate Britain, London; BJ416) and *Morning, Returning from the Ball, St. Martino* (Tate Britain, London; BJ417); also *Going to the Ball (San Martino)* (fig. 38) and *Returning from the Ball (St. Martha)* (fig. 39); also *"Hurrah! for the Whaler Erebus! Another Fish!"* (fig. 58) and *Whalers (Boiling Blubber) Entangled in Flaw Ice, Endeavoring to Extricate Themselves* (Tate Britain, London; BJ426); also *Undine Giving the Ring to Massaniello, Fisherman of Naples* (fig. 34) and *The Angel Standing in the Sun* (Tate Britain, London; BJ425).

1850: *Mercury Sent to Admonish Aeneas* (Tate Britain, London; BJ429), *Aeneas Relating His Story to Dido* (destroyed, formerly Tate Britain, London; BJ430), *The Visit to the Tomb* (Tate Britain, London; BJ431) and *The Departure of the Fleet* (fig. 91).

5. John McCoubrey, "Turner's *Slave Ship*: Abolition, Ruskin, and Reception,"

Word & Image 14, no. 4 (1998): 319–53. Hamilton, *Turner: A Life*, 285–86, 289. Regrettably, the fragile condition of *Slave Ship* prevented it from being included in this exhibition.

6. *Rockets and Blue Lights* was cat. 112 in the 1841 British Institution exhibition.

7. The other exhibited paintings in 1840 were: *Venice, the Bridge of Sighs* (Tate Britain, London; BJ383); *Venice, from the Canale della Giudecca, Chiesa di Santa Maria della Salute* (Victoria and Albert Museum, London; BJ384); *The New Moon; or, "I've Lost My Boat, You Shan't Have Your Hoop"* (Tate Britain, London; BJ386); and *Neapolitan Fisher-Girls Surprised Bathing by Moonlight* (BJ388/BJ389—two versions of this subject exist, one of which is in the collection of the Huntington Art Gallery, San Marino, Calif.).

8. See entries for the paintings at BJ385 and BJ387.

9. Ruskin, *Works*, 3:571–73.

10. *The Times* (London), 12 August 1839, p. 6; 23 August 1839, p. 6; 9 September 1839, p. 6; 11 September 1839, p. 2; 12 September 1839, p. 5. Robert and Samuel Wilberforce, *The Life of William Wilberforce by His Sons* (London: John Murray, 1838).

11. Thomas Fowell Buxton, *The African Slave Trade*, 2nd ed. (London: John Murray, 1839), 104–5.

12. One of Buxton's informants regarding the conditions aboard slave ships was Gustavus Vasa, whose book *The Interesting Narrative of Olandah Equiano; or Gustavus Vasa, Written by Himself*, was printed and sold by the author in London in 1793.

13. McCoubrey, "Turner's *Slave Ship*."

14. James Hamilton, *Turner and the Scientists*, exh. cat. (London: Tate Gallery, 1998), 86–91; and James Hamilton, *Faraday—The Life* (London: HarperCollins, 2002), 239–40.

15. Thomas Gisborne, *Walks in the Forest, or Poems Descriptive of Scenery and Incidents Characteristic of a Forest at Different Seasons of the Year*, 4th ed. (1799); Ovid, *Metamorphoses*, book 13, lines 895–967.

16. Thomas Gisborne, "Walk the First—Spring," 6th ed. (1803), 5. The final line is on p. 26.

17. *Correspondence*, 244.

18. Hamilton, *Turner: A Life*, 260–61, 290. See also entry at BJ374; and Helen Guiterman, "The Great Painter: Roberts on Turner," *Turner Studies* 9, no. 1 (1988): 2–9.

19. *Athenaeum* (London), 5 June 1841.

20. *Spectator* (London), 8 May 1841.

21. For full analyses of the painting and its pendant, see Sheila M. Smith, "Contemporary Politics and the Eternal World in Turner's *Undine* and *The Angel Standing in the Sun*," *Turner Studies* 6, no. 1 (1983): 40–50; and J. R. Piggott, "Water, Fire, and the Ring—Turner's *Undine*," *Turner Society News*, no. 82 (August 1999): 14–20.

22. Ruskin, *Works*, 3:653.

23. William Shakespeare, *Macbeth*, act 4, sc. 1; Ruskin, *Works*, 3:569.

24. Shakespeare, *Macbeth*, act 2, sc. 2.

25. Ruskin, *Works*, 3:572.

26. Turner's copy of Eastlake's translation, *Theory of Colours*, is in a private U.K. collection.

27. John Gage, "Turner's Annotated Books: Goethe's 'Theory of Colours,'" *Turner Studies* 4, no. 2 (1984): 34–52.

28. Thornbury, *Life*, 348–52. See also L. L. Reynolds and A. T. Gill, "The Mayall Story," *History of Photography* 9, no. 2 (1985): 89–107.

29. None of these photographs appears to have survived, with the exception of a copy of a putative daguerreotype portrait of Turner by Mayall, reproduced in R.J.B. Walker, "The Portraits of J.M.W. Turner: A Check-List," *Turner Studies* 3, no. 1 (1983): 30.

30. Thornbury, *Life*, 348–52.

Chapter Three. Interlude: Turner the Elderly Traveler

1. Alaric Watts, "Biographical Sketch of J.M.W. Turner," in *Liber Fluviorum* (London: H. G. Bohn, 1853), xxxii.

2. Ian Warrell, *Turner on the Loire*, exh. cat. (London: Tate Gallery, 1997), 28.

3. TB LXXXI, pp. 58–59.

4. Letter of JMWT to James Lenox, 16 August 1845 (*Correspondence*, 288). This journey inspired the painting *Staffa, Fingal's Cave* (1832; BJ347), purchased in 1845 by James Lenox of New York. The work was the first painting by Turner to enter an American collection. It is now at the Yale Center for British Art, New Haven.

5. John Milton, *Paradise Lost*, book 7, lines 210–15. See also Andrew Wilton, *Turner and the Sublime*, exh. cat. (London: British Museum Publications, 1980), 12–13.

6. See the entry at BJ132.

7. For Hakewill's drawings, see *Picturesque Tour of Italy* (London: John Murray, 1820). See also Cecilia Powell, "Topography, Imagination and Travel: Turner's Relationship with James Hakewill," *Art History* 5, no. 4 (1984): 408–25.

8. See Jan Piggott, *Turner's Vignettes*, exh. cat. (London: Tate Gallery, 1993).

9. *The Thanet Itinerary or, Steam Yacht Companion*, 3rd ed. (Margate: Bettison, Garner, and Denne, 1825), 24–25.

10. Watts, "Biographical Sketch," xxxii.

11. TB XXXVII.

12. "Kent" sketchbook, 1846–47 (TB CCCLXIII 6).

13. Ibid., fol. 12.

14. "Ancona to Rome" sketchbook (TB CLXXVII), inside front cover.

15. "Leaves of Rue. Bruised Vincu[?] treacle / Mithridate, and scrapings of Pewtr / Pewter—each 4 ounces. Boild / slowly in 2 quarts of Strongs Hale [*sic*] / until the ale is one quart. / 9 Table spoonsful 7 mornings fast / ing. Warm cattle 10 cold dog 5 / apply some of the ingredients stra[i]ned to / the wound within 9 days of the / Bite." "Rhine, (between Cologne and Mayence) also Moselle and Aix-la-Chapelle" sketchbook, c. 1835 (TB CCXCI a 14).

16. "Brussels up to Mannheim-Rhine" sketchbook (TB CCXCVI), inside front cover.

17. Hubert Wellington, ed., *The Journal of Eugène Delacroix: A Selection*, trans. Lucy Norton (London: Phaidon, 1951), 292.

18. Richard Redgrave and Samuel Redgrave, *A Century of Painters* (1865), modern edition, ed. Ruthven Todd (London: Phaidon, 1947), 263–64.

19. Robert K. Wallace, "Reminiscences of Turner, from *The Crayon*, 1855," *Turner Studies* 8 (1988): 1, 46–47.

20. *Photographic News*, 1860, 407; quoted in Wilton, *Turner in His Time*, 226–27.

21. William Callow, *William Callow, R.W.S., F.R.G.S.: An Autobiography* (London: A. and C. Black, 1908), 66–67.

22. Ruskin, *Works*, 13:190.

23. John Gage has determined "E. H." to be Edward Hakewill (*Correspondence*, 236), although Cecilia Powell has pointed out that Hakewill did not marry until 1853; Powell, *Turner in Germany*, exh. cat. (London: Tate Gallery, 1995), 8 n. 10.

24. "No matter what be[fell] Hannibal—W. B. and J. M.W. T. passed the Alps from (?near) Fombey (?) Sep 3 1844." Inscription in "Grindelwald" sketchbook (TB CCCXLVIII 17a). Brockedon was an enthusiastic Alpiniste, having crossed the Alps fifty-eight times in attempts to find Hannibal's crossing point. See Hamilton, *Faraday*, 210–12.

25. Letter of JMWT to G. Cobb, 7 October 1840 (*Correspondence*, 238).

26. Letter of JMWT to W. Miller, 22 October 1841 (*Correspondence*, 246).

27. *Correspondence*, 284, 297, and accompanying notes.

28. Letter of JMWT to H. Fawkes, 28 December 1844 (*Correspondence*, 275).

29. Finch Papers, c. 2d. 17, fol. 205, Bodleian Library, Oxford; quoted in *Correspondence*, 155 n. 9.

30. Letter of JMWT to James Holworthy, 7 January 1826 (*Correspondence*, 112).

31. Brian Bowers and Lenore Symons, eds., *Curiosity Perfectly Satisfyed—Faraday's Travels in Europe, 1813–1815* (London: P. Peregrinus in association with the Science Museum, 1991), 14. See also Hamilton, *Faraday*, 60.

32. Letter of Mrs. Callcott to her sister, Lyons, 22 May 1828; National Art Library, Victoria and Albert Museum, London, 86.PP.14/IV, 9.

33. *Correspondence*, 238. The London to Brighton railway opened in September 1841.

34. See entry at BJ409.

35. "Return from Italy" sketchbook (TB CXCII), fol. 2a.

36. Letter of JMWT to James Holworthy, 7 January 1826 (*Correspondence*, 112).

37. Letter of JMWT to Charles Eastlake, 16 February 1829 (*Correspondence*, 147).

Chapter Four. The Deep

1. Robert K. Wallace, "Reminiscences of Turner, from *The Crayon*, 1855," *Turner Studies* 8, no. 1 (1988): 46–47. This article reprints and discusses the anonymous report that appeared in the "Sketchings" column of the New York art magazine *The Crayon*, 14 February 1855.

2. Ibid.

3. *Illustrated London News*, 12 August 1843, 108.

4. Letter of Charles Dickens to Martin Farquhar Tupper, 19 March 1850, in *Letters of Charles Dickens*, ed. Madeline House, Graham Storey, et al., 12 vols. (Oxford: Clarendon, 1965–), 6:67–69.

5. Charles Dickens, *Christmas Stories*, Fireside Edition, p. 189.

6. See *The Sketching Society, 1799–1851*, comp. Jean Hamilton (London: Victoria and Albert Museum, 1971). Reference to Morgan's membership is in Dickens, *Letters*, 5:481n.

7. John Ruskin, *Dilecta*, in Ruskin, *Works*, 35:547.

8. The subject of the watercolor is a passage in Sir Walter Scott's *The Pirate* (1822), as quoted in the Reverend G. N. Wright, *Landscape—Historical Illustrations of Scotland and the Waverley Novels* (London: Fisher and Son, 1836–37), 2:39–41. It is identified and put into context in Eric Shanes, *J. M. W. Turner: The Foundations of Genius,* exh. cat. (Cincinnati: Taft Museum of Art, 1986), no. 54.

9. *The Times* (London), 6 May 1845.

10. *Punch*, January–June 1845, p. 233.

11. *The Times* (London), 6 May 1845.

12. *Literary Gazette*, 17 May 1845.

13. Richard Hakluyt, *The Principal Navigations, Voyages, Traffiques, and Discoveries of the English Nation* (1589; 1600), Everyman ed. (London: Dent, 1907), 1:241–54, 268, 411.

14. "Greenwich" sketchbook, c. 1808–9 (TB CII), fols. 1v, 6v, 9r; transcribed in Wilton, *Painting and Poetry*, 157–59.

15. See Peter Bicknell and Helen Guiterman, "The Turner Collector: Elhanan Bicknell," *Turner Studies* 7, no. 1 (1987): 34–44.

16. W164 and W1524, respectively.

17. Letter of JMWT to Elhanan Bicknell, 31 January 1845 (*Correspondence*, 279).

18. Letter of J. J. Ruskin to J. Ruskin, 15–19 September 1845.

19. Thomas Beale, *A Few Observations on the Natural History of the Sperm Whale . . . [together with] A Sketch of a South-Sea Whaling Voyage . . .* (London: John Van Voorst, 1839), 174. Turner erroneously gave p. 175 as the reference for this descriptive passage in his entry for *Whalers* (fig. 57) in the 1845 Royal Academy exhibition catalogue ("Vide Beale's Voyage, p. 175"). He gave the reference "Vide Beale's Voyage p. 163" to the other painting titled *Whalers* at the 1845 exhibition. This is now in the Turner Bequest at Tate Britain. Beale was also cited by Turner as the source for *"Hurrah! for the Whaler Erebus! Another Fish!"* (fig. 58).

20. Barry Venning, "Turner's Whaling Subjects," *Burlington Magazine* 127 (1985): 75–83. George Manby's book is *Journal of a Voyage to Greenland in the Year 1821* (London, 1822).

21. *The Whaler—"He breaks away"* (Fitzwilliam Museum, Cambridge; W1411); the "Channel" sketchbook (c. 1845; Yale Center for British Art, New Haven), published in Andrew Wilton, "A Rediscovered Turner Sketchbook," *Turner Studies* 6, no. 2 (1986): 9–23; also TB CCCLVII 6, TB CCCLIII 21.

22. Jack Lindsay, *J. M. W. Turner: His Life and Work—A Critical Biography* (Greenwich, Conn.: New York Graphic Society, 1966), 192. For Turner's activities at Wapping, see Hamilton, *Turner: A Life*, 232–33 and 282; and Anthony Bailey, *Standing in the Sun: A Life of J. M. W. Turner* (London: Sinclair-Stevenson, 1997), 239–40 and passim.

23. Hamilton, *Turner and the Scientists*, chaps. 3, 6, and passim.

24. Robert K. Wallace, "The Antarctic Sources for Turner's 1846 Whaling Oils," *Turner Studies* 8, no. 1 (1988): 20–31. Wallace here challenges Venning's proposal (Venning, "Turner's Whaling Subjects," 75–83) that the 1846 whaling subjects are set in the Arctic.

25. A catalogue of books known to have been in Turner's library at his death is in Wilton, *Turner in His Time*, 246–47.

26. I am grateful to Pieter van der Merwe for this insight.

27. But see Peter Bicknell, "Turner's *The Whale Ship:* A Missing Link?" *Turner Studies* 5, no. 2 (1985): 20–23. Bicknell proposes William Huggins's *A Whaler in the South Sea Fishery*, c. 1830–35, as the primary source. This painting, formally very close both to the lithograph and Turner's painting, was in Bicknell's collection in the 1840s.

28. Accession no. D-43.

29. Gillian Forrester, *Turner's "Drawing Book": The Liber Studiorum* (London: Tate Publishing, 1996), chap. 3 and passim.

30. Letter of JMWT to William Buckland, 30 November 1843 (*Correspondence*, 262).

31. Thomas Dickinson, *A Narrative of the Operations for the Recovery of the Public Stores and Treasure Sunk in H.M.S. "Thetis," at Cape Frio, on the Coast of Brazil, on the 5th December 1830* (London, 1836). The lithographs are reproduced in Gage, *Correspondence*, pls. III and IV.

32. For example, TB LXXVII 43; TB LXXXI 68; TB CXIV 2.

33. Transcribed in Wilton, *Painting and Poetry*, 153.

34. TB CCLXXX 4; see Piggott, *Vignettes*, cat. no. 54, p. 90.

35. The story of Noah's Ark is in Genesis 6:14–22, and chap. 7; the drunkenness of Noah in Genesis 9:20–27.

36. "One morn, the heavens / Grew dark with wings; earth with unnumber'd steps / Sounded; bird, beast, in long procession sought / Their destin'd refuge. . . / Then darkness cover'd all, / Deathlike, unsunn'd, as though primeval night / Resumed her empire. Torrents from the skies / Plunged prone in solid downfall." From Gisborne, "Walk the Sixth—Winter—Frost," in *Walks in the Forest*, 127.

37. Transcribed Wilton, *Painting and Poetry*, 181. For "The Fallacies of Hope," see Jan Piggott, "Poetry and Turner," in *The Oxford Companion to J. M. W. Turner*, ed. Evelyn Joll, Martin Butlin, and Luke Herrmann (Oxford: Oxford University Press, 2001).

38. See Hamilton, *Turner and the Scientists*, chap. 7.

39. Letter of JMWT to David Roberts, endorsed 1847; cited in Andrew Wilton, *Apollo* 113 (1981): 59; and John Gage, "Further Correspondence of J. M. W. Turner," *Turner Studies* 6, no. 1 (1986): 2–9, letter no. 307a. This may refer equally to a steamboat or a steam train journey.

40. Hamilton, *Turner: A Life*, appendix 3.

41. It remains an assumption, but perhaps a reasonable one, that Mrs. Booth arranged Turner's bed in Margate so that he could at least see the sea as he lay there.

42. BJ453–BJ486. The group includes other works in this exhibition—*Yacht Approaching the Coast* (fig. 81) and *Sunrise with Sea Monsters* (fig. 61)—as well as more specifically narrative paintings, such as *The Evening Star* (National Gallery, London; BJ453) and *Fire at Sea* (Tate Britain, London; BJ460).

43. Eric Shanes has suggested that had Turner brought the picture to an exhibitable level of finish he might have given it a more poetic title, such as *Hymn to the Sun*. BBC Radio 3 program: "Turner—The Eye of the Storm" (Producer: Susan Marling), first broadcast January 2001.

44. Hamilton, *Turner: A Life*, 248–49.

45. See entry for BJ461.

46. Tate no. 4658.

47. The meaning of the series of initial letters at the top right edge of the canvas has not been determined: "M M N Ns T Ts"

48. Tate no. 5477.

49. Tate no. 4445.

50. Tate no. 2425.

51. Tate no. 5479.

52. There is no reliable reason why this should necessarily be "Folkestone" or any specified Kent seaport.

53. Wilton's reading of the lines is: "Lost to all Hope she lies / each sea breaks over a derelict [?] / on an unknown shore / the sea folk [?] only sharing [?] the triumph" (W1425).

54. Thornbury, *Life*, 105.

55. Virgil, *Aeneid*, bk. 4.

Further Reading

The Turner literature is wide, deep, and of many moods, like the sea. Listed here are books that are either relevant to the marine aspect of this exhibition or are of a more general nature with extensive bibliographies. The entire Turner Bequest can be accessed at the Tate website (www.tate.org.uk).

Bailey, Anthony. *Standing in the Sun—A Life of J.M.W. Turner.* London: Sinclair-Stevenson, 1997.

Brown, David Blayney. *Turner in the Tate.* London: Tate Gallery, 2001.

Butlin, Martin, and Evelyn Joll. *The Paintings of J.M.W. Turner.* Rev. ed. 2 vols. New Haven: Yale University Press, 1984.

Egerton, Judy. *Turner—The Fighting Temeraire.* London: National Gallery, 1995.

Finberg, A. J. *The Life of J.M.W. Turner, R.A.* 2nd rev. ed. Oxford: Clarendon, 1961.

Gage, John. *J.M.W. Turner—"A Wonderful Range of Mind."* New Haven: Yale University Press, 1987.

————, ed. *Collected Correspondence of J.M.W. Turner.* Oxford: Clarendon, 1980.

Hamilton, James. *Turner: A Life.* London: Hodder and Stoughton, 1997.

————. *Turner and the Scientists.* Exh. cat. London: Tate Publications, 1998.

————, ed. *Fields of Influence: Conjunctions of Artists and Scientists, 1815–60.* Birmingham: University of Birmingham Press, 2001.

Joll, Evelyn, Martin Butlin, and Luke Herrmann, eds. *The Oxford Companion to J.M.W. Turner.* Oxford: Oxford University Press, 2001.

Lindsay, Jack. *J.M.W. Turner: His Life and Work.* Greenwich, Conn.: New York Graphic Society, 1966.

Rodner, William S. *J.M.W. Turner—Romantic Painter of the Industrial Revolution.* Berkeley: University of California Press, 1997.

Shanes, Eric. *Turner's Human Landscape.* London: Heinemann, 1990.

Wilton, Andrew. *J.M.W. Turner: His Art and Life.* Fribourg, Switzerland: Office du Livre, 1979.

————. *Turner in His Time.* New York: Abrams, 1987.

Checklist of the Exhibition

Unless otherwise noted, works listed will be exhibited at all venues. Dimensions are provided in inches and centimeters, height preceding width. Within each section, exhibited oil paintings are listed first, followed by unexhibited oils and works on paper. When listings are available, works are cross-referenced with the following sources:

BJ Martin Butlin and Evelyn Joll, *The Paintings of J.M.W. Turner*, rev. ed., 2 vols. (New Haven: Yale University Press, 1984)

TB Turner Bequest (Tate Britain, London), searchable by Finberg number on the Tate's website: www.tate.org.uk

W Andrew Wilton, *J.M.W. Turner: His Art and Life* (Fribourg, Switzerland: Office du Livre, 1979)

A Power Supreme

View from the Terrace of a Villa at Niton, Isle of Wight, from Sketches by a Lady
Exhibited 1826
Oil on canvas, 18 x 24 in. (45.7 x 61 cm)
Museum of Fine Arts, Boston.
Bequest of William A. Coolidge
Fig. 3 | BJ234

"Now for the Painter," (Rope.) Passengers Going on Board
Exhibited 1827
Oil on canvas, 67 x 88 in. (170.2 x 223.5 cm)
Manchester Art Gallery
Fig. 8 | BJ236

Port Ruysdael
Exhibited 1827
Oil on canvas, 36 ¼ x 48 ¼ in.
(92 x 122.5 cm)
Yale Center for British Art, New Haven, Connecticut. Paul Mellon Collection
Fig. 5 | BJ237

Van Tromp's Shallop, at the Entrance of the Scheldt
Exhibited 1832
Oil on canvas, 35 x 47 in. (89 x 119.5 cm)
Wadsworth Atheneum, Hartford, Connecticut. The Ella Gallup Sumner and Mary Catlin Sumner Collection Fund, Endowed by Mr. and Mrs. William Lidgerwood
Fig. 19 | BJ344

Rotterdam Ferry Boat
Exhibited 1833
Oil on canvas, 36 ⅜ x 48 ¼ in.
(92.3 x 122.5 cm)
National Gallery of Art, Washington, D.C. Ailsa Mellon Bruce Collection
Exhibited Williamstown only
Fig. 20 | BJ348

Wreckers—Coast of Northumberland, with a Steamboat Assisting a Ship off Shore
Exhibited 1834
Oil on canvas, 35 ⅝ x 47 ⁹⁄₁₆ in.
(90.4 x 120.7 cm)
Yale Center for British Art, New Haven, Connecticut. Paul Mellon Collection
Exhibited Williamstown only
Fig. 21 | BJ357

*Venice: The Dogana and
San Giorgio Maggiore*
Exhibited 1834
Oil on canvas, 35 ½ x 48 in.
(90.2 x 121.9 cm)
National Gallery of Art, Washington, D.C.
Widener Collection
Exhibited Williamstown only
Fig. 22 | BJ356

*Keelmen Heaving in Coals
by Moonlight*
Exhibited 1835
Oil on canvas, 35 ½ x 48 in. (90.2 x 121.9 cm)
National Gallery of Art, Washington, D.C.
Widener Collection
Exhibited Williamstown only
Fig. 23 | BJ360

Dunwich, Suffolk
c. 1830
Bodycolor on blue paper, 6 ⅞ x 10 ⅛ in.
(17.4 x 25.7 cm)
Manchester Art Gallery
Exhibited Manchester and Glasgow only
Fig. 25 | W900

Lyme Regis, Dorset
c. 1834
Watercolor and bodycolor with scraping out
on paper, 11 ½ x 17 ⅝ in. (29.2 x 44.8 cm)
Cincinnati Art Museum. Gift of Emilie
L. Heine in Memory of Mr. and Mrs.
John Hauck
Exhibited Williamstown only
Fig. 26 | W866

Ship and Cutter
c. 1825
Watercolor and graphite on paper,
9 ⅜ x 11 ⅜ in. (23.8 x 28.9 cm)
Museum of Fine Arts, Boston. Gift of
William Norton Bullard
Exhibited Williamstown and Manchester only
Fig. 11 | W777

Shipping
c. 1828–30
Pen and brush and brown ink and white
highlighting, with bodycolor over graphite
on blue wove paper, 5 ⅜ x 7 ⅜ in.

(13.6 x 18.6 cm)
Yale Center for British Art, New Haven,
Connecticut. Paul Mellon Collection
Exhibited Williamstown only
Fig. 12 | W915

Ship Aground: Brighton
c. 1828–30
Black ink, watercolor, and bodycolor on blue
paper, 5 ⅝ x 7 ⅝ in. (14.3 x 19.4 cm)
Yale Center for British Art, New Haven,
Connecticut. Paul Mellon Collection
Exhibited Williamstown only
Fig. 13 | W917

Fishing Boats Becalmed off Le Havre
1830s?
Watercolor and bodycolor on blue paper,
5 ½ x 7 ¹¹⁄₁₆ in. (14 x 19.5 cm)
Yale Center for British Art, New Haven,
Connecticut. Paul Mellon Collection
Exhibited Williamstown only
Fig. 14 | W1042

Seashore, from Hastings
c. 1830–35
Watercolor over pencil on buff paper,
5 ¼ x 7 in. (13.3 x 17.8 cm)
Fogg Art Museum, Harvard University,
Cambridge, Massachusetts
Fig. 15 | W927

Ship Leaving Harbor
After c. 1830
Watercolor on paper, 9 ¼ x 12 ⅜ in.
(23.5 x 31.4 cm)
Tate Britain, London
Exhibited Manchester and Glasgow only
Fig. 16 | TB CCCLXIV a 98

The Multitudinous
Seas Incarnadine
————

*Rockets and Blue Lights (Close
at Hand) to Warn Steamboats of
Shoal Water*
Exhibited 1840
Oil on canvas, 36 ¹⁄₁₆ x 48 ⅛ in.
(91.8 x 122.2 cm)

Sterling and Francine Clark Art Institute,
Williamstown, Massachusetts
Fig. 27 | BJ387

Dawn of Christianity (Flight into
Egypt)
Exhibited 1841
Oil on canvas, diam. 31 in. (78.5 cm)
Ulster Museum, Belfast
Fig. 31 | BJ394

Glaucus and Scylla
Exhibited 1841
Oil on panel, 31 x 30 1/2 in. (78.3 x 77.5 cm)
rectangular (exhibited as a circle)
Kimbell Art Museum, Fort Worth, Texas
Exhibited Williamstown only
Fig. 32 | BJ395

Undine Giving the Ring to
Massaniello, Fisherman of Naples
Exhibited 1846
Oil on canvas, 31 1/8 x 31 1/8 in. (79 x 79 cm)
Tate Britain, London
Fig. 34 | BJ424

Interlude: Turner the
Elderly Traveler
————————

Snowstorm, Mont Cenis
1820
Watercolor on paper, 11 x 15 3/4 in.
(29.2 x 40 cm)
Birmingham Museums and Art Gallery
Exhibited Manchester and Glasgow only
Fig. 40 | W402

Entry to the Grand Canal, Santa Maria
della Salute, Venice
1840
Watercolor with bodycolor and scraping out
over pencil on paper, 8 9/16 x 12 1/2 in.
(21.8 x 31.8 cm)
Private collection
Exhibited Williamstown only
Fig. 37 | W1368

Falls of the Rhine, Schaffhausen
1841?
Watercolor, pen, and red ink over gray wash
on paper, 8 7/8 x 11 1/4 in. (22.6 x 28.6 cm)
Indianapolis Museum of Art.
Bequest of Kurt F. Pantzer, Sr.
Exhibited Williamstown only
Fig. 44 | W1461

The First Steamer on Lake Lucerne
1841?
Watercolor with scraping out on paper,
9 1/8 x 11 3/8 in. (23.1 x 28.9 cm)
University College, London
Exhibited Manchester and Glasgow only
Fig. 45 | W1482

Town and Lake of Thun
1841?
Watercolor on paper, 9 x 11 3/8 in.
(22.7 x 28.7 cm)
Trustees, Cecil Higgins Art Gallery,
Bedford, England
Exhibited Manchester and Glasgow only
Fig. 50 | W1505

Alpine Landscape
1843?
Watercolor over pencil on paper, 9 x 11 3/8 in.
(23 x 28.9 cm)
Manchester Art Gallery
Exhibited Manchester and Glasgow only
Fig. 47 | W1496

Swiss Pass
1843?
Watercolor and pencil with some scratching
out on paper, 9 1/4 x 11 1/2 in. (23.2 x 29.1 cm)
Manchester Art Gallery
Exhibited Manchester only
Fig. 46 | W1513

Goldau
1843
Watercolor on paper, 12 x 18 1/2 in.
(30.5 x 47 cm)
Private collection
Exhibited Williamstown only
Fig. 43 | W1537

Bellinzona, from the Road to Locarno
1843
Watercolor with scraping out on paper,
11 1/2 x 18 1/2 in. (29.2 x 45.7 cm)
Aberdeen Art Gallery and Museums
Exhibited Glasgow only
Fig. 49 | W1539

Eu by Moonlight
1845
Watercolor on paper, 9 x 13 3/8 in.
(22.8 x 33.3 cm)
Tate Britain, London
Exhibited Manchester and Glasgow only
Fig. 42 | TB CCCLIX 1

Brunnen, from the Lake of Lucerne
1845
Watercolor and bodycolor on paper,
11 3/8 x 18 7/8 in. (29 x 47.7 cm)
Sterling and Francine Clark Art Institute,
Williamstown, Massachusetts
Fig. 48 | W1545

The Deep

*The Dogana and Santa Maria della
Salute, Venice*
Exhibited 1843
Oil on canvas, 24 3/8 x 36 5/8 in. (62 x 93 cm)
National Gallery of Art, Washington, D.C.
Given in memory of Governor Alvan T.
Fuller by The Fuller Foundation, Inc.
Exhibited Manchester and Glasgow only
Fig. 82 | BJ403

The Evening of the Deluge
c. 1843
Oil on canvas, 29 7/8 x 29 7/8 in. (76 x 76 cm)
National Gallery of Art, Washington, D.C.
Timken Collection
Fig. 67 | BJ443

*Van Tromp, Going about to Please
His Masters, Ships a Sea, Getting a
Good Wetting*
Exhibited 1844
Oil on canvas, 36 x 48 in. (91.4 x 121.9 cm)
The J. Paul Getty Museum, Los Angeles
Fig. 54 | BJ410

Whalers (The Whale Ship)
Exhibited 1845
Oil on canvas, 36 1/8 x 48 1/4 in.
(91.8 x 122.6 cm)
The Metropolitan Museum of Art, New
York. Catharine Lorillard Wolfe Collection,
Wolfe Fund, 1896
Fig. 56 | BJ415

*"Hurrah! for the Whaler Erebus!
Another Fish!"*
Exhibited 1846
Oil on canvas, 35 1/2 x 47 1/2 in. (90 x 121 cm)
Tate Britain, London
Fig. 59 | BJ423

The Wreck Buoy
c. 1807; reworked and exhibited 1849
Oil on canvas, 36 1/2 x 48 1/2 in.
(92.7 x 123.2 cm)
National Museums and Galleries on
Merseyside (Walker Art Gallery), Liverpool
Exhibited Manchester and Glasgow only
Fig. 85 | BJ428

The Departure of the Fleet
Exhibited 1850
Oil on canvas, 35 3/8 x 47 3/8 in.
(89.5 x 120.5 cm)
Tate Britain, London
Fig. 91 | BJ432

Yacht Approaching the Coast
c. 1840–45
Oil on canvas, 40 1/4 x 56 in.
(102 x 142 cm)
Tate Britain, London
Fig. 81 | BJ461

Seascape with Distant Coast
c. 1845
Oil on canvas, 36 x 48 in. (91.5 x 122 cm)
Tate Britain, London
Fig. 77 | BJ467

Stormy Sea Breaking on a Shore
c. 1840–45
Oil on canvas, 17 1/2 x 25 in.
(44.5 x 63.5 cm)
Yale Center for British Art, New Haven,
Connecticut. Paul Mellon Collection
Fig. 84 | BJ482

Sunrise with Sea Monsters
c. 1845
Oil on canvas, 36 x 48 in. (91.5 x 122 cm)
Tate Britain, London
Fig. 61 | BJ473

Figures on a Beach
Possibly after 1845
Oil on millboard, 10 1/4 x 11 3/4 in.
(25.9 x 29.9 cm)
Tate Britain, London
Exhibited Manchester and Glasgow only
Fig. 86 | BJ496

Stormy Coast Scene
After c. 1830, possibly 1840s
Watercolor on paper, 10 1/4 x 13 3/4 in.
(26 x 34.9 cm)
Tate Britain, London
Exhibited Manchester and Glasgow only
Fig. 71 | TB CCCLXIV a 140

Dawn after the Wreck
(The Baying Hound)
c. 1841
Graphite, watercolor, bodycolor, scraping,
and chalk on paper, 9 5/8 x 14 1/4 in.
(24.5 x 36.2 cm)
Courtauld Institute Gallery, Somerset House,
London
Fig. 88 | W1398

Sunset
c. 1840–45
Watercolor on paper, 8 3/4 x 11 3/4 in.
(22.2 x 29.8 cm)
Manchester Art Gallery
Exhibited Manchester only
Fig. 75 | W1414

Sunset
c. 1845–50
Watercolor on paper, 9 x 12 7/8 in.
(22.9 x 32.7 cm)
Museum of Fine Arts, Boston. Bequest of
Mrs. Henry Lee Higginson, Sr.
Exhibited Williamstown and Manchester only
Fig. 76 | W1420

Sky Study
c. 1845
Watercolor on paper, 11 1/2 x 17 1/4 in.

(29 x 43.7 cm)
Tate Britain, London
Exhibited Manchester and Glasgow only
Fig. 72 | TB CCCLXV b 17

Storm Clouds, Looking out to Sea
1845
Watercolor on paper, 9 3/8 x 13 3/4 in.
(23.8 x 33.6 cm)
Tate Britain, London
Exhibited Manchester and Glasgow only
Fig. 58 | TB CCCLVII 12

Wimereux
1845
Pencil and watercolor on paper,
9 3/8 x 13 3/4 in. (23.8 x 33.6 cm)
Tate Britain, London
Exhibited Manchester and Glasgow only
Fig. 70 | TB CCCLVII 4

Beach Scene
c. 1845
Watercolor on paper, 11 1/2 x 17 1/4 in.
(29.1 x 43.8 cm)
Tate Britain, London
Exhibited Manchester and Glasgow only
Fig. 73 | TB CCCLXV b 18

Blue Sea and Distant Ship
c. 1845
Watercolor on paper, 11 1/8 x 17 1/2 in.
(28.2 x 44.4 cm)
Tate Britain, London
Exhibited Manchester and Glasgow only
Fig. 74 | TB CCCLXV b 21

Sea Monsters and Vessels at Sunset
c. 1845
Watercolor and chalk on paper,
8 3/4 x 12 3/4 in. (22.2 x 32.5 cm)
Tate Britain, London
Exhibited Manchester and Glasgow only
Fig. 65 | TB CCCLIII 21

"Lost to All Hope . . ."
c. 1845–50
Watercolor and graphite on wove paper,
9 1/16 x 12 13/16 in. (23 x 32.5 cm)
Yale Center for British Art, New Haven,
Connecticut. Paul Mellon Collection
Exhibited Williamstown only
Fig. 87 | W1425

Sketch of Three Mackerel
c. 1835–40
Watercolor on paper, 8 ³/₄ x 11 ³/₈ in.
(22.4 x 28.7 cm)
Ashmolean Museum, Oxford
Exhibited Manchester and Glasgow only
Fig. 62 | W1399

Study of a Gurnard
c. 1840
Watercolor and gouache on blue-gray wove
paper, 7 ¹/₂ x 10 ³/₄ in. (19 x 27.4 cm)
Fogg Art Museum, Harvard University,
Cambridge, Massachusetts.
Gift of Meta and Paul J. Sachs
Fig. 63

Study of a Gurnard
c. 1840
Watercolor and bodycolor on paper,
7 ⁵/₈ x 10 ⁷/₈ in. (19.3 x 27.6 cm)
Victoria and Albert Museum, London
Exhibited Manchester and Glasgow only
Fig. 64 | W1404

Index

Photography Credits